Praise for *Ideas Abo*

"What I especially like about *Ideas About Art* is
learner a natural starting point for thinking abo. ...ocussion
about ideas and concepts – *meaty things in art* ...u then providing the
reader with a place to *go* with those ideas."

Mark Anderson, *North Kansas City District Art Supervisor,*
Oak Park High School, Kansas City, MO

"Kathleen K. Desmond's ideas not only validated some of my instincts, they
gave me some specific and tangible suggestions. I thank her for her friendly
and accessible tone. So much of what I read is informative and stimulating,
but makes me feel like an outsider because I don't talk 'that way.'"

Sandy Sampson, *Interdisciplinary Artist, Parallel University*

Ideas About Art

Kathleen K. Desmond

A John Wiley & Sons, Ltd., Publication

This edition first published 2011
© 2011 Kathleen K. Desmond

Blackwell Publishing was acquired by John Wiley & Sons in February 2007. Blackwell's publishing program has been merged with Wiley's global Scientific, Technical, and Medical business to form Wiley-Blackwell.

Registered Office
John Wiley & Sons Ltd, The Atrium, Southern Gate, Chichester, West Sussex, PO19 8SQ, United Kingdom

Editorial Offices
350 Main Street, Malden, MA 02148-5020, USA
9600 Garsington Road, Oxford, OX4 2DQ, UK
The Atrium, Southern Gate, Chichester, West Sussex, PO19 8SQ, UK

For details of our global editorial offices, for customer services, and for information about how to apply for permission to reuse the copyright material in this book please see our website at www.wiley.com/wiley-blackwell.

The right of Kathleen K. Desmond to be identified as the author of this work has been asserted in accordance with the UK Copyright, Designs and Patents Act 1988.

Wiley also publishes its books in a variety of electronic formats. Some content that appears in print may not be available in electronic books.

Designations used by companies to distinguish their products are often claimed as trademarks. All brand names and product names used in this book are trade names, service marks, trademarks or registered trademarks of their respective owners. The publisher is not associated with any product or vendor mentioned in this book. This publication is designed to provide accurate and authoritative information in regard to the subject matter covered. It is sold on the understanding that the publisher is not engaged in rendering professional services. If professional advice or other expert assistance is required, the services of a competent professional should be sought.

Library of Congress Cataloging-in-Publication Data is available for this title.

9781405178839 hardback
9781405178822 paperback

A catalogue record for this book is available from the British Library.

This book is published in the following electronic formats: ePDFs 9781444395990; Wiley Online Library 9781444396010; ePub 9781444396003

Set in 10.5/13pt Minion by SPi Publisher Services, Pondicherry, India
Printed in Malaysia by Ho Printing (M) Sdn Bhd

1 2011

Dedicated to Bill Desmond

Contents

Illustrations

Preface

Annual College Art Association's conference sessions conducted by the Education Committee, of which I was chair for several years, were packed with eager art faculty willing to step up to the microphone and reveal the need for teaching art theory to undergraduates at their institutions. Faculty reported that young artists were passionate about making things and were skilled in using a variety of media, but what they didn't seem to know was what artists, art critics, curators, or art historians thought, knew, or did. These problems were found in every type of educational institution, from art schools and private colleges to comprehensive and research universities all over the United States. Educational systems in European countries didn't seem to have this same need because in those countries there is an advanced familiarity with concepts and theory prior to higher education. My university tackled the problem by developing a course called "Artists in Contemporary Society" to infuse art theory, philosophical aesthetics, and ethics, and requires it of all studio art, graphic design, interior design, and art education majors.

While designing and teaching "Artists in Contemporary Society," a search for useful books ended with the adoption of *Puzzles About Art: An Aesthetics Casebook* (1989) by Margaret Battin and three other philosophers. It features contributions of case studies in the arts, mostly visual, but including music and poetry, by a host of other philosophers, at least one whom is also an artist. *Puzzles About Art* explains classical aesthetic philosophies and uses case studies both to "develop insight into aesthetic issues and ultimately to test and challenge aesthetic theories" (p. v), as explained in the Preface. Authors Margaret Battin and Ronald Moore were well aware that puzzle cases "play an important role in both teaching and research in aesthetics" (p. v) and wrote several articles about using the case method for teaching aesthetics. Teaching and learning using the case method is well documented

in educational literature and widely used in medicine, business, and education. *Puzzles About Art*, however, was the first case study text for learning about art. I was enjoying using *Puzzles About Art* in "Artists in Contemporary Society" when a bright graphic design student told me that although this was a good book, he thought it was outdated. "You need to write a new one," he told me, "one that has current stories we can relate to and includes art and design theory."

Well, I thought, he's right. *Puzzles About Art* did not address contemporary art or the significant developments in the disciplines of photography, design, and art/aesthetic education, major areas in most universities. Further, there was no mention of non-Western art or aesthetics or Postmodern theories. I added Howard Smagula's *Re-Visions* (1991) to the required readings because at least it included Feminist aesthetics, Ellen Dissanayake's ethological studies of art, and articles by and about cultural theorist Jean Baudrillard. But that still wasn't current enough; thus the birth of *Ideas About Art*. As Chair of the College Art Association Education Committee, I collected and used the data from those sessions to inform and support this text.

Ideas About Art is the result of what I have learned from living and teaching in London, Amsterdam and Maastricht (the Netherlands), the Midwest, Southwest, and Northwest United States, and from traveling extensively in Europe, North and Central America, and especially from living in and teaching near Kansas City. We may scoff about the myopic, bi-coastal orientation of much of the artworld, but it is a reality. And some may think Kansas City is provincial backwater rather than the thriving cultural art scene that it is. What occurs here, where I live, is a very valuable inclusion to this text because it speaks to the authenticity and the usefulness of the contents beyond that "artworld reality." Noted art critic Peter Plagens (2007) extolled the vitality of the Kansas City art scene in an article for *Art in America*. He credited the *Kansas City Star*'s full-time visual art critic, Alice Thorsen. Very few cities have full-time art critics in the first place, but Kansas City continues its support of the arts with art critics writing for the *Kansas City Star* and the regional arts journal, *Review*. Art journals and even newspapers are becoming defunct these days, but not in Kansas City. In 2008, Kansas City was lauded again in *Art in America* for its significant standing in the artworld (Maine 2008). "Everything is up to date in Kansas City," as the song goes.

Contemporary stories gleaned from the mainstream world news and artworld news are included in *Ideas About Art* to make content current and

engaging to an art-interested (and student) audience. Discussions of non-Western, Feminist, and Postmodern philosophies are featured in addition to classical Western aesthetic philosophies in order to illuminate art and design theories, cultural theories, and contemporary art theories. Of course not all philosophers, cultural or art theorists, artists and art movements, art critics, and art issues are included. Some concepts are noted and not fully explained, providing readers with an invitation to review, research, and add new ideas to their personal repertoire that support their arguments and defend their positions. Provocative questions nudge the reader to further thinking and consideration of ideas perhaps previously not considered. "Oh, I hadn't thought of it that way before."

Stories from mainstream everyday artworld goings-on with embedded questions that require knowledge about art history, art theory, aesthetics, and ethics to discuss judiciously replace traditional case studies. Some stories function as case studies, but most of them are narratives with aesthetic or ethical dilemmas intended to engage readers. Stories include diverse forms of visual art in contemporary Western and non-Western cultures. Answers to questions posed are not so much right or wrong as they are insightful, interesting, and thought provoking. Responses to these issues and questions help develop critical thinking.

With its coverage of Western and non-Western aesthetics, ethics, economics, censorship, Feminist aesthetics, and Postmodernism, along with discipline-specific chapters on design, photography, art/aesthetic education, and artists, curators, and art critics, the book aims to provide an art-centered and up-to-date read. Within the short chapters, everyday stories about art, artists, art critics, art museum, and gallery professionals found in newspapers and art journals provide provocative stimuli in diverse contexts. Grappling with current art issues that these narratives initiate provides opportunities to substantiate ideas and practice arguments supported by philosophies and theories in the visual arts.

Chapters on design (graphic design, interior design/architecture), art/aesthetic education, and photography are included because many university art departments and art schools grant degrees in these areas and this book is intended for students of art and design and art education who want to understand theories that support their studies. A chapter about photography is included because so much of contemporary art depends on theories of reproduction, from Plato's mimetic theory to Walter Benjamin's "The Work of Art in the Age of Mechanical Reproduction" to cultural theories espoused by Postmodern thinkers like

Jacques Derrida, Michel Foucault, Roland Barthes, and Jean Baudrillard. The chapter on art and aesthetic education focuses on aesthetic education with historical notions of philosophical inquiry and movements in art education that provide a foundation for art and aesthetic education at all age levels.

Individual chapters about the disciplines of crafts or material arts, ceramics, and sculpture are not included because concepts about these disciplines are featured throughout the text. There is no art vs. craft discussion because it is not germane to contemporary art debates. Stories are mainstream art-world examples rather than culturally specific or traditionally specific to disciplines because the stories are intended to highlight everyday global art ideas found in any media in many places around the world, even in the Midwest.

Some may wonder why there aren't more female philosophers in this volume, just as readers of art history books in the 1970s wondered why there weren't women artists in their books. Peg Brand addressed the dearth of women philosophers in her American Society of Aesthetics article "Mining Aesthetics for Deep Gender" (2005), and concluded: "Answering, 'Why so few women?' naturally leads to a Feminist critique of art, art history, and the philosophy of art." This is sometimes called Feminist aesthetics. One simple answer to the question is that in the past there were few educated women and few women in the arts, both as practitioners and as theoreticians. Feminist aesthetics seeks to dismantle long-standing foundations of philosophical aesthetics, to question underlying assumptions both historically and conceptually. Because males have historically been the authors of Western art histories and because current scholarship is dependent on knowledge of the past and the present, efforts to include non-Western and Feminist theories are presented here. The chapter "Feminist Art, Aesthetics, and Art Criticism" specifically addresses these exclusions, while the entire text seeks to be inclusive.

The text explains philosophical aesthetics, art theories, and art practices in accessible language with stories that provide a supporting foundation for forms of art and careers in art that readers aspire to or in which they currently find themselves. Useful active learning strategies, founded in constructivist learning theories and based on educational psychology about how people learn, are effective for employing the content of this text in group or classroom settings and are included below. Strategies for teaching aesthetics to artists are outlined in "Actively Teaching (Artists) Aesthetics" (Desmond 2008a).

Actively Learning Critical Thinking and Art Theory

Active learning requires participation. Learners cannot sit back and wait to be "filled up" with knowledge; they must engage with the readings, the images, and with each other. Group processing theory and educational experience supports learners working in groups or teams. Groups are assigned sections of the text to present to the class. They cannot simply make a powerpoint presentation, or "lecture" at the front of the class. Presentations must engage the entire group in working out the concepts being studied. This can involve creating artworks to make a point, or developing symbols to understand what Nelson Goodman meant by a symbol system, or engaging in debates about whether something is a work of art or not by taking the positions of different philosophies like essentialists (Plato and Danto), antiessentialists (Wittgenstein and Weitz), or anti-anti-essentialists (Dickie). Debates about censorship and asking questions like in what places, under what conditions, and for what reasons should this artwork be shown are always good for active engagement. *Dirty Pictures*, a film about Robert Mapplethorpe's *The Perfect Moment* portfolio shown in Cincinnati, starts a conversation about how censorship goes beyond the issue of the First Amendment and and affects people's lives and our rights to view or make art.

Sometimes class debates become very heated! Students learn that their arguments weigh more if they can back them up with theory and clear thinking. Arguments surround current issues. The 2008 election included the copyright controversy over artist Shepard Fairey's use of a photograph of Barack Obama to design the internationally known image of HOPE. Damien Hirst's auction at Sotheby's is controversial for economic and ethical reasons. There are news items every day that can be used to "incite" thinking about art, for instance, Artdaily.org (*www.artdaily.org/index.asp*) or one of the newspapers with a full-time visual art critic, like the *Kansas City Star* who employs art critic Alice Thorson full time. There is always something interesting, even in the comic section, to discuss or argue about. Developing critical thinking, writing and speaking, supported by philosophy and art theory, provides students of art with ideas for their own artwork and helps them understand what artists, art critics, and art professionals do, what they think, and how they go about their work.

Learning

Cognitive learning theories support that we learn from experience, by doing, and that learning comes from placing experience within a framework of existing knowledge. Doing involves repeated practice and use of rewards to encourage perseverance. Experience and repetition encourage learning that includes a psychological concept called depth of (information) processing and allow learners to claim ownership of knowledge and apply it in problem solving.

Learning is more effective (i.e. 'deep learning' rather than 'shallow learning') if it is active rather than passive during the process. Learning by doing (experiential learning) is generally more effective than learning by listening or reading or looking. When learning is active (using information to solve a problem), learners are more likely to remember what they have learned and more likely to process the information and reflect on how they learned, especially if there are incentives to do this. Incentives include being able to see the relevance of what is being learned so the information is connected and in a context. When learning is active, several skills are learned at once, i.e., finding and processing information and being able to explain it to others.

Active Learning

Active learning has foundations in constructivist theory and is based on the notion that different people learn in different ways, that the process of learning is about self-development, and that learning is only meaningful when learners make knowledge their own. Elements of active learning are talking, listening, writing, reading, and reflecting. Strategies for active learning include group projects, presentations, short writing exercises, and case study debates. Teaching resources consists of outside speakers, content-specific assignments, and appropriate textbooks, like *Ideas About Art*.

According to research studies, the lecture method of teaching has the lowest learner retention rate. Teaching others has a 90 percent retention rate, practice by doing 75 percent, and discussion groups 50 percent. Strategies that incorporate active learning elements promote learner self-development and the learning process.

Empirical studies prove that active learning is more successful than individual learning. The most significant study was in a large medical school that assigned a team of first-year medical students, enrolled in the required anatomy course, a cadaver and teacher-generated assignments for students to learn, in teams, what had previously been taught in large lecture classes. Students were required to develop their own strategies and actively learn anatomy. Scores on the national anatomy exam, which all medical students must pass in order to continue in medical school, were significantly higher when students were given the opportunity to learn actively in teams rather than in a lecture format.

Active learning can engage students in critical thinking and philosophical dialogue. The Socratic method is a kind of active learning. Group processing and team-based learning are also a kind of active learning. Active learning allows learners to engage with content, making knowledge meaningful and contributing to self-development and their own learning process. Active learning provides learners with opportunities to exercise their creative and critical thinking and to make knowledge relevant and their own.

Today's Learners

William Perry (1970) described the concrete thinking and the dualistic nature of beginning-level adult learners with an example of a typical question of the teacher – "just tell me what you want." Students at this level of intellectual development regard their instructors as the ultimate authorities. They often consider the development of their own thinking skills to be a "frill" of or an intrusion into the *real* substance of learning as they conceptualize it.

Concrete thinkers can be challenged with abstract art ideas if they are given an opportunity to make art part of their everyday existence in ways that will remain with them and be useful and meaningful for the rest of their lives. It's important that learners think critically and become comfortable with ambiguity. This can be accomplished in a community of learners. "Hook" learners with the stories and case studies in this book. Find your own relevant stories. Make up your own stories with a few facts.

Some learners are introverts and need time to think before they can come up with responses that won't embarrass them. When you call on a student who responds, "I don't know" when you know they do, it's probably because they are an introvert and need time to prepare their answer. Giving students

a few minutes to write answers to questions will allow for reflection and better answers from both introverts and extraverts. Time to think and write and reflect allows extraverts to prepare better answers than those they are immediately ready to volunteer. You know the extraverts. They volunteer answers before you even have the question out of your mouth. Active learning provides for a variety of learning differences, including psychological learning differences.

Cognitive development theorists promote strategies for different learning predispositions and for different levels of readiness for learning. Learning differences are described in cognitive and developmental psychology as well as in educational psychology literature. Encouraging learners to recognize and use their own creative energies in constructing knowledge by providing them with a framework for learning is an essential component in teaching. Creating a variety of active learning strategies for engaging students in discovering how knowledge is essential to and meaningful in their lives is on ongoing challenge.

Teaching as Art

Critical thinking skills developed through practice arguing about relevant stories fosters a deeper understanding of any discipline and allows for continued learning. Think about teaching as an artwork, a "performance," and story telling as key to teaching performance. Influential twentieth-century artist Joseph Beuys claimed, "To be a teacher is my greatest work of art."

In order to connect content to something important in students' lives, seek relevance. What is important to students? Ask questions. What kind of music do students listen to? What kinds of posters hang on their walls? What designs on CD covers do they think are effective? Why? Ask learners to define art or music or film. Ask these questions often.

It's surprising how the answers to these questions change over time and from group to group. Learners, no matter what age, connect with the familiar – with what they know. They connect with what is important to them now, at this time and in this place, making context vitally important. (See the matrix in Gracyk 2008.)

Because students today learn differently than they did thirty years ago, professors must go beyond using powerpoint and look to new technologies like Facebook, blogs, and maybe even text messaging! In the humanities it means keeping up with cultural theory, visual culture, and contemporary practices.

When the College Art Association conducted a session called "Alternative Modes of Pedagogy: Theory and Practice in Teaching Art History," it was based on Ernest Boyer's *Scholarship Reconsidered: Priorities of the Professoriate* (1990), which supported Carnegie Foundation findings that 70 percent of today's professors acknowledged that teaching was their primary interest. (Boyer was a former director of the Carnegie Foundation for the Advancement of Teaching.)

In a later CAA session, "What Do First Year College Students Know About Art, Anyway?" (Desmond 2001), professors reported that young art students have little or no knowledge of theory or aesthetics and they had not been taught to think critically. So important is critical thinking and aesthetics to the CAA that in 2006 noted philosopher Arthur Danto was keynote speaker. Danto (2006) detailed contemporary aesthetics brilliantly that evening and his published remarks are required reading in "Artists in Contemporary Society." Current trends call for teaching critical thinking, art theory, and aesthetics in college art curriculums. In 2010, "WTF? Talking Theory with Art and Art History Undergrads" was presented at the CAA (Desmond 2010). It was with this continued interest in teaching and learning aesthetics and art theory that pedagogical theories and practices are explored at the CAA. *Ideas About Art* can be used as an effective method in a pedagogical framework for teaching and learning aesthetics and art theory.

Active Teaching with Stories About Art

Stories and case studies are useful in connecting content to something relevant in students' lives. Local newspapers or Internet news sites provide relevant stories. Case studies can be examined in terms of values as well as consequences. Rarely does a week go by without at least one artworld news item appearing that is conducive to a case study or story. (This encourages students to pay attention to world issues.) Short writing experiences can provide practice for more formal essays. Develop your own stories to connect learners to daily life issues and content of your class in which critical theory plays a part.

Ideas about the transformation of found objects, about the temporary nature of art, and about the need for participants to engage with the art to make it art came to life several years ago when a young artist collected all the garbage bags from in front of houses in his neighborhood on garbage

day. He took them to his studio, spray-painted all the bags white, and installed CD players that played "Return to Sender" that were activated when the bags were lifted. He replaced the bags, not on the streets, but on the front porches of the houses from which they were taken.

Most of the residents understood, but one resident became afraid. After all, memories of the 9/11 attacks were still fresh. This resident called the police and the police called the bomb squad. When the young artist heard this news he went directly to the art school where he was enrolled and explained he had performed this act. The young student appeared in court with his parents and was required to write "What I learned from this experience" by a city judge.

What did this art student write about what he learned? What would you or your students write about this or a similar experience? A discussion about whether this is art or not, or how it is art, or what philosophies or art theories support or refute it being art are active learning exercises that develop and hone critical thinking skills.

A contemporary example surrounding Picasso's *Guernica*, chosen for reproduction in the lobby of a new Omni Hotel (now a Doubletree Inn) by a design group, was perfect for active learning activities. The design group explained, "*Guernica* will help create the ambiance we want for the Omni: a mixture of Midwestern warmth and European sophistication. We're trying to create almost a European, worldly type feel, an eclectic blend that says you're in the heartland, but with a very up-scale feel. That's picked up in the artwork" (Karash 1995). The spokesperson went on to admit she was not aware of the work's historical significance and her choice of *Guernica* for the Omni "has nothing to do with what it means." Pablo Picasso, a Spaniard, intended his painting to be a moving protest against the bombing of the small town of Guernica, in Basque Country Spain, by German and Italian warplanes during the Spanish Civil War. *Guernica* depicts the tragedies of war and the suffering it inflicts on innocent civilians.

How could anyone miss the severed head or arm, the broken sword or the woman with the dead child in her arms screaming in horror? There are a bull and a horse in the painting. Maybe that's the heartland part? Where would the Midwestern warmth be? What part of *Guernica* contains the European sophistication? Could it be war? Or Cubism? Letters to the editor of the local newspaper encouraged aesthetic debate with headings like "Picasso's Angry Protest," "Elevator Art," "Back to School," "Damage Control," and an editorial with the heading "Guernica is to cows as this city is to ..." (In the end, the idea to reproduce *Guernica* was abandoned in favor

of a medieval tapestry. The property has changed hands since and the Doubletree has absolutely no information on this. It is documented in the newspaper archives.)

If people did not know about *Guernica*, how would they be able to form an argument or even comment on this event? Knowledge of art history, art theory, and critical looking and thinking all become relevant to those who experienced this issue.

Some Teaching Strategies for Active Learning

A powerful (and scary) teaching strategy is to model your own thinking by demonstrating how you work through problems using critical thinking and theories. The physical evidence of a wastebasket full (or computer trash icon) of first drafts or thumbnail sketches can be effective. Another effective approach can be to think out loud in class and allow students to follow your process. Visually track your process on the board or on an overhead.

Armed with stories and case studies and related questions for as many groups of three as you have previously organized, ask students to read case studies, answer the questions, and prepare their answers for presentation. (Each group member has a job: recorder, spokesperson, and facilitator.) Give groups five to seven minutes to process the assignment before calling on groups to report to the entire class. This allows thinking, writing, and oral presentation practice. Asking students to write their answers before being called on allows all learners to think more carefully about their answers.

Providing practice as part of classroom participation is a successful active learning teaching strategy. Allow students to work in groups answering questions. In small groups students can present their thinking and receive comments from their peers before they present their thinking to the entire class. This allows students to learn how to think critically and support their ideas in a safe environment. After practice, students will feel confident enough to present their well-supported ideas to the entire class.

Develop strategies that allow students to work in cooperative teams. Studies show that having uneven numbers of students, given specific roles in groups like spokesperson, facilitator, and recorder, leaves less room for slackers and more room for team work and learning, work that will be useful in future work environments.

Begin a problem-solving lecture with a question, a paradox, an enigma, or a compelling, unfinished story – some tantalizing problem that hooks

student interest. The answer unfolds during the class hour with the answer revealed with only about five or ten minutes left in the period. The resolution could be an interactive process in which students' tentative solutions are elicited, listed on the board, and discussed. Ideally, when the problem is resolved, most students will have figured it out themselves just before the teacher's solution is announced at the end of class. Answers that can be well argued and can be backed up are the best answers. This needs to be reinforced – actively!

Acknowledgements

Thanks to Cavalliere Ketchum, Professor Emeritus of Photography, University of Wisconsin Madison, for introducing me to storytelling with his tales of growing up in the Wild West and "photographers-I-have-known" and for creating a seamless path to our shared mentor, Jack Taylor.

A special thank you to Jack Taylor himself, Professor Emeritus of Art Education, Arizona State University, master teacher, storyteller, and mentor extraordinaire who modified my behavior, supported my creativity, and fortified my teaching repertoire with stories, scholarship, and life lessons.

Thanks to Rudy Wohlgemuth for putting me up to writing this in the first place, and to Joe Hanson, whose knowledge and positive encouragement (even from the golf course) supported me beyond measure.

Thanks to too-many-to-name University of Central Missouri art, design, and art education students enrolled in Artists in Contemporary Society who knowingly and unknowingly contributed stories, ideas, and support.

Special thanks to Mick Luehrman, Professor of Art Education and Chair of Art & Design, University of Central Missouri, for his ever-positive attitude, spot-on advice, and generous support both intellectually and administratively. Thanks, too, to President Aaron Podolefsky, Provost George Wilson, and Dean Gersham Nelson for all manner of their support.

Thanks to Jayne Fargnoli, Senior Editor at Wiley-Blackwell, who found my College Art Association presentation interesting enough to help me develop this text and who supplied tough and enduring editorial sustenance. An exceptional thank you to the team at Wiley-Blackwell in Oxford: Lisa Eaton, Production Manager, for her competence and calm counsel, and Justin Dyer, Project Manager, for his extraordinary sensitivity and attention to detail and quality.

Thanks to my family, Ann and John Kadon, Tom Kadon, Jean Estrella, Lupe and Abby, and to friends and colleagues who granted me "cloistered scribe" status for a very long time.

Thanks to many friends, artists, and arts professionals for their significant support and contributions to this work: Mark Anderson, Porter Arneill, Jane Aspinwall, Robert Bingaman, Peg Brand, Marie Combo, Irina Corstache, Millie Crossland, Mo Dickens, Ellen Dissanayake, Michele Fricke, Elizabeth Garber, GEAR, Mark Getlein, jj Higgins, Joyce Jablonski, Jun Kaneko, Suzie Klotz, Hung Liu, Chris and Melanie Lowrance, Luba Lukova, John Lynch, Kyle Martin, Jeremy Mikolajczak, Armin Mühsam, Jaune Quick-to-See Smith, Jan Schall, Lisa Schmidt, Susan Schonlau, Steve Shipps, Stacey Sherman, Janet Stevens, Susan Stevenson, May Tviet, Renee Weller, and Matt Zupnick.

Public Opinion/Public Art
I Don't Know Anything About Art, But I Know What I Like!

What About Graffiti?

Is graffiti art? Is it public art? It is exhibited in public, but not funded with public money. Does that make it public art – or not? Since it is illegal in most places, does that make it a crime and therefore not art? Do you have graffiti in your city or town? Do you have public art in your city or town? Who funded that art? Sometimes private donors supply the funds and choose the art for the entire community, like in Newark, Ohio, where a rich banker provided the money and chose the art for the community with no community input. Other cities, like Kansas City, Missouri, enjoy a public art program that includes citizens from all stations of the community on the selection panels. This kind of "ownership" in public art promotes pride not only in the art but in the city as well.

What Fuels Claims?

You have heard others say and you may have even said yourself, "I don't know anything about art, but I know what I like!" I always wonder why people think it's okay to claim they know nothing about something and then judge it, make decisions about it, spend money on it, and even try to persuade others about it. That doesn't happen in "hard" disciplines like science and technology. If someone doesn't know anything about technology, for instance, it is unlikely

Ideas About Art, First Edition. Kathleen K. Desmond.
© 2011 Kathleen K. Desmond. Published 2011 by Blackwell Publishing Ltd.

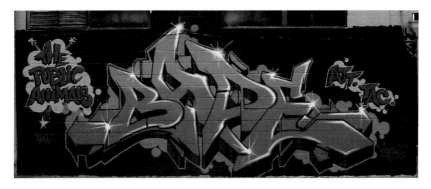

Figure 1.1 GEAR (Mark Schweiger), American (b. 1968). *Bade.* Spray paint, alley wall of 3 Axis, Kansas City, MO, 9 × 16 feet (approx.).

others will pay attention to what they think about technology. What fuels the passion people have for claiming to know nothing about art, and to know what they like? Perhaps it is some expressive quality like creativity, imagination, preference, or taste. Sometimes art is about something viewers don't know about or understand. Is taste, preference, imagination, creativity, or expression different or better if knowledge informs it? Here are a few stories about art, artists, and art audiences along with some questions about art issues that are complex and overlap. Some of the issues will be addressed in this chapter and others will be addressed in subsequent chapters in this book.

Does everyone have to "like" every work of public art? Is it even possible for every citizen to like every work of art, public or not? Do we need to know something about art to appreciate it? Is art a matter of preference, familiarity, and taste alone? Who decides what art is in the case of public art? Are criteria for art different when public funds are used?

Some people think appreciating art is a private affair that should be savored in silence. They believe it is a matter of personal preference or taste. This contributes to another over-used cliché, "beauty is in the eye of the beholder," which attempts to give credibility to a solitary experience of art. Yet a significant part of cultural history includes art objects that have become enduring objects of public appreciation and been placed in locations for the largest public exposure. When art is experienced in public contexts, critical debates ensue because it is bound to conflict with someone's personal preference or taste. Critical thinking about art requires knowledge of visual form, content, and context. Art history, visual culture, and stories about what has preceded us in this place and this time are good places to start thinking critically about art.

Art has defined locations throughout history and has even became synonymous with places, cultures, and peoples, like the Parthenon in Athens, the Arch in St. Louis, the Eiffel Tower in Paris, and the *Clothespin* in Philadelphia, for instance. Even if some of it, like the Elgin Marbles from the Parthenon, now in the British Museum in London, remains only as architectural or sculptural fragments or images in paintings or photographs, these artworks and artifacts help us know cultural histories, ourselves, and people of other cultures as well.

Unique Public Art

"Defend the professionalism of the process, the artist and the art," exclaimed a message from a director of a city artists' organization. "Support our municipal arts administrator as he defends Public Art." More than one hundred members of the local art community – artists, art historians, art critics, art gallery directors and art museum curators, art administrators, interior designers, and architects – answered the call and showed their support by attending a standing-room-only, two-hour meeting in a City Hall on a hot and humid August day. This open city council meeting in a city with a model 1% for the arts program was called to discuss the approval of a competitive $1 million public art commission.

The minutes of the meeting reported, "One council member spoke out against the style of art that had been presented to the council, not the artist. She was looking for something that would be unique" to the city.

The city council member who didn't like the sculptures chosen for a prestigious downtown location said the piece was like her "red cocktail dress – not appropriate for business." She had her own ideas about what "her" city should have on this site. She did not want to just "rubber stamp" her approval of a decision made by a municipal art commission selection panel. She requested this open city council meeting to discuss the matter and to try to persuade her fellow council members not to approve this particular public art installation.

A 19-member selection panel reviewed 156 formal proposals from artists during a 17-month-long process. The selection panel requested fully developed models and presentations from seven artists. After all the presentations and deliberations, the panel chose Jun Kaneko's *Water Plaza* (2007), an installation of seven ceramic

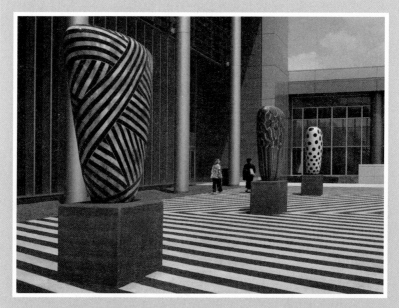

Figure 1.2 Jun Kaneko, American (b. Japan, 1949). *Water Plaza*, 2007.

sculptures on zigzag-patterned concrete. Kaneko is an internationally known artist with a studio in the neighboring state.

But this lone city council member didn't "like" Jun Kaneko's work. She thought it all looked the same and that it would not enhance the city to have work that could be found anywhere. "I want something unique to my city," she proclaimed.

During the meeting, almost every city council member prefaced their comments with statements like "I don't know anything about art," or "I know what I like, like everyone does," or "I don't know what it is, but it looks good to me." Male council members illustrated their rationale by holding up their neckties and declaring that their beauty was a credit to their wives, who had selected them.

The Director of the Municipal Art Commission explained to those who claimed not to know anything about art that the people from the art community who were in attendance at this meeting not only knew something about art, they "live art."

He further explained that this particular selection panel consisted of 15 voting and 4 advisory members, including art professionals,

architects, educators, and civic leaders who had engaged in the lengthy deliberation process. The city council was the final body in the process required to approve this $1 million public art commission.

This open city council meeting began with remarks by the Municipal Art Commission Director, the Director of the City Arts Council, and one of the architects for the building project who was also an advisory member on the selection panel. Letters were read to the council from members of the art community who could not be present for the meeting. Jun Kaneko presented his process in developing *Water Plaza* for this specific site. Kaneko's presentation included an overview of his work along with photographs, drawings, and his preliminary research.

Near the end of two hours, audience members were allowed to make comments. An interior designer took the podium and explained that Jun Kaneko's work would bring international recognition to the city. She reminded the council, especially the dissenting council member, that seeing a Renoir painting in France and seeing one here would not make Renoir's work any less unique or valuable. Renoir's paintings are recognizable because of their style. She explained that other cities and other countries have Renoir paintings in public collections and there are Renoirs in personal art collections all over the world, including this city. These collections enhance the value of Renoir's work rather than rendering them less unique. Jun Kaneko is a contemporary artist. Perhaps, she suggested, the same criteria could be applied to historically recognized artists and their styles as to the works of art created in the twenty-first century? Or does art have to be old before it becomes valuable?

A year after this hearing, the visual art critic for the *Kansas City Star* reported, "For the fifth time in a decade, a Kansas City public artwork has been singled out in the 'Public Art in Review' section of *Art in America* magazine's annual guide to museums, galleries and artists" (Thorson 2008). The distinction went to Kaneko's *Water Plaza*, which was one of 21 public artworks across the United State featured in the August 2008 guide. Kaneko's million-dollar project was commissioned under the city's 1 percent for art program, which sets aside 1 percent of public costs of civic building construction, explained the *Kansas City Star* article. "This tribute reflects our standing in the national public art landscape and reaffirms the significance of the arts in our region," said Porter Arneill, Director of the Kansas City Missouri Municipal Art Commission.

Public Art

Since the mid-sixties, public art has enjoyed growth, support, and accept-ance throughout the United States, a latecomer in the history of art with world attention only since the 1950s. Local businesses and national corporations joined with federal and state and city governments in championing the case of new accessible art for the public. Both government and business recognized the need to make high-quality public works of art available to many people in various geographic locations.

Kansas City's public art exemplifies a growing public interest in the arts with governmental and corporate responsiveness. It is acquired not only through its 1 percent for the arts program, which is common to many cities, but also through Avenue of the Arts, a unique private–public partnership that showcases a wide range of innovative art in downtown Kansas City that provides new opportunities for local artists.

In January 2009 "More Public Displays for Artworks" appeared in the *Kansas City Star*'s Arts Section and described more than a dozen of the art-works Porter Arneill had presided over since he took charge, in 2002, of the city's 1 percent for the arts program (Thorson 2009): from a series of ele-vated parking control arms activated by road-mounted sensors, called *Seven Sentinels* (2008), located at the City Vehicle Impound Facility by Kansas City artist Matt Dehaemers, to *Inheritance* (2008), a five-part piece featur-ing maps and interactive artworks that explore the theme of community for the Southeast Community Center by Kansas City husband and wife team Julia Cole and Leigh Rosser, to *Red Eye* (2009), the East Village Parking Facility featuring mixed-media panels by California artist Gordon Huether. Public Art in Kansas City features local as well as international artists like Jun Kaneko, Alice Aycock, Joel Shapiro, Deborah Butterfield, Terry Allen, and Robert Morris.

Public art programs in the United States had their beginnings as a key component of social programs in the 1930s. Some of the greatest American artists emerged during that time and their creations included murals in schools, post offices, and government buildings, sculptures, photographs, urban park systems, and public monuments, as well as community theatre, educational programs, and writing projects. Public artworks changed the American landscape. This American heritage was evidenced in the 2009 inaugural celebrations, which included different styles of music, poetry, speeches, and sermons in honor of the new American President, Barack Obama, who is a writer, orator, and supporter of the arts.

The National Endowment for the Arts and the Art in Public Places Program

The United States Federal Government funds the National Endowment for the Arts (NEA). It was organized in the 1960s and initiated the Art in Public Places Program. The process of funding art for Art in Public Places sought to avoid imposing a governmental "Big Brother" approach to art selections that gave the community little say in a selection process and alienated the citizenry and instead supported requests for public funding for the arts that came directly from the community.

The first commission for a major sculptural work for a specific site was in 1966, when Grand Rapids, Michigan, requested NEA funds for Alexander Calder's *La Grande Vitesse*, a huge monochrome, abstract sculpture slated for the floundering city's downtown plaza. This was an excellent example of public art, the NEA thought, because the work was by a renowned artist who engaged the community's imagination in a variety of ways. Urban renewalists liked the increased support the sculpture lent to their rebuilding efforts, social activists and cultural leaders envisioned the plaza and sculpture to be a staging ground for open-air theatre, fairs, and concerts, townspeople enjoyed the national recognition and sense of pride their city gained from the extensive publicity, and resident artists saw the sculpture as a symbol of deliverance from the aesthetically unenlightened views of the "locals." The sculpture, because of its abstractness, could be interpreted in a variety of ways, engaging viewers and inviting them to enjoy it in new ways each time they viewed it.

The importance of *La Grande Vitesse* in obtaining national recognition for the city turned President Ford, a Michigan native, into a staunch supporter of the Art in Public Places Program. Years later, Ford said he didn't even know what a Calder was at the time. He was not alone. For many years Grand Rapids residents asked, in all honesty, "Who was the artist who made the Calder?" President Ford assured members of Congress that "A Calder in the center of an urban redevelopment area helped regenerate a city."

Of course the recognition Grand Rapids earned from Calder's sculpture was not without controversy. Even though the city was revitalized and official stationery and street signs with the Calder image publicized the city's pride in the Calder sculpture, public debate of the age-old argument ensued: "They spent my tax dollars on that?" This kind of lively controversy provided an opportunity for a community to examine its goals and priorities. In this way, public art avoids the detached realm of classical aesthetics and enters the real world of social issues and debate.

Even into the NEA's second decade, after its significant impact on communities all over the country, there were questions regarding the use of public money for art. Were only "elitist" artists or institutions being funded? Had the outreach policy resulted in a lessening the "quality" of supported art programs? Pleasing the diverse constituency that exists in America is an impossible task. Unlike medical research, national defense, and the space program, public arts programs have earned much less support in terms of both importance and funding.

Public sculptures with particularly difficult histories include Mark Di Suvero's installation in Grand Rapids, *Motu Vigel* (*Tire Swing*) (1977), which changed into a radically different artwork from the originally proposed piece. The piece not only met with dismay and disappointment, it led to what the government deemed as a breach of contract. The dispute was clouded and complex with the execution of contracts, international exhibitions, private funds, and community petitions. It resulted in new understandings of what is required of artists, government, and the private sector.

"I don't know anything about art, but I know what I like!" is heard as a defense for not knowing the "esoteric" or "mysterious" qualities of art, and being in a situation where an opinion about art is required. It is often an excuse for what comments will be coming next. It is used to dismiss important matters in art as being unimportant. Everyone has a right to their own taste and their own decisions about what art they like and don't like, what art they place in their homes, what clothes or jewelry or body piercing or markings they prefer, but what about when the art is public art?

Unfortunately, the National Endowment for the Arts became mired in politics on the national level during the 1990s when Senator Jesse Helms' wife saw a catalog from the exhibition called *The Perfect Moment* (1988–9) by photographer Robert Mapplethorpe. She was offended by the homoerotic images and thought the work was immoral. Mrs. Helms asked her husband to do something about Mapplethorpe's pictures. The film *Dirty Pictures* (2000) is a dramatization of issues, aesthetic, social, and human, that can manifest themselves during controversies sparked by the arts. More than ten years of social and political battles ensued that drastically cut the National Endowment for the Arts, the smallest of the federal budgets. The NEA added new stipulations to awards to individual artists and eventually eliminated awards to individual artists. Artists who were awarded NEA grants refused the money because they felt the new restrictions violated their artistic freedom and integrity.

These "Culture Wars," as they came to be called, found their way to art museums and galleries, universities, and even to Hollywood. The "cultural

elite" who supported the First Amendment to the U.S. Constitution and artistic freedom were pitted against the "moral majority" right-wing conservative government. It was an ugly period in U.S. cultural history that is slowly healing though awareness and experience of the benefits of supporting the arts. Interestingly, there is a movement requesting the President of the United States to create a Secretary of the Arts, equivalent to Ministers of Culture in other countries.

Another Public Art "Problem"

World-renowned artist Richard Serra created a different kind of public art problem with his sculpture *Tilted Arc* (1981). Serra's piece, which was installed in the Plaza of the Jacob Javits Federal Building in lower Manhattan in New York City, was, like the Jun Kaneko installation in Kansas City, chosen by a group of government and community members. All members of the selection committee approved the model of the sculpture. A contract was issued. Serra built and installed the sculpture on the Plaza. But the people who worked and used the Plaza of the Federal Building didn't like *Titled Arc* and they complained. A hearing was conducted and it was decided to remove the sculpture.

Site-specific sculpture is made for a specific space, a specific location. *Titled Arc* was a site-specific sculpture that would lose its aesthetic value when removed from the site for which it was created. *Titled Arc* was designed specifically for the Plaza. It would not be art if it was not in this specific site because the element of space and location, and, in this case, dislocation, would be destroyed. Removing the sculpture, which is ultimately what happened, is an example of people who don't always know much about art, but who felt strongly about not liking the way *Tilted Arc* changed their space. They did not like the feeling of dislocation that Serra had successfully created and they strongly objected to having to live with it. They wanted their familiar Plaza back and they were successful in reclaiming it by exercising opportunities for debate and discussion.

Public Art Collaborative Artist Teams

There are two prolific, and often controversial, husband and wife collaborative teams who have made major contributions to outdoor art for the public around the world. Both couples are as different in their content,

process, and approaches as in the controversies that surround their work. Christo and Jeanne-Claude (Jeanne-Claude died in November, 2009) have used various materials to "wrap" islands off the coast of Florida, the Reichstag in Berlin, the Pont Neuf in Paris, and the coast of Little Bay in Sydney, Australia. In 2005 they created 7,503 saffron-colored fabric *Gates* in Central Park in New York City. Their works are deliberately temporary. The Central Park *Gates* were up for only 16 days. Christo and Jeanne-Claude do not accept government or corporate funds and that takes them out of the public money debate but does not exclude them from the aesthetic debates about the artworks themselves. They fund all their own projects by selling original drawings and sketches, books, and videos, even postcards with bits of former installations, like the piece I bought at the Ludwig Forum in Aachen, Germany. Even though their art is not created with public money, it is art for the public and has been enjoyed, discussed, and debated all over the world. The content of their work is about experience, public debate, and discussion. Their art is as much about social comment as it is about the visual forms and experiences they create. Comprehension of their work would include knowledge about visual art elements as well as aesthetic issues and political processes both public and private.

Claes Oldenburg and Coosjie van Bruggen (van Bruggen died in January 2009) are another remarkable collaborative artist team. They re-create objects from everyday life in a playful way on a gargantuan scale. Like the Calder in Grand Rapids, Oldenburg and van Bruggen created huge sculptures that were controversial at first and after awhile were embraced and even laid claim as defining the place: for instance, their 45 foot tall *Clothespin* (1976) in Philadelphia, and 96 foot tall *Batcolumn* (1977) in Chicago, or their giant *Trowel I* (1971–6) in the Rijksmuseum, Kröller Müller Otterlo, the Netherlands and *Trowel II* (1984) in New York, and the four 18 foot tall *Shuttlecocks* on the lawns of the Nelson-Atkins Museum in Kansas City.

The collaboration between Claes Oldenburg and Coosje van Bruggen shows their strong and distinct identities. Their dialogue, articulated in an exchange of words and images, dramatically addresses the complexity of the contemporary world. Oldenburg and van Bruggen think about culture, landscape, and architecture and work playfully with everyday objects. Their approach to art in the urban context goes beyond the security of museum walls. They work on large-scale projects, creating public works for cities in Europe, America, and Asia. Every project is developed through a dialogue of sketches, drawings, studies, and models. Both teams, Christo and Jeanne-Claude and Oldenburg and van Bruggen, document their ideas, which are in continual

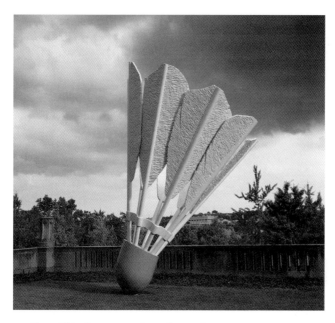

Figure 1.3 Claes Oldenburg, American (b. Sweden, 1929) and Coosje van Bruggen, American (b. The Netherlands, 1942–2009). *Shuttlecocks* (one of four), 1994. Aluminum, fiberglass-reinforced plastic, paint, h × diam.: 230 9/16 × 191 7/8 inches.

transition. These are all elements of creativity: flexibility, developing alternatives, continuing transitions from idea to idea. Like the largest public project, the smallest drawing on a scrap of paper represents an in-depth analysis of the form and content that characterizes artists' explorations. Oldenburg and van Bruggen reflect on human fragility and the microcosm of events that define daily life; Christo and Jeanne-Claude add the nature of social and political order to the dialogue; and both artist couples reveal their ability to communicate values that transcend linguistic and cultural barriers.

Contributions to Aesthetic Value

Terms used in describing these events, the art, and the artists include art knowledge, creativity, imagination, preference, taste, and judgment. From a theoretical point of view, creating public art is rather an oxymoron. Art is generally taken to be an individual endeavor, an act of expression or imagination specific to the artist. The descriptions of the form, process, and

content of artworks by Richard Serra, Jun Kaneko, Christo and Jeanne-Claude, and Oldenburg and van Bruggen contribute to an understanding of the aesthetic and artistic values with which artists imbue their art objects. Kaneko's work is mysterious and equivocal, controlled and commanding, with both Eastern and Western values that are unchanging, thriving, and intellectual, as well as good humored, skillful, and revolutionary (Capital Improvements Management Office 2009). Oldenburg and van Bruggen reflect on human fragility and events that define daily life. Christo and Jeanne-Claude work with the nature of social and political order. It seems all of these artists communicate their specific knowledge about art in the works they create. Their artistic values transcend linguistic and cultural barriers.

Cultural values, creativity, and imagination

In terms of public art, however, additional values come into play. Public art addresses a place and a time in a way that an artwork in a museum does not. Public art, these days, demands the participation of the viewer – participation not only in terms of engaging with the object but in terms of engaging the environment, both physical and cultural, in which the artwork is situated. Public art is a creative study of the space and the time in which it exists, and the viewer is invited to think about that. Artists are keenly aware of the specific site in which their sculpture will be placed. Note the extensive proposal Jun Kaneko developed for Kansas City and the drawings, plans, and sketches made by Oldenburg and van Bruggen after visiting sites before creating a work, or the very deliberate selection of location and time-consuming permissions process that Christo and Jeanne-Claude engage in so their content, meaning, and message can be part of the viewer's conscious or subconscious participation.

Public art counts on public engagement. Artists who make art for the public are acutely aware of the different kind of audience participation that public work demands as opposed to work for sale to individuals or on display in museums. While knowledge, creativity, and imagination of the artist are essential components of any artwork, the knowledge, imagination, creativity, preference, judgment, and taste of the audience are also factors in public art.

Preference and taste

Audiences factor their own comfort levels into their preferences and taste. Psychologists tell us we are comfortable with the familiar and artists know audiences will like something on the same order of what they grew up with

or what they have seen before and may take that into consideration. If artists try to take their creativity and imagination beyond public preference, taste, and comfort, problems can arise. The same applies if audiences are unwilling to take some time to take up new ideas, creativity, and imagination.

Critical judgment

Audiences don't always make the distinction between what they like and their judgment of the quality of an artwork. Often, preference or taste and judgment are confused. If we like something, we think it is good, and if we don't like it, we think it is bad. Good and bad are judgments. A judgment is an informed decision based on knowledge of the subject. Liking or not liking is preference or taste. Taste or preference, liking or not liking something, does not have to be defended. Art in our private lives can be about what we like. After all, why would we place something we don't enjoy in our home? If we wanted to publish an art review or register our judgment about an artwork in a public arena, we would be making a judgment and judgments must be defended. Art knowledge is a good way to defend a position about art.

Art knowledge

Knowledge of art theories and ideas provides the strength of support you want for your arguments about these art issues and, if you are an artist, for developing your own philosophy for art making. (Artists write artists' statements to help viewers understand how their work has been influenced by concrete and conceptual ideas, and defend their statements with art knowledge.)

In the case of Jun Kaneko's public art installation in Kansas City, does it help to know that Jun Kaneko was born in Nagoya, Japan, where he studied painting before he came to the United States and turned his focus to sculptural ceramics? Or that he studied with Peter Voulkos and Paul Soldner in California, who defined the contemporary ceramics movement? Or that he has a prolific roster of work appearing in international exhibitions in more than 40 museum collections including the Smithsonian American Art Museum? Or that he executed over 25 public art commissions in Europe and Japan as well as the United States? Or that he established a third studio in Omaha, Nebraska, where he primarily works?

Jun Kaneko creates large-scale sculptures, including his series of large "Dango" ("dumpling" or "closed form" in Japanese) ceramic pieces resembling vases without openings. His work is "unrivaled in the field of ceramic art,"

said his former teacher and legendary ceramics sculptor and influential artist, Peter Voulkos. "His technical achievements alone have redefined the possibilities the medium has to offer. His ceramic works are an amazing synthesis of painting and sculpture." They are "enigmatic and elusive, simultaneously restrained and powerful, Eastern and Western, static and alive, intellectual and playful, technical and innovative" (Ceramics Today n.d.).

Additional Points to Consider

There are several issues embedded in these events, such as people not feeling confident talking about art and being afraid to acknowledge there might be something to know about it that they don't know, "I don't know anything about art …" The issue about what is beautiful and what has cultural significance and who gets to decide what art is are all embedded in public art examples. Certainly the issue of preference and taste and the question of originals and style and "uniqueness" are part of the events described in this and other chapters in this book.

Some observers of public art deliberations wonder why, if a city's council members didn't know anything about art, they were deliberating about it and making decisions about it. Some wondered why council members didn't try to learn something about art before the meeting. In the end, the Kansas City, Missouri, City Council spoke out in behalf of the selection process used to choose the artist for this specific project and approved the decision of a selection panel who made it their business to know something about art.

Non-Western Ideas About What Art Is

Is Art Situational? Cultural? Biological? Universal?

Boxes of Bones

Tony Hillerman, the author of many best-selling mystery novels, died in 2008, but not before being honored for his knowledge of and respect for Native American cultures, particularly Hopi and Navajo in the Southwest. A key character in his *Talking God* (1989) is Henry, who is half Native American. Henry works in one of the Smithsonian Museum's vaults that holds boxes and boxes of skeletal remains of Native Americans. He is deeply troubled by these boxes of Indian remains in museum storage and thinks they should be returned to the tribes from which they came. He considers these remains to be a case of grave robbing.

To convey his sense of outrage, after some research into prestigious cemeteries in the Eastern United States, Henry mails two boxes to the museum director. Upon opening them, she discovers skeletal remains, and, recognizing the return address of the cemetery, realizes, to her shock and horror, that the bones are those of her grandparents.

While the story in Hillerman's mystery novel is fictitious, this real headline appeared in the first section of a major newspaper, "Smithsonian Will Return Skeletal Remains to Tribe" (Blumenthal 2007). The skeletal remains of six members of the Nisqually tribe had been stored in wooden boxes in the Smithsonian Institution's National

Ideas About Art, First Edition. Kathleen K. Desmond.
© 2011 Kathleen K. Desmond. Published 2011 by Blackwell Publishing Ltd.

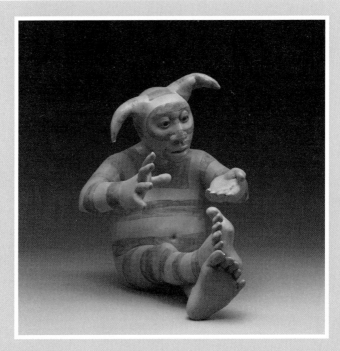

Figure 2.1 Roxanne Swentzell, Native American (b. 1962), Santa Clara, New Mexico. *Kosha Appreciating Anything*, 1997. Clay and pigment, 16 × 13 × 17 inches.

Museum of Natural History. No one knows the names or the identity of the people to whom these remains belong. No one knows the stories of their lives. Some of these remains were donated to the Smithsonian 150 years ago after a naturalist working with the Pacific Railroad surveys found them. After a federal law in 1989 was enacted, the Smithsonian "repatriated" (offered to return) nearly one-third of the 18,000 sets of skeletal remains of American Indians. The article went on to say, "While it would be unthinkable now, the remains were donated to the Smithsonian at a time when naturalists were exploring the West, and the bodies of American Indians, along with thousands of other items, were collected and cataloged. Part of a naturalist's interest in the world involves collecting things," a representative of the Smithsonian said. "There was a lot of interest in the differences among people. The differences among tribes."

Do all humans in all cultures develop rituals surrounding their dead? Should those rituals be honored by peoples in other cultures or at other times in history? Why do we have this strong feeling about the remains of the dead?

Art Is a Situation

"Art is not an object, but a situation," claims philosopher Arnold Berleant. Further, he writes that every art object functions aesthetically and can be understood only as a part of an experiential situation involving appreciative, creative and performative aspects, as well as objective ones. It does not matter whether we call something art or not – what is important is how the object works in appreciative experience. It is such experience that is the heart of the aesthetic. Berleant's thinking helps prepare our Western cultural attitudes for studying non-Western cultures and global contemporary art.

Culture Defined

Culture can be defined as shared values, beliefs, and ideas by a group of people. Western culture is founded in early Greek and Roman values of government and society, while non-Western cultures have significantly different histories and approaches to values, beliefs, and ideas about living in the world. Non-Western cultures share different values, ideas, and beliefs from Westerners. A major part of understanding any art object or experience is to consider the time and the culture from which it came – the context.

Cultural Transformations

The symbolic capacity of works of art to stand on their own creates marks of "affective" presence in some cultures, according to Suzanne Gott, who researched and studied rituals in southern Ghana, West Africa. Gott is a professor of art history in the Department of Critical Studies at the

University of British Columbia Okanaga who holds two doctoral degrees in African art and visual culture. Her research focus has been on the art and visual culture of southern Ghana's Ashanti Region. She explores issues of gender, comparative aesthetics, display, and performance and investigates continuities and/or transformations of precolonial art and aesthetics in colonial, postcolonial, and contemporary art and visual culture. Gott first traveled to Ghana in 1990 to study display and performance as an aesthetic process.

Gott's research advances theoretical insights provided by Feminist theories, cultural studies, postcolonial theory, semiotics, and comparative aesthetics and phenomenology (Gott 2003, 2004). Her research of women's art and visual culture within the cosmopolitan urban environment of Kumasi, the historic capital of southern Ghana's Ashanti Region, explores Asante ideologies of power, status, and elite visual culture in the colonial and postcolonial periods. Funerals, the most important life-cycle event in Asante society, provide a most enduring context of study.

Gott (2004) describes highly ritualized funerals in southern Ghana that incorporate hand-made coffins in shapes that identify the deceased's reputation in life, whether it be a camera to identify an avocation of photography or a chicken or bean shape signifying a life-long business of raising chickens or growing beans. Hand-carved coffins, like that in the shape of a Lamborghini made in 1991 by Kane Kwei, have been a family business for many years. Special coffins, professional storytellers, preachers, singers, elaborate food, and celebration are all components of a good funeral in Ghana. The Asante people of southern Ghana think they do funerals "right." Funerals are advertised in newspapers and people plan to attend funerals of the most prestigious dead, knowing the celebration will be elaborate and the food excellent.

Family mourners wear traditional clothing, with symbolic colors and designs. Colors represent levels of grief. Red is the highest level, with blacks and indigos symbolizing the second level. The third level of grief is symbolized by a combination of red, black, and indigo. Mourners wear their finest clothes to funerals in a competitive display called *poatwa*. Funerals are social events for many people who are "funeral hoppers," called *preman*. The fine clothes worn by *preman* women indicate their level of wealth. Women are independent and self-sufficient and have their own bank accounts, so their finery represents their own wealth, not the wealth of their family or a husband.

The more people who participate in the funeral, the more honor that is bestowed upon the deceased person. It is not necessary for mourners to

have known the deceased. It is important that as many people participate as possible. Even tall blonde women who clearly are not from the area are welcome, as Dr. Gott was when she studied in Ghana.

African Arts

African arts come from all of the different regions and cultures in Africa. There are hundreds of different cultures in Africa, a continent so large that it would take 325 days to drive around its perimeter. Africa has three different kinds of geographical regions: deserts, savannahs, and rainforests. The indigenous materials for these regions are used in making objects for experiences that Westerners have placed in art museums: wood from the rainforests; grasses, reeds, and clay from the savannahs; copper, bronzes, and metals from the desert regions.

Some of the characteristics for determining art in Africa are shared by other cultures, like those of Native Americans, indigenous South Americans, and Australian Aborigines. Masks worn by Native Americans, for instance, become the spirits they represent and everyone in the community believes that. Some of the visual elements in objects made in Africa, South America, and North America are amazingly similar because they are inspired by similar natural, cultural, and spiritual elements.

African art often describes the spirit world. Everyone in the culture recognizes the masks of the spirits and the ceremonies, dances, and music that make these experiences important to the community. Some spirits carry messages from people to the gods, others settle arguments, even wars, and still others teach cultural behaviors. Most spirits are male, like Ga Wree-Wre (from the Dan culture in Liberia and Ivory Coast), who lives in the forest and settles serious arguments, or Eshu (from the Yoruba culture in Nigeria and the Republic of Benin), who carries messages from the people to the spirits. Sowei (from the Mende culture in Sierra Leone) is the only known mask worn by a woman. Sowei teaches girls cooking and healing and readies them for marriage in a rite of passage ritual. Masks and costumes are used in ceremonies understood by everyone in the community and they usually appear with dance, music, and song. Traditional African arts include a variety of characteristics and they are different for each culture in Africa. Even though everyone in the culture understands these characteristics, they are not always thought of as "art." Traditional African art is not regarded as art by Africans in the same way Westerners think of "art."

Ritual and Art

Ritual and art are inseparable, says Ellen Dissanayake, who wrote *What Is Art For?* (1988), *Homo Aestheticus: Where Art Comes From and Why* (1992), and *Art and Intimacy* (2000). Art is essential to the fullest realization of human nature. It is not something added to human nature, Dissanayake says, it is the way we are. Human predisposition to make and enjoy art draws on our universal, biological nature, she explains (Dissanayake 1988, 1992).

Art is closely related to both play and ritual, including ceremonies and religion. In fact, art, ritual, and play all fall under the umbrella of what Dissanayake calls "making special," or "elaboration." The human tendency to make things special was first manifested when functional items were selected partially because of their attractiveness. The propensity to make things special had adaptive value because it enhanced the survival of those who had it. Consequently, art-making practices that followed, appearing along with religion, inherited a similar functionality.

In terms of art, making special or elaboration takes the form of intentionally decorating oneself and one's environment in order to provide aesthetic enjoyment. Art is often conjoined with ceremony to amplify features already made relevant by their ritual function. Art is adaptive because, along with ritual and play, it promotes community benefits that improve the wellbeing of society's members. It highlights and affirms what is important to their lives such as control over nature, manual competence, group lore, genealogy, wisdom, and traditions. Art plays a vital role in promoting cooperation, mutual identification, and social cohesiveness.

In conjunction with ceremony, art makes group knowledge more impressive, compelling, and memorable, promotes agreement and cooperation, and addresses the uncertainty inherent in the human condition. Art allows for the expression of what cannot be verbally articulated. It reconnects us to a global, emotion-filled, metaphorical kind of thinking that we exercised as children and it addresses universal themes that tell us about our common human heritage.

"Making Special" or "Artification"

Ellen Dissanayake's research showed her that people all over the world, for tens of thousands of years, have been makers and users of the arts. This fact suggests that art must be necessary to the human species and not an

accident. But why? What does art do for people everywhere? How did art begin? What *is* art, anyway? These are biological as well as philosophical questions, and Dissanayake decided to approach art as if she were an ethologist (a biologist who studies the behavior of animals). Rather than start with art *objects* like paintings or art *qualities* like beauty or skill, she considers art as something people *do* – a "behavior of art."

Dissanayake first proposed that art is a behavior or activity of making something special. Over the years she has refined and extended this idea, now calling it "artifying" and claiming that the common denominator of all the arts is making the ordinary *extra*-ordinary. A plain cave wall is made extraordinary with painting or engraving, an ordinary urinal is made extraordinary by placement in an art gallery. In a poem, ordinary words are made extraordinary with rhyme, meter, altered word order, and other literary devices. When dancing, ordinary body movements of walking, bending, or reaching are made extraordinary – different from the everyday.

Dissanayake notes that in preindustrial societies and presumably in ancient small-scale societies from many thousands of years ago the arts are especially evident in ritual ceremonies. Just think about it. Take away the arts (the costumes, masks, body decoration, altered surroundings, decorated paraphernalia, dancing, singing, and chanting) and you have no ceremony. Ceremonies are about important life concerns, such as safety, health, prosperity, fertility, and reconciliation, and stages of life, such as birth, puberty, marriage, childbirth, and death. Dissanayake suggests that spending time, effort, and care on artifying will draw the participants' attention and interest to the subject or message of the ceremony, making it memorable, compelling, and emotionally satisfying. Because everyone participates, the group feels bound together and confident of a good outcome to the particular concern of the ceremony.

Although today we don't usually consider our ceremonies to be tied to survival, most people artify events that are important to them, such as birthdays, holidays, graduations, or sports events, and then feel emotional satisfaction and unity with others who share these with us.

Dissanayake's scheme implies that art (as artification) occurs in everyone, not just a few designated artists. She observes that very young children are predisposed to artify. Without being taught, they move to music, sing along or alone, use their hands to grasp, manipulate, and make marks, decorate their bodies and possessions. They enjoy stories, word games, and make-believe. If they grow up in a society where everyone is doing these things, they naturally do them too.

In recent years, Dissanayake has made a plausible case for locating the roots of artification in our species' remote past, in features that occur in the interactions of mothers with their babies. In the universal behavior of "babytalk," caretakers alter their voices, faces, and physical gestures when they engage face-to-face with infants. Ordinary expressions of friendliness such as smiles, mutual gaze, nods, soft voices, and pats are made extraordinary. They are exaggerated, repeated, simplified or formalized, and dynamically varied or elaborated. As babies mature, caretakers manipulate their expectations, as in games such as Peek-a-Boo or Eensy Weensy Spider.

Dissanayake notes that these same alterations – repetition, exaggeration, elaboration, formalization, and manipulation of expectation, in visual, aural, or movement modalities – are used by artists everywhere with their media. She calls these the "operations" of artification. Ordinary objects, bodies, surroundings, movements, language, stories, and even ideas are made extraordinary by means of these operations.

Dissanayake is aware that some people are more talented or motivated artifiers than others. She accepts that in modern societies an artworld often decides whom to call an artist. But she points out that in the earliest human societies, and even today in the few pre-industrial societies that remain, everyone engages in the arts, unselfconsciously. Even today, people artify without realizing it – as with body piercings, tattoos, and holiday decorations. People still make art about things they care about.

In earlier societies, the arts addressed and helped to satisfy universal emotional needs for belonging, meaning, competence, and demonstrating one's care about humanly important matters of life, death, desire, loss – what is called "the human condition." Dissanayake passionately and eloquently claims that they can and still do so. She is a passionate and eloquent advocate for art. She maintains that we have become alienated from the concerns, practices, and activities that would fill our lives with meaning, coherence, and competence and that art can reconnect us with those meaningful activities.

Art and Human Life

Adaptive behaviors that generate art as one of their byproducts include the development of language, abstract thinking, and other symbol systems. Dissanayake emphasizes that art played a role in the preverbal history of the

human species and continues in the preverbal infant stage of individual development, and that the human compulsion to elaborate and decorate goes beyond symbolization. She regards the past with a deep sensitivity to the cost imposed on us by the elevation of technology, individualism, hedonism, and an artificial environment that shields us from the psychological, physical, and social realities of existence. Not only is advanced man no longer fitted for human life; modern life is no longer fitted for human nature.

Dissanayake thinks ethologists fare better than anthropologists, sociologists, philosophers, and Postmodernist theoreticians in explaining the importance of art in human life. She thinks aesthetic features of art objects and experiences, and their apprehension, contribute centrally to human functions.

Cultural Anthropology

Richard L. Anderson is Professor Emeritus in the School of Liberal Arts, Kansas City Art Institute, and author of *Calliope's Sisters: A Comparative Study of Philosophies of Art* (1990) and *American Muse: Anthropological Excursions into Art and Aesthetics* (2000). Among his many publications and presentations, he published "Do Other Societies Have Art?" in *American Anthropologist* (1992) and presented "The Non Western Artist: Mythic or Mythical Hero?" at a national art conference (1988). Anderson agrees with Ellen Dissanayake that there is no single motivation that prompts art in all human cultures. Rather than providing an ethological explanation that art making is biological, Anderson supports a cultural anthropological view about the nature of art. He also uses the ideas of art historians, art critics, and philosophers to support his position. Anderson seeks to examine deeper understandings of particular art forms in non-Western human cultures in the hope of developing an appreciation of global art and aesthetics.

With art and aesthetics, the best way to proceed, according to cultural anthropologists, is to recognize that the use of the word "art" usually recognizes values beyond practical contributions to daily living. Art has a sensuous appeal. Production of art reflects skills that are more highly developed in the maker than among other members of the society. After developing a very broad and tentative position, the anthropologist studies societies, cultural objects, and activities by addressing the question "how do people here think about their 'art'"?

Anthropologists try to describe art and aesthetics as they look "inside" cultures. They attempt to explain a broad level of generalities by looking for patterns of similarities and differences that exist in the "arts" of the societies surveyed. A comparative study of aesthetics develops an appreciation of the arts of other societies and provides a means to perceive them in ways intended by their creators and their appreciators. These comparisons reinforce art activities not as mere curiosities but as sophisticated manifestations of spiritual, cultural, and emotional meaning.

By learning about non-Western aesthetic systems, an appreciation of the rich diversity of human thought as it relates to art can be gained, says Anderson: 'Cross-cultural aesthetic understandings may also enrich us by stimulating new perspectives on our own philosophies of art, providing us with new ways of looking at the natural, social, and cultural worlds around us – just as the exposure of early twentieth-century Western artists to art objects from Africa and elsewhere stimulated important new directions in Western art styles" (Anderson 1990: 8).

Non-Western aesthetic systems provide a starting point for comparative aesthetics. After studying the conceptual structures of art in a variety of times and places, commonalities and patterns in cultural definitions of art are revealed. Culturally significant meaning can include beauty, communication with the spiritual and the sacred, pleasure and satisfaction, spiritual salvation, sacred truths, religious truths, religious transformation, communion and action, a path to higher levels of consciousness, moral and ethical goodness, social values, goodness and evil, health, happiness and safety, harmony and energy, symbols, icons, and purely aesthetic responses.

Art, Beauty, and Human Evolution

Denis Dutton (d. 2010) was a professor of philosophy at the University of Canterbury in Christchurch, New Zealand, and author of *The Art Instinct* (2009), in which he argues that the commonly held Modernist view that art appreciation is culturally learned is wrong. He proposes that art appreciation stems first from evolutionary adaptations made during the Pleistocene epoch. He makes a case for a cross-cultural definition of art that includes a set of cluster criteria often disputed by anthropologists and art theorists. Dutton thinks anthropologists and art theorists dislike cross-cultural definitions of art because they support the universality of art. He makes a case for

evolutionary adaptations of pleasure by comparing playing video games with listening to fugues and with creative storytelling – from preliterate tribes through Greek theatre to contemporary film and television – being understood by human beings everywhere. Evolutionary pleasures come from instinctive processes that have been in place for thousands of years, he says. Pleasure seeking could be at the heart of artistic experience and a byproduct of ancient instincts that has evolved for other purposes. Or, he wonders, is art a discrete instinct in itself?

Dutton wonders how it is that Chopin is loved in Korea, Spaniards collect Japanese prints, Shakespeare is enjoyed in China, and pop music and Hollywood movies have swept the modern world. He attempts to re-examine the widest possible perspective of aesthetic pleasure and achievement by bringing an understanding of evolution to bear on art for the purpose of enhancing enjoyment of it. Dutton believes Darwinian aesthetics can restore the vital place of beauty, skill, and pleasure to high artistic values. He thanks Charles Darwin for laying the foundation for the proper study of art not only as a cultural phenomenon but as a natural one as well.

Cross-cultural characteristics found in the arts can define art in terms of a set of cluster criteria such as the features of a work of art or the qualities of the experience of art. These criteria offer a neutral basis for theoretical speculation, thinks Dutton, and the criteria are inclusive of arts across cultures and historical epochs. Dutton notes philosopher David Novitz, who claims that "precise formulations and rigorous definitions" are of little help in capturing the meaning of art cross-culturally.

Dutton has developed criteria for defining art cross-culturally: (1) direct pleasure; (2) skill and virtuosity; (3) style; (4) novelty and creativity; (5) criticism; (6) representation; (7) special focus; (8) expressive individuality; (9) emotional saturation; and (10) intellectual challenge. Dutton believes that these features, taken individually or jointly, can help answer the question of whether an art-like object, performance, or activity, from our own culture or from another, can be called art.

There is much speculation in and about this method of labeling objects and experiences "art" from this cross-cultural point of view. It crosses two Western philosophical points of view, antiessentialism and anti-antiessentialism, and disagrees with Anderson's cultural anthropological cross-cultural methodology, though it doesn't seem to be contrary to Dissanayake's ethological point of view. This is a new (2009) methodology, so it's hard to say where these points of view fit within non-Western approaches to identifying and understanding art. What do you think?

Personal and Cultural Revolution

China's socialist past is a non-Western reference for most of artist Hung Liu's paintings, now extensively exhibited in the United States. Hung Liu, a contemporary artist, was born in 1948 in Changchun, China, a city defended by the Nationalist Army of Chiang Kai-shek from the advance of Communist forces led by Mao Tse-tung. Hung Liu's father was a captain in the Nationalist Army. When Changchun was put under siege, even with American food and supply drops, starvation and panic set in.

The family fled the city looking for food and crossed into Communist territory, where Liu's father was detained by troops and sent to a labor camp. He was not seen by his family again for 46 years. The family moved to a village in the Manchurian countryside and took the name of "Liu." After Changchun fell to the Communists, the family returned to what was then called "the dead city."

When Hung Liu was 10 years old she went to live with her aunt in Bejing and entered a very prestigious girls' school. She performed at the top of her class. In 1968, when Liu was 20 years old, the Cultural Revolution was initiated by Mao Tse-tung and continued for 10 years. Anything and everything with Western influence, including missionaries and foreigners, was purged from China during the Cultural Revolution. Mao wanted the support of

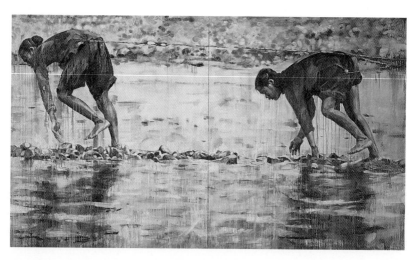

Figure 2.2 Hung Liu, American (b. China, 1948). *Mu Nu* (Mother and Daughter), 1997. Oil on canvas, diptych, 80 × 140 inches.

young people, so he provided free train travel for them. Liu traveled all over China. When Mao decided that educated young people should be "re-educated" by the proletariat – soldiers, workers, lower- and middle-class peasants – Liu was sent to the countryside, where she worked among them in a rice field seven days a week for four years.

While Liu labored in the rice field she used an old camera she was keeping for a friend to make pictures of the workers and their families. "I had this great satisfaction and pleasure," she said, "that I could do something so casual," something that didn't require people to go to town and put on new clothes. "They could just stand in front of the fence" (Liu 1989). Liu developed the prints at night since she didn't have a darkroom.

Liu entered the Revolutionary Entertainment Department at Beijing Teachers' College to study art and art education. A catalog of a show there could be 20 works by 20 artists that all looked like they were done by one person because the style and subject matter were the same – the revolution or Chairman Mao.

In 1976 both Zhou En-Lai, Prime Minister under Mao, and "Chairman Mao" died. Many Chinese took paper flowers to Tiananmen Square in their honor. The authorities swept them off by the next morning, showing the shift in the mood of the country. By 1978 the "Open Door" policy of the West was established.

Hung Liu studied mural painting at the Central Academy of the Fine Arts, traveled to the Dunhuang Buddhist cave murals in the Gobi Desert, which she copied, and visited famous religious shrines throughout China. She was accepted to the University of California San Diego Graduate School of the Visual Arts in 1979 but could not leave China because her passport was denied.

While waiting for her passport to be issued, Liu studied traditional calligraphy and stamp making. Finally, in 1984, she boarded her first airplane and left China for the United States with $20 in her pocket. In San Diego she met contemporary artist Eleanor Antin, a performance artist, and Feminist art critic Moira Roth. Allan Kaprow, her teacher, was famous for "Happenings," a sort of updated version of Dada Performance Art. One day he took his class to a large dumpster and brought old chairs and buckets of paint and told his students to "do something." Liu was at a complete loss. In China she had been taught to create the "perfect painting. Everything had to be arranged and planned, the cool colors next to the warm, because we were taught that way, almost like paint by numbers. Those numbers were programmed into my head," she said (Liu 1989).

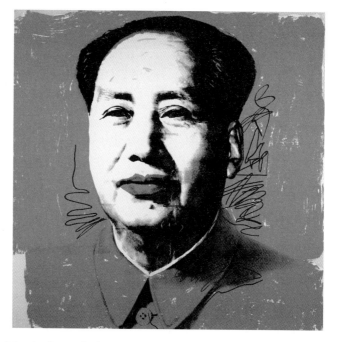

Figure 2.3 Andy Warhol, American (1928–1987). *Mao Tse-tung*, 1972. Color serigraph, 36 × 36 inches.

A fellow student rescued her from her dilemma by grabbing the paint, mixing it together, and pouring it on one of the chairs. Liu thought, "I can do that." She said much of what she learned from Kaprow and from coming to the United States was "un-learning" the traditional art making she had been taught to make in art schools in China.

By the late 1980s Liu began researching the Chinese immigration to California and painted a mural that used both Chinese and American elements, including books like D.D. Wang's 1987 *What You Should Know about Life among Americans.*

Liu created an installation of 1,000 felt cutouts of Mao's face placed on glass blocks called *Where is Mao?* (1972) "He was everywhere in images but nowhere in presence." She chronicled a hunger that she thinks many contemporary Chinese artists her age must have felt, to paint "something that didn't have Mao's face on it" (Liu 1989).

Liu's work references traditional practices and life in China like the feet binding of higher-class women. She used this as a universal symbol for the

suffering of women under all Chinese regimes, ancient and modern. She also began to use historical photographs made during the Cultural Revolution. She references what she lived through when the Red Guard would come into houses and remove all Western-inspired objects and look through all personal items. Families were forced to burn their family photographs because the Red Guard might find them and ask, about a wedding photograph, for instance, "How did you have the money to buy this wedding gown?" "You are a class of family who considers themselves to be better than others and you must be sent to re-education camps." Many old Chinese photographs were lost.

On a trip to China in 1991 Liu discovered old Chinese catalogs and photographs and used them in her paintings as symbols of universal human suffering, a recurrent theme in her work. On using historical photographs, Liu said, "As an escapee from propaganda art in China, I looked toward the ancient artists of my culture and traveled extensively to ancient monuments."

Liu became interested in the peculiar ironies that result when ancient Chinese images are reprocessed within contemporary Western materials. Liu is known for the hallmark dripping paint in her work, which she interprets as weeping, passing of time, faded memories, and getting away from that "perfect painting surface" she had been taught in China. She also uses dripping paint as a way to "lose" the identity of the people in the photographs. Liu's work is highly layered, so much so that if there is no explanation of the painting, a Western viewer might miss the full meaning, or layers, of the work. The drips are like a veil that both preserves and destroys meaning and image simultaneously.

Liu does not foster bitterness over the hardships she has endured. There is no sense of victimization, no hostility, no anger, simply warmth, kindness, and laughter. As with the ideal balance of yin and yang, the polar opposites as perceived in Eastern mysticism, the "evil" of this woman's cultural history and the "goodness" of her personae are in harmony with the lyrical lines and colors she incorporates with traditional Chinese symbols and images in Postmodern appropriations.

Perhaps there are some connections that can be made among non-Western cultures like those in China, Africa, Native America, and Pre-Columbian Mexican traditions. One thing for certain is that even ancient traditions are re-contextualized in today's world. It seems clear that appropriation and adaptation of images and ideas from the past for use in contemporary art, experiences, and rituals are a way to keep human cultural and biological heritage "special," alive, and meaningful.

El Día de los Muertos

El Día de los Muertos is a combination of beliefs and rituals that have evolved from indigenous Mexican traditions and conquering Spanish Catholic influences. Celebrated on November 1 and 2, the Catholic Holy Days of All Souls' Day and All Saints' Day are when the spirits of the dead return to earth, "on the wings of butterflies," to take part in the pleasures of the flesh. Families create *ofrendas*/altars that celebrate the lives of loved ones by providing basic elements of earth, wind, fire, and water. The souls of loved ones come to visit on the wings of the wind, lighted by the fire of candles, and their thirst is quenched with water. They are offered a special Day of the Dead bread along with fruits and flowers, particularly marigolds, the traditional flowers of the dead.

An extra candle is always added for forgotten souls. Families place photographs and personal belongings of the deceased on *ofrendas*, along with favorite foods, flowers, and beverages. The altars are created to be as inviting as possible. The Day of the Dead celebrates the life on earth of those who have passed into the world of reality. Some believe that in physical life we are only dreaming and that in death we finally awake to the real world. El Día de los Muertos is the one day a year when the souls of the dead are among us, enjoying the pleasures of the flesh that they enjoyed when they were on earth.

Some people respond deeply to the spirit of All Souls' Day, especially if they live in states that border Mexico or they have visited Mexico or studied with Mexicans in study abroad programs where they developed an understanding and appreciation of Mexican culture. Many people celebrate the lives of those who have died during the special "days of the dead" and find comfort and meaning in remembering loved ones with symbolic objects, like *milagros* (miracle or prayer), that they can leave on community altars at El Día de los Muertos celebrations.

This is not a ghoulish festival with tricks and treats. It is derived from All Hallowed Eve, the night before All Saints' Day. It is easy to see how Americans developed Halloween festivities after learning about Day of the Dead rituals that include offering food, water, candy, alcohol, flowers, and other "treats" that loved ones enjoyed, in celebration of their life on earth. The skeletons in the Day of the Dead rituals are alive: dancing, drinking, bathing, getting married, playing instruments and making music, getting drunk, and making art. If art can be defined as an object or an experience with extraordinary significance, Day of the Dead altars meet the criteria.

Visually and culturally rich, El Día de Los Muertos is a meaningful celebration of life. Some families create traditional *ofrendas* as remembrances of loved ones that include photographs, special objects, candles, flowers, water and bread, even favorite foods and beverages. Community altars invite visitors to "share the joy of the celebration of loved ones who have passed."

Day of the Dead Poem
Ancient Mexican Verse for the Dead

We only come to dream, we only come to sleep;
It is not true, it is not true
That we come to live on earth.
Where are we to go from here?
We came here only to be born,
As our home is beyond,
Where the fleshless abide.
Perchance, does anyone really live on earth?
The earth is not forever,
But just to remain for a short while.

Cultural Objects in Museums

At around two hundred years old, museums are a relatively recent Western cultural development. The goals of museums are to preserve and display objects of the past for present and future audience appreciation. The idea of museums is new to non-Western cultures. Some non-Western cultures do not value the preservation of objects that have served their purposes in social or spiritual ceremonies. Some objects function through personal or community rituals and are never meant for public display. Other objects are discarded after use in a ritual; having served their purpose, they no longer have any special power or significance. Various non-Western cultures do not consider certain objects to be "art." Nevertheless, such objects are still considered to be worthy of display and documentation in a Western context, either as products of biological adaptation (Dissanayake) or owing to their cultural significance (cultural anthropologists).

There is a general perception that items stored or displayed in a museum present some kind of knowledge about human activity or culture. Remember the case of the Native American bones stored in boxes in the Smithsonian that began this chapter?

We have come to learn from anthropological, philosophical, and ethological theories (Gott, Anderson, Berleant, Dissanayake, and Dutton) that there are objects and experiences considered to be "special," or "art," in all cultures. Determining which objects or experiences are considered art by which cultures is the trick. We learned that non-Western cultures have different criteria for aesthetic appreciation than Western cultures. We learned that utilitarian objects in non-Western cultures used for social, cultural, and spiritual ceremonies may not be considered candidates for aesthetic appreciation and are not intended for preservation in museums. Westerners may have to adjust their thinking about what should be preserved or presented and about how to judge, learn, and value objects.

We learned that context is essential in determining what art is and that context includes social, political, religious, psychological, and philosophical concepts and issues. All art has form, subject matter, content, and context, and it is the context that can lead us to the deeper understanding of the meaning, or the content, of an art object or experience.

3

Western Ideas About What Art Is

What is it about art that makes it important enough in our lives to be worth arguing about? Why are we compelled to defend our ideas about art and to even try to define art? Contemporary Western thinkers like Arthur Danto (2006), whose current definition of art (if one is needed, he wonders) is "works of art are embodied meaning," and Jean Baudrillard's "simulacra and simulation" can help us understand contemporary art and also contribute to concepts about the nature of art and culture.

Aesthetics (the study of the philosophy of art) is a branch of philosophy that includes epistemology (the study of knowledge), ethics (the study of morality), and politics (the study of public organization, or civil behavior) and can help support positions on art issues. So can art theory, now deeply embedded in contemporary art and aesthetics. Originally defined as the theory of beauty, aesthetics expanded its focus in the eighteenth century, again in the 1950s, and has once again done so in our current Postmodern period, to include art theory and new questions about what art is.

Arguments about aesthetics have been expressed in specialized philosophical terms like essentialism, antiessentialism, and anti-antiessentialism. There are also overlapping categories of philosophy and art theory that support arguments about aesthetics such as representation, expressionism, formalism, institutionalism, instrumentalism, cognitivism, Feminist aesthetics, continental philosophies, art criticism, and Feminist art criticism. All of these ideas are worthwhile for developing arguments about the philosophy of art and can contribute to understanding contemporary art and society.

Ideas About Art, First Edition. Kathleen K. Desmond.
© 2011 Kathleen K. Desmond. Published 2011 by Blackwell Publishing Ltd.

That's Not Art! (No Matter Who Says So!)

A well-known artist was vacationing in a small beach community where the curator of the local art museum met him walking along the beach. The curator explained to the artist that the museum had no money to purchase new art and how honored the museum would be to be given a work by the artist. The artist stopped and thought for a moment, smiled, and picked up a dead fish lying on the beach. "Here," said the artist, "take this. Title it *Ineffable*."

Is a dead fish art? Ever? Never? Is the dead fish art when it is on the beach? Is it art when it is displayed in an art museum? Is it art because an artist said it was art? Does its title make it art? Is it art because an art museum curator displayed it in a certain way? What if the art museum curator says it is art? Is it art then? Do museum viewers have a say in whether the dead fish is art or not?

There are probably many answers to these questions, and there may be as many reasons that back up those answers. What knowledge is necessary for answers to such questions to go beyond simply opinion and toward an argument that would be taken seriously? Is there a definition of art that can be used to support answers to these questions?

On the first day of a university art appreciation class, scholars answer this question on the last page of their notebooks: Art is _____. Think about this for a moment and fill in your own answer: Art is _____.

Thinkers in this class struggle to answer questions about whether or not a pile of bricks, stacked exactly the same way, one by a famous artist in a prestigious art museum and another by a neat bricklayer on a construction site, are both art, or if just one is art, and why. Or whether human remains, Native American or Egyptian mummies, ought to be displayed in museums. Everyone recognizes that these questions are controversial and everyone has their own views on these subjects, and everyone's opinion may be

different. One thinker wondered if an artwork could be created for the sole purpose of causing people to argue about whether or not it can be considered art! (Would the dead fish qualify?)

During the course of three months these definitions are edited, changed, modified, and refined as thinkers learn about visual art elements and principles of design, art criticism, and art history in both Western and non-Western cultural contexts.

To say that definitions of art are many and varied is an understatement. Whether art can be defined at all is even a matter of debate. Some people think art is indefinable and the question is best answered with "I know it when I see it." Others say art is a "life-changing" quality in a work of art, the ability of an image or experience to be emotionally or artistically unforgettable.

Some Western art "masterpieces" are thought of as art created by "old master" European painters and sculptors from the thirteenth through the eighteenth centuries. Artists achieved a high level of skill and recognition before becoming masters of their own studios or local artists' guilds. Some surpassed this achievement with technique, skill, emotive properties, and innovation: artists like Leonardo da Vinci, Michelangelo, Raphael, El Greco, Caravaggio, Rembrandt, Vermeer, Goya, and others. Non-Western art is often thought of as useful, in functional or spiritual ways, as noted by Ellen Dissanayake, Richard Anderson, and Denis Dutton. Some artists in non-Western societies don't sign their work like Western artists do because it is thought to be an integral part of the community and not the work of just one person. In some non-Western cultures and periods, artists were required to study the traditions of art making from family members, similar to European guilds and master studios.

Aesthetics

For the purposes of this book, aesthetics is the philosophy of the nature and value of art. The study of aesthetics can guide thinkers toward intelligent arguments about art. Concepts in this chapter address a variety of ideas concerning what art is from a Western analytical philosophical point of view – from Plato to Danto. Semiotics, supported by continental philosophers from Derrida to Baurdrillard, will be addressed later. Non-Western traditions and aesthetics were addressed in the previous chapter.

Contemporary art presents an entirely new set of standards often grounded in conceptual theory rather than community or cultural

standards. Is it the artist, the viewers, the art idea (theory), the form, or the subject matter that makes a great work of art? All of these? All of the time? In all cases? Can we even define art? What are our choices?

Some Definitions of Art
(Developed by University Students)

Art is without definition because it is all about perception.

Art is not a particular object or style, it is an idea and the way the idea is manifested – that's what turns it into a form that can be called art.

Art is visual, mental, and physical.

Art is the creation and expression of a feeling, thought or idea the artist wants to convey.

Artists define art.

Art is what I find appealing.

It is not art unless the ideas challenge what art is.

Art is whatever the viewer wants it to be and the same for the artist who creates it.

Art is the voice of the era in which it was produced.

Art is the physical expression of an idea or concept.

I used to think anything could be art as long as it looked "pretty." Anything can still be art, but it is the idea behind it that makes it art.

Art can be almost anything with legitimate reasoning behind it. All year long we have had to back up our reasons. I think that if you can prove it is art, then it is.

Traditional Western Philosophical Positions

Traditional Western points of view that may be useful for arguing about what art is include essentialism, antiessentialism, and anti-antiessentialism. With thought, these concepts can be modified and expanded to develop your personal definition of art.

Essentialism

Essentialism refers to the belief that there is an underlying and unchanging "essence" to someone or something. Essentialism is a generalization stating that certain properties possessed by a group (people, things, ideas) are universal and not dependent on context. For instance, what constitutes the essence of a dog? The essential properties of a dog are those without which it is no longer a dog. Other properties, such as spots, or color, or number of legs, are considered inessential. How would you explain the essence of a dog?

In philosophical terms, the word "essence" relates to the early Greek philosophy of "form." All entities have two aspects, "matter" and "form." It is the particular form (essence) that gives something its identity, its "whatness" (i.e., "what it is"). Greek "form" is an idea, an ideal, even a spiritual concept. It is not physical. We can't touch it.

Essentialism and the Mimetic Theory

Plato was one of the first essentialists. Platonic essentialism has been the predominant philosophy of art, beginning with the definition that "art is imitation," also called the Mimetic Theory. Plato believed in the concept of ideal forms, a metaphysical, sort of spiritual, description of all natural entities. Natural entities are representations, or imitations, of ideal forms. Copies. It takes intellectual engagement to understand ideal forms and their physical manifestations. Artists merely imitate the already imitated physical representations of ideal forms. Thus, art is a copy (the artwork) of a copy (the physical representation) of ideal forms; a third removed from the original.

For example, the ideal form of a circle is a perfect circle, something that is physically impossible to make, yet the circles we draw and observe have an essential idea in common. This idea is the ideal form. Plato believed that these ideas are universal, eternal, and vastly superior to their representations in the physical world. He thought that we understand these manifestations in the material world by comparing and relating them to their respective ideal form. Because art was a third-generation imitation, art was useless, he thought, and perhaps even dangerous.

Put another way, Plato claimed that art imitated the physical world. Creating art is basically an act of copying the physical world, already a copy of ideal forms. Plato thought our world of ordinary objects was just a shadow of reality. Only forms (essences) are "real" and ordinary people cannot experience these forms directly.

A work of art is a copy of a copy of a form, the essence of reality, rendering art useless. Plato thought that for something to be useful, it must add knowledge to society. Art failed to add any knowledge to society because it simply imitated what was already known, giving it no social value or purpose. Art was an imitation of nature, which was already a copy of ideal forms. Art could not be trusted because artists could not master everything they represented in their work. Artists misrepresented ideas and created unreliable work. Nothing could be learned from art, so said Plato.

Art could be dangerous, too, Plato thought, because it ignored the intellect and concepts, focusing on sensual pleasures and keeping viewers ignorant of forms (essence) like truth, justice, goodness, and beauty. Further, art stirs emotions and may lead to irrational actions that could be detrimental to society. For these reasons, Plato supported censorship. Censorship was a way to protect the minds of citizens from the dangers that lurked in artworks of all kinds.

Aristotelian transition

Aristotle was Plato's student, and agreed with his teacher that art is an imitation of forms (Mimetic Theory). Aristotle disagreed, however, that art was useless and that little could be learned from art or that emotions evoked through art were dangerous. In fact, Aristotle thought much could be learned from studying artists' imitations of human responses and events. He described the social function and ethical use of art and thought art could be expressive. Aristotle thought all artwork was a representation (imitation) and could teach humans about expressive responses. He applied his ideas to poetry and performance more than to the visual arts, but contemporary thinkers like you can perhaps expand Aristotle's support to include the performance-based and experiential arts of today. Aristotle's ideas provide a transition from essentialism to antiessentialism, the concept that for any given kind of entity there is not just one essential characteristic that it must possess, but several shared characteristics.

Antiessentialism

"The idea that in order to get clear about the meaning of a general term one has to find the common element in all its applications shackled philosophical investigation," said Ludwig Wittgenstein, one of the chief proponents of antiessentialism (Battin et al. 1989: 7). Antiessentialism argues that for any given kind of entity there are no specific traits that entities of that kind must possess.

Wittgenstein rejected general definitions based on "sufficient and necessary conditions," a philosophical method of proof. Contributing to the philosophy of language, he thought that instead of philosophical "cravings for generality," a more suitable analogy for connecting specific uses of the same word was "family resemblance." There was no reason to look for one, essential core in which the meaning of a word – art, for instance – is located. There is no reason to try to find what is common to all uses of that word. He used the example of the word "game." What if we defined "game" as a "competitive contest," mused Wittgenstein. This definition doesn't work because some competitive contests, such as wars, are not what we would call a game. And there are games, like solitaire, that are not competitive contests. So instead of a single common feature, Wittgenstein looked at the actual usage of the concept of the word in question as a set of overlapping features. The strength of the concept resides not in the fact that one idea is common to the whole, but in the overlapping of many concepts. Wittgenstein called these "family resemblances."

"Family resemblances" demonstrated a lack of boundaries and distance from the exactness that characterized different uses of the same concept, like art and artworks. Wittgenstein is best known for challenging that essentialist desire, moving past finding the commonalities of a concept, and moving toward a new way of looking at concepts. Wittgenstein's "family resemblances" are found in all aspects of philosophy, from the philosophy of language to its obvious correlation to aesthetics.

Adaptations of Wittgenstein's antiessentialist theory of language were applied to the visual arts by philosophers Paul Ziff and then Morris Weitz (Battin et al. 1989: 7–8), who related the conceptual overlap and family resemblance to the concept of art. Weitz thought that knowing what art is was not simply apprehending some obvious or hidden essence of the thing, but it was being able to recognize, describe, and explain the things we call art by virtue of their similarities. Both Ziff and Weitz thought that art had to be an open concept that was alterable and delicate because openness was a precondition for creativity in art.

Anti-antiessentialism – The Institutional Theory of Art

George Dickie, however, rejected antiessentialist arguments that art cannot be defined by developing his own theory of art. The Institutional Theory of Art, also called anti-antiessentialism, has two characteristics for classifying a work of art: (1) it is an artifact with (2) a set of aspects that has had

conferred upon it the status of candidate for appreciation by a person or persons who are acting on behalf of a certain social institution (the artworld).

In 1984 Dickie revised his definition of art by creating a set of five deliberately circular definitions that he thought revealed the infinite nature of art and published it in *The Art Circle: A Theory of Art* (Dickie 1987: 80–2).

1 An artist is a person who participates with understanding in making a work of art.
2 A work of art is an artifact of a kind created to be presented to an artworld public.
3 A public is a set of persons the members of which are prepared in some degree to understand an object that is presented to them.
4 The artworld is the totality of all artworld systems.
5 An artworld system is a framework for the presentation of a work of art by an artist to an artworld public.

The Institutional Theory focuses on the established practice of art and its appreciation and has the advantage of highlighting the social context through which art is generated. It provides for properties that are not directly exhibited to the senses. Dickie's Institutional Theory is based on Arthur Danto's notion of an artworld that claims that an artwork is an artifact that has the status of candidate for appreciation awarded to it by a suitable representative of a formal social institution known as the artworld. Accordingly, any artifact can be a work of art as long as it is "admitted" by the artworld. In other words, art is the consequence of social agreement rather than having intrinsic aesthetic features, or art is what the artworld says it is. In a later version, Dickie claimed that a work of art is an artifact created for presentation to a group of persons (the artworld public) who are prepared, to some extent, to understand artworks.

Even Dickie's 1984 revision of his Institutional Theory does not account for art practices that do not include an object, such as performances, ceremonies, and experiences like those of German artist/shaman Joseph Beuys and of Indigenous peoples in non-Western cultures.

No pigeonholes

It is worth noting that philosophers and art critics and artists cannot be categorized, or placed into pigeonholes. Critical and creative thinkers grow, develop, evolve, and change their minds. This dynamic activity reminds us

that we are required to engage and to think critically and creatively if we want to understand and appreciate art. Artists, philosophers, and critics engage in a world of ideas that include useful distinctions like essentialism, antiessentialism, and anti-antiessentialism, along with overlapping and corresponding art theory terms like realism, formalism, expressionism, instrumentalism, and institutionalism. These are meant to be helpful in thinking about the nature and value of art and useful guides toward intelligent discussions about art.

From antiessentialist back to essentialist

Contemporary philosopher Arthur Danto agreed, at first, with antiessentialist Ludwig Wittgenstein that art didn't need a definition. He thought we all knew what art was when we saw it and our ability to know this was not dependent upon having a definition. Wittgenstein thought overlapping features among a diverse set of characteristics correctly designated something as art. The effort to frame a definition in essentialist terms was, he claimed, a waste of time.

However, after encountering today's ever-changing world of art, Danto changed his antiessentialist view to an essentialist one. In this Postmodern aesthetic period, we need a definition of art, he thought. Danto's definition of art was developed during the 1960s when works of art were more or less indiscernible from familiar "real" objects. Those were exciting times, he said, but how could you tell the real objects from art? Danto (2006) continued to try to understand and to write about art, and in order to do so he came to an essentialist definition that "works of art have embodied meanings."

There was a time when perception and knowledge of art theory, art history, and art movements was sufficient for understanding works of art, said Danto. These characteristics could be described as similar or resembling each other and this would be considered an antiessentialist point of view because there is more than one essential quality. Danto doesn't think this anti-essentialist point of view is sufficient today. The difference between art and reality is not something that can be observed perceptually anymore, he says, because contemporary artists purposefully try to eliminate the distance between art and reality. Danto has come to think that works of art possess the essential quality of "embodied meanings," returning his thinking to the essentialist camp.

Danto thinks Postmodern artists attempt to blur the distance between art and reality (or, in Plato's terms, the physical manifestations of those ideal

forms) by using unaltered identifiable objects in their artworks and assigning different meanings to those objects. For instance, Mierle Laderman Ukeles, artist-in-residence at the New York City Department of Sanitation, uses garbage to create installations. She uses recycled materials, also known as garbage, in ways that transform meanings and synthesize concepts about art and everyday life. She creates new ideas, concepts, and aspirations for materials and for human behavior. Her work also addresses Feminist aesthetics in terms of service to community and the impermanence of materials.

Art has meaning, says Danto. Art is about something. However, the meaning of an artwork is not always evident by simply looking. Many objects in the world have meaning and are not art. So how can you tell what is art and what is not? Danto (2006) thinks "works of art embody their meanings and thus require interpretation." Further, he thinks the artist must affix meaning to their work for it to be called art. In the past, art was created in a way that all the information viewers needed to understand the piece was visually represented.

Today, however, art can no longer be explained as solely an aesthetic experience. Aesthetic experience is no longer the point of art in this Postmodern aesthetic period. Typically we do not immediately grasp the prospects of artworks. It must be explained. This is what Danto calls the "cognitive conception." Philosopher Nelson Goodman, who appears in future chapters, supported cognitive knowledge for understanding and interpreting art.

Art Criticism Maps Meaning

Art criticism, as defined by some, is informed talk about art for the purpose of understanding and appreciation. Some art critics think their job is 91 percent education of their readers and 9 percent personal opinion. Danto thinks that in this time of radical pluralism there are other considerations for art criticism than value judgments, including ethical, political, and moral judgments. According to Danto, art criticism is necessary now more than ever because critics map meaning onto the object or experience. This is a very important concept not often considered by the general public.

Even artists have trouble understanding other artists' work without some sort of explanation. For instance, an observer may not know why a particular material like a piece of cloth or gunpowder would have meaning to Cai Guo-Qiang, who uses a wide variety of materials, symbols, narratives,

and traditions from his Chinese culture, including Chinese medicine, philosophy and images of dragons, tigers, roller coasters, computers, vending machines, and gunpowder. Gunpowder? Cai's Chinese heritage and personal history made these materials special to him. He has created meaning for "real" objects and materials.

After 9/11, Cai Guo-Qiang used gunpowder both as metaphor and as a material. He made violent, beautiful explosions with gunpowder. He thinks the artist, "like an alchemist, has the ability to transform certain energies, using poison against poison, using dirt and getting gold." Gunpowder has a specific and universal meaning to Cai going back to his life during the Chinese Cultural Revolution, when he developed a rebellious nature fostered by his feeling that he could not please either the official or the unofficial political agenda of the time. He began investigating the accidental, that which could not be controlled. The idea behind Cai's work was to derive power from nature. It was a release from the repression he felt around him. Once the meaning behind the gunpowder is explained, viewers can understand its significance and appreciate the artwork.

Some Western Art Theories and Ideas

Continuing a quest for informed discussions about art includes useful and overlapping categories for supporting positions about what art is. Here is a brief survey of some art terms – representation, formalism/abstraction, expressionism, instrumentalism, and institutionalism – along with a few examples of how artists and philosophers think about these ideas and what they may say to support their positions. You'll recognize these terms because they overlap with some of the philosophical categories already discussed, like Plato's Mimetic Theory and representation and Dickie's anti-antiessential Institutional Theory of art as institutionalism. Don't worry if you don't recognize all these philosophers or artists. All the philosophers will be discussed in future chapters.

Mimetic/imitation or representation theory

Representation has lasted from Plato's time (ca. 428–347 B.C.E.) until today. As we have seen, Plato formulated the idea that art is mimesis, an imitation, now called the Mimetic Theory. Plato was not a fan of art, visual art in particular. He did not think anything could be learned from imitations.

Even though Plato thought art was useless, he did recognize that it was powerful and, thus, potentially dangerous. He thought it was necessary to censor works of art that could provoke negative emotions or teach bad morals.

Eighteenth-century French writer Abbé Bateaux agreed with Plato and claimed that poetry, painting, dance, and music exist only by imitation. Nothing is real. Everything is imagined, painted, copied, artificial.

Contemporary French cultural theorist and philosopher Jean Baudrillard observed that imitations are the essence of our experiences today and we don't even require the "real" thing anymore; the copy of the copy of the copy is satisfactory. Baudrillard's observations of contemporary mimesis are explained as *simulacra and simulation*, the interaction between reality, signs, symbols, and society. He claimed contemporary society had replaced reality and meaning with signs and symbols and that the human experience is a simulation of reality rather than reality itself. Simulacra are the signs of culture and the media that create a perceived reality. Baudrillard thought society had become so reliant on simulacra that it had lost contact with the real world on which the simulacra are based. Ideas of representation, then, espoused by thinkers from Plato to Baudrillard, remain fodder for significant visual art content. (See a visual example of simulacra and simulation called Dove evolution on YouTube: *http://www.youtube.com/watch?v=iYhCn0jf46U*.)

Mimesis/Representation

Philosophers who argue for the Mimetic Theory would say that art is (and should be) imitation. They might say something like: A most praiseworthy artwork conforms accurately to the object portrayed.

Artists who want to re-create things in the real world might say something like famed representational British landscape painter John Constable did: "I hope to show that…imagination alone never did, and never can, produce works that are to stand by comparison with realities" (Goldwater and Treves 1945: 271–2).

Formalism

At the turn of the twentieth century, art shifted toward abstraction and the appreciation of form rather than representation or imitation of nature. This brought about formalism. Formalism places the emphasis in an

artwork on the design and visual qualities. Picasso called formalism "art about art" early in the twentieth century. He meant that art could be about the elements and principles of visual art and design, alone, without imitation or a match to the external world that representation required.

Philosophers and art critics Clive Bell and Roger Fry, members of the influential Bloomsbury Group, were the most noted early promoters of formalism. Clive Bell, an essentialist, wondered what quality all objects shared that could evoke our aesthetic emotions. He thought "significant form," the emotions evoked from the relationship and combination of lines and colors, was the one quality common to all works of visual art. Clement Greenberg, during the years of Abstract Expressionism (1940s through 1970s), also defended a version of formalism.

Formalism

Philosophers argue that art is (and should be) about form – the elements of art and principles of design – about formal order. They might say something like: Lines, colors, and textures forming the shapes and defining the space reveal aesthetic emotion, or significant form.

Artists concerned with formal order and the elements of art and principles of design might say they treat the cylinder, the sphere, the cone, and every element in proper perspective so that each side of an object or plane is directed toward a central point, like Paul Cézanne did.

Paul Signac, a Neoimpressionist, said, "By the elimination of all muddy mixtures, by the excusive use of the mixture of pure colors, by a methodical divisionism and a strict observation of the scientific theory of colors, the artist ensures a maximum of luminosity, of color intensity, and of harmony" (Goldwater and Treves 1945: 378).

And Marc Chagall said, "For me a picture is a plane surface covered with representation of objects – beasts, birds, or humans – in a certain order in which anecdotal illustration logic has no importance. The visual effectiveness of the painted composition comes first" (Goldwater and Treves 1945: 433).

Expressionism/Expressionist Theory

Expressionist Theory requires that a work of art evoke a response of awakening feelings, moods, and emotions in the viewer. Aristotle speculated that sense impressions form our experience of seeing. In fact, Aristotle thought art was a catharsis of emotions and that an artist's self-expression often conveyed universal themes from which much could be learned. Philosopher and critic R. G. Collingwood (1930s) was a proponent of self-expression. He believed that we create an imaginary experience or activity for ourselves that expresses our emotions, and we call this art.

Expressionism

Philosophers argue that art is (and should be) the expression of feelings, moods, and/or ideas.

Artists are concerned with expressing feelings, moods, and/or ideas.

Georgia O'Keeffe said, "Long ago I came to the conclusion that even if I could put down accurately the thing that I saw and enjoyed, it would not give the observer the kind of feeling it gave me. I had to create an equivalent for what I felt about what I was looking at – not copy it" (O'Keeffe 1977: 63).

"What I am after, above all, is expression," said Henri Matisse. "I am unable to distinguish between the feeling I have for life and my way of expressing it. Expression, to any way of thinking, does not consist of the passion mirrored upon a human face or betrayed by a violent gesture. The whole arrangement of my picture is expressive" (Goldwater and Treves 1945: 409–10).

Instrumentalism

Instrumentalism requires that art move people to act for the betterment of society. Art serves as "instrument" for furthering a point of view that might be moral, social, religious, or political. Instrumentalism takes expressivism one step further and seeks to provoke viewers to some sort of action. This is exactly what Plato feared and why he thought art could be dangerous and should be censored.

Karl Marx's theory of art, in the nineteenth century, regarded art as the expression of the superstructure of society, whose forms were determined by the economic base. These ideas are more instrumental than expressionistic, although they are both; they advocated moving people to social action. During the same period, Leo Tolstoy sought to move people to some sort of spiritual action through art. He said that art is a human endeavor filled with emotions, and that external symbols signify the feelings lived through and communicated by emotions and experiences.

Instrumentalism

Philosophers argue that art serves (and should serve) a useful, functional purpose (pragmatic, functionalist, or instrumentalist theories).

Artists are concerned with making useful, functional artworks that move people to some sort of action.

"Art is a language, instrument of knowledge, instrument of communication," said Jean Dubuffet (Ashton 1985: 123).

Francisco Goya said:

> The artist, persuaded that the censure of human errors and vices... may also be the object of painting, has chosen as appropriate subjects for his work, among the multitude of extravagances and follies which are common throughout civilized society, and among vulgar prejudices and frauds rooted in custom, ignorance, or interest, those which he has believed to be aptest to provide an occasion for ridicule.... (Goldwater and Treves 1945: 203)

Institutionalism

George Dickie developed the Institutional definition of art that claims art is what the artworld says it is. Institutionalism focuses on unconventional works of art that can only be identified as works of art because they are placed in a museum or gallery. Of course, if you adhere to the Institutional Theory of art, you would probably want to become a member of the artworld (institution) so your opinion would count!

Feminist aesthetics

Feminist aesthetics pursues questions about philosophical theories and their assumptions regarding art and aesthetic categories. Despite the seemingly neutral and inclusive theoretical language of philosophy, virtually all areas of the discipline bear the mark of gender. Feminist aestheticians inquire into the ways that gender influences the formation of ideas about art, artists, and aesthetic value. Philosophical theories adapted by feminists have been highly influential in the critical interpretation of art and popular culture and in the development of contemporary artistic practice.

Cognitive aesthetics

Cognitive aesthetics meets the needs of our post-aesthetic period, Danto says, and is just what the cognitivist character of contemporary art calls for. Nelson Goodman, in the 1970s, thought that symbols were pervasive and fundamentally important to developing ideas. He thought our interest in symbols is manifestly cognitive. Goodman developed a version of aesthetic theory and defined works of art as symbols within symbolic systems. He treated the problematic issues of artistic representation and expression as semantically based questions of reference and denotation. Goodman and others, such as Wittgenstein and Danto, believed that understanding depends on interpretation. Interpretation is a means of understanding what an art object refers to, how it refers, and within which system of rules it makes that reference. Both Danto and Goodman promote understanding over judgment.

Goodman, who was an authority in fields from cognitive science to artificial intelligence and from art criticism to analytic philosophy, thought that understanding a certain style of art or work by a particular artist, or comprehending a symphony in an unfamiliar form – to see or hear in new ways – was as cognitive an achievement as learning to read or write or add.

Goodman was a professor of philosophy at Harvard University who specialized in aesthetics and epistemology. His book *Languages of Art* (1976) is a major contribution to twentieth-century aesthetics. He was a gallery director in Boston for a time and a life-long art collector with an in-depth knowledge of Western and non-Western art. Visual and performing arts, especially in multi-disciplinary contexts, were an important part of his life and work. Although his major work was in philosophy, Goodman touched the arts, the sciences, psychology, and education.

Goodman made no distinction between scientific understanding and aesthetics. They are but two complementary means for making and understanding our worlds. Goodman believed the cognitive nature of art invited the arts to be partners with the sciences in the pursuit of understanding: "Truth cannot be defined or tested by agreement with the world; for not only do truths differ for different worlds but the nature of agreement between a world apart from it is notoriously nebulous" (Desmond 2007a: 28).

Consider This

Remember the dead fish story at the beginning of this chapter? After learning about various and different ways of thinking about the nature and value of art, about art theory, and upon examining your own definition(s) of art, have you developed substantial support for answers to the questions posed about whether or not that dead fish is or was or can ever be art? Now try your ideas out on this story.

Two Fountains

In 1916, the Society of Independent Artists was founded in New York City, with the goal to hold annual art exhibitions by avant-garde artists. The exhibitions were open to artists who wanted to display their work. Everything submitted would be shown. There were no juries or prizes.

For the 1917 exhibition, Marcel Duchamp, a recognized artist, entered a readymade, as he called works he was creating at the time, titled *Fountain*. It was an ordinary porcelain urinal purchased from a plumbing supply store, hung at a 90 degree angle and signed with his pseudonym, R. Mutt. It was rejected for exhibition because it was judged to be not art but an immoral display.

A response to this judgment was published in *The Blind Man* magazine in May 1917. The article claimed it was absurd to think Mr. Mutt's fountain was immoral. It is no more immoral than a bathtub is immoral. It is a fixture that can be seen every day in a plumbing supply store. Further, the article went on to say, "Whether Mr. Mutt with his own hands made the fountain or not has no importance. He CHOSE it. He took an ordinary article of life, placed it so that its

Figure 3.1 Marcel Duchamp, American (b. France, 1887–1968). *Marcel Duchamp Cast Alive*, 1967. Bronze, onyx, and black Belgian marble, 21½ × 15¾ × 9¼ inches.

useful significance disappeared under the new title and point of view" and created a new thought for that object.

Duchamp was part of an art movement called Dada that began as a protest against World War I. Artists outraged by a society that supported a war that ended with 10 million dead and 20 million maimed wanted to protest everything. Dada was anti-art, anti-middle-class society and politicians, anti-good manners, anti-business as usual, anti-all that had brought about the war. Dada was also about creativity, life, silliness, and spontaneity. Dada was provocative and absurd. Dada refused to make sense or to be restrained.

Marcel Duchamp is the Dada artist with the most lasting impact on American art in the twentieth century. His readymades (a work of art not *made* by the artist but *designated* by the artist as art) investigated

the boundaries between art and life in a way that later generations have returned to again and again. Duchamp used objects with no aesthetic value and exhibited them as art. He intended the objects to be returned to their original use after exhibition.

Is Duchamp's *Fountain* art? Could it be art when Duchamp didn't even *make* the urinal himself but rather simply *chose* it? Is it art because it was signed by a famous artist? Could it be art because it was written about in an art magazine? If you were a judge of an art show today, would you accept this work (if it hadn't been shown before)? What would you do if an artist submitted a reproduction of the urinal?

Sherrie Levine made *Fountain* in 1991. Her gleaming bronze reproduction of Duchamp's *Fountain* pays homage to the concepts in Duchamp's original version and adds value to his ideas with the bronze material. It's not a urinal that would be found anywhere else. It was chosen by the artist and made by the artist. It was a copy of Duchamp's *Fountain*. Levine did not acknowledge Duchamp by referencing him in the title of her work. She presented the work as her own. This is a Postmodern practice known as *appropriation*, an artistic recycling of existing images and ideas (see Chapter 10). Levine also used Feminist theory in her work by appropriating only male artists and making the point that women have been excluded from the recognized "masters" of the artworld.

Developing Your Definitions of Art

Western philosophers Plato and Aristotle, Clive Bell, R. G. Collingwood, Ludwig Wittgenstein, George Dickie, Nelson Goodman, Arthur Danto, and Jean Baudrillard wrote about these issues and none of them agree with one another. Some of their ideas overlap or connect and can be useful in developing our own philosophies. The ideas of these thinkers can come to the aid of artists and others who want to defend their ideas about what art is.

4

Beauty
Does Art Have to be Beautiful?

Beauty is a Mystery of Life

When artist Agnes Martin thinks about art, she thinks about beauty. She thinks beauty is the mystery of life. "It is not in the eye, it is in the mind. In our minds there is awareness of perfection" (Beckley with Shapiro 1998: 399). She believes we respond to beauty with emotion and that all art is about beauty. She thinks all positive art represents and celebrates beauty, and that all negative art protests the lack of beauty in our lives.

> ### Some Definitions of Art
> #### (Developed by University Students)
>
> I used to think anything could be art as long as it looked "pretty."
>
> Art is what I find appealing.
>
> Art is beauty.
>
> Art can be beautiful or ugly.
>
> Art is a whole lot more than an object. It expresses beauty.

> Can art be beautiful and horrific? Is it okay to appreciate beautiful images aesthetically if they depict immoral or horrible events?

Ideas About Art, First Edition. Kathleen K. Desmond.
© 2011 Kathleen K. Desmond. Published 2011 by Blackwell Publishing Ltd.

Horrific Beauty

Jonathan Moller was a freelance photographer and human rights advocate in Guatemala between 1993 and 2001. He portrayed genocide, political censorship, and violations of the Universal Declaration of Human Rights in a beautiful, yet emotionally exhausting body of photographs called *Our Culture is Our Resistance: Repression, Refuge and Healing in Guatemala.* Moller photographed Guatemalan families exhuming the remains of their loved ones and reburying them after having to run away from the government soldiers who murdered them years before. These works are moving both in their aesthetic beauty and in their horror.

Jonathan Moller's photographs focus on the violent repression directed against the civilian population by the Guatemalan army in the early 1980s when the military carried out a "scorched earth policy" in northern and northwestern areas of the country. Over 450 villages were completely wiped off the map. More than 200,000 men, women, and children were massacred. Another 200,000 fled the country, one million were displaced internally, and 40,000 were disappeared and their whereabouts are still unknown. Some of the indigenous peasants escaped into Mexico, while others fled to remote mountain and jungle areas, where they formed highly organized communities silently resisting death and army control. They were accused of being guerrillas and were hunted by the army.

The United Nations Truth Commission found that the United States trained, aided, and directly supported the Guatemala military in its genocidal counterinsurgency campaigns against civilian populations at the School of the Americas in Fort Benning, Georgia. Thousands of American citizens have protested against the School of the Americas, seeking its closure, for more than 20 years.

In the official chronicles of Guatemala, these events never occurred. There are no reports of scorched earth, massacres, body dumps, and genocide. "But the bones of the dead prove the opposite," said the 1992 Nobel Peace Laureate, Rigoberta Menchú Tum. "The bones of the dead don't lie. In Guatemala, every clandestine cemetery that is found, every bone that is recovered from Mother Earth speaks of the people who were annihilated, of the home burned, of the indiscriminate massacres. In short, they speak of the crimes against humanity, of the genocide committed by the Army against the indigenous population" (Moller 2004: 7).

Jonathan Moller worked with the Forensic Anthropology Team of the Catholic Church's Office of Peace and Reconciliation in Quiché, Guatemala. He spent time in rural areas working to support Guatemala's hardest-hit displaced and refugee populations, documenting the exhumations of clandestine cemeteries. These cemeteries, on hidden ridges and forested slopes, were fashioned by refugees who were in hiding, and held the bodies of their loved ones, who had been killed by soliders or had died of hunger or illness.

Survivors searched for the remains of the loved ones they had buried in the clandestine cemeteries and now, no longer in hiding, they exhumed and reclaimed their remains, and buried them with a proper ceremony and traditional mourning. These exhumations allowed survivors to begin healing and gave them the opportunity to expose the truth about what happened and, in some cases, seek justice. Moller's photographs reveal the strength and dignity of these people and documents the atrocities that occurred. They tell the story of repression and unspeakable violence suffered by the majority of indigenous Guatemalans.

The Executive Director of Amnesty International USA, William F. Schultz, described Guatemala as a country of "beauty and nightmare, horror and courage." Schultz credited Moller for capturing this complexity through his lens. Moller (2002) said,

> [I]n those profoundly beautiful mountains and jungles, I married my passions for photography and social justice. It is my hope that in some way this work speaks to my vision as an artist and an activist, and especially to the lives of those in Guatemala who survived and resisted death and exploitation, and who continue to struggle for their land, their basic rights, and their culture.

Moller used long, descriptive titles for each photograph. Each title described the place and the event, true to the traditions of documentary photography.

Photography educator and critic Nathan Lyons was juror for the Society of Contemporary Photography's 2002 *Current Works* exhibition. He selected Moller's work for the prestigious Fellowship Award, earning Moller a one-person exhibition of his work at the SCP. During his juror's lecture, Lyons asked viewers to extend their considerations to include the dialogue of art critics and philosophers like Nelson Goodman and Arthur Danto who discuss symbols and symbol systems. According to Lyons (2002), "[T]he nature of the photograph and its subsequent effect should not confuse our attempt to understand the aesthetic and social context in which the photographer worked." This may reveal something about the photographer's need for

making the images, as well as the possible concerns of those who view them. Lyons noted the dilemma of an "authoritative voice seducing us into believing that a system reconstitutes the world rather than understanding that a system only affords us a limited way of traversing it." In effect, "authority over imagination becomes the system and not the observation."

Viewpoints on Beauty

Beauty is a concept studied in several disciplines, such as philosophy, sociology, psychology, cultural studies, and visual culture. In the most general terms, beauty could be defined as the characteristic of a person, place, object, or idea that provides a perceptual experience of pleasure, meaning, or satisfaction. In its most profound sense, beauty may engender a salient experience of positive reflection about the meaning of one's own existence. Experiences of beauty require interpretations balance and harmony with nature that may lead to feelings of emotional well-being.

Early Greek philosophers saw a strong connection between mathematics and beauty. Ancient Greek architecture is based on a mathematical view of symmetry and proportion called the golden ratio (or golden mean), which was carried through to the Renaissance in architecture, sculpture, and painting. Two qualities are in the golden mean if the ratio between the sum of those quantities and the larger one is the same as the ratio between the larger one and the smaller. The golden ratio is an irrational mathematical constant. It was believed that this proportion was most visually pleasing. Mathematicians have studied the golden ratio because of its unique and interesting properties, while artists have found the golden ratio useful in creating representational and beautiful art.

Theories of beauty have been proposed from Plato's "Pure Forms" to Plotinus's hierarchy of Forms, with beauty at the top of that hierarchy. Beauty is the source of perfection and the standard by which relative beauty of all objects and Forms are judged, said Plotinus. Plato argued that beauty is an essential characteristic of a work of art. It is difficult, however, to isolate beauty as a single feature in a work of art and equally difficult to ascertain the relationship between any qualities of art and a viewer's response to those qualities.

Medieval philosopher and theologian Thomas Aquinas argued that beauty originates in perceptions evoked by the object and are unified in the mind to form the idea of beauty as a cognitive delight. The sensuous, formal,

and unifying qualities of a "whole" can evoke intellectual responses and affect imagination and perception. Aquinas's theory assumes that beauty has both objective and subjective elements. Both Plotinus and Aquinas emphasize the intellectual character of the aesthetic.

In contrast, at the turn of the twentieth century, American philosopher George Santayana argued that the concept of beauty developed from personal responses to phenomena that please, interest, or stimulate emotional reactions. Santayana and others thought beauty only existed in subjective emotional reactions, not in intellectual responses. This leads to the often incorrectly used phrase beauty is "in the eye of the beholder."

The difficulty of defining beauty as an objective quality or set of qualities led to theories of taste as the determining factor in aesthetic judgments. Philosophers of taste disagreed about the features that evoke a sense of taste. According to Immauel Kant, writing in the eighteenth century, in order to determine beauty we do so through imagination, not through cognition, but perhaps in conjunction with feelings of pleasure and pain. The judgment of taste is not a logical judgment of cognition, but an aesthetic one understood subjectively. Taste is a sense of the imagination by which we respond qualitatively to phenomena.

The difficulties incurred in identifying art with beauty or with linking aesthetic judgments with a sense of taste have led some philosophers to conclude that concepts of beauty, the phenomena of art, and the idea of the aesthetic are independent. If beauty is an objective quality that triggers an aesthetic response, then the idea of beauty is different from a definition of art because many kinds of experiential objects may be beautiful or trigger such a response.

Beauty, art, and the aesthetic are three independent concepts according to many contemporary philosophers. Contemporary theories focus on the concept of the aesthetic, rather than beauty, as the proper subject for philosophy of art. To some philosophers the nature of the aesthetic was a "disinterested" contemplative appreciation and to others a disinterested sense of pleasure. Psychology and philosophy contributed ideas to twentieth-century notions of the aesthetic. To appreciate something aesthetically, "disinterested detachment" and "psychical distance" is required, said thinkers Edward Bullough and George Dickie. Modern philosophical ideas characterize an aesthetic response as a contemplative "disinterested" appreciation of aesthetic qualities, expanding Kant's ideas about disinterestedness.

Standards of beauty can be implicit, suggested by association with past judgments, or explicit, with definite and unqualified standards. Ludwig Wittgenstein

said that declaring something is beautiful is merely a gesture of approval. The search for a standard of beauty is futile. Aristotle thought the chief "forms of beauty are order and symmetry and definiteness." St. Thomas Aquinas claimed, "elements of order requisite for beauty are integrity or perfection, due proportion or harmony, and brightness or clarity." Immanuel Kant said we know we have correctly judged beauty when our "mental faculties are being stimulated in such a way that the imagination enters into a kind of free play with the cognitive powers, producing a variety of pleasure completely independent of interest" about whether the thing taken to be beautiful actually exists.

These ideas may sound rather confusing, but consider these arguments as attempts by philosophers to be as clear as they possibly can in order to sort out how to define and discuss the elusive concepts of beauty, art, and the aesthetic. Keep these in mind as you develop your own philosophies of art, beauty, and the aesthetic.

Beauty and Ugliness

Some philosophers think something can be both beautiful and ugly. Others think beauty and ugliness are on opposite ends of a value scale, while still others think ugliness is a minimum of beauty. Augustine felt that ugliness was just a lack of beauty, or rather a failure to see beauty. Just as we do not experience positive evil, we experience an absence of good. Many religious mystics, artists, and art theorists agree with Augustine. Twentieth-century Italian philosopher Benedetto Croce thought beauty was successful expression – an absolute with no degrees – whereas ugliness exists in infinite gradations of inadequate or incomplete expression.

Ugly Art

Nineteenth-century English painter John Constable thought nothing was ugly. "I never saw an ugly thing in my life," he said; no matter what the object may be, "light, shade and perspective will always make it beautiful." Greek philosopher Plutarch, by contrast, thought the ugly could not become beautiful. A picture of an ugly thing could not be a beautiful picture because it would not be consistent with its original. Imitation was admired by Plutarch, who thought the reason

we admire representation in art is because the artist's cunning has an affinity with our intelligence.

Vincent Van Gogh tried to make an ugly painting when he created *The Night Café* in 1888. The painting depicts the interior of the café with five customers at tables along the walls of the room and a waiter, to one side of a pool table near the center of the room. One scholar described the café as an all-night haunt with local drunks, derelicts, and prostitutes slouching at tables and drinking together at the far end of the room. Van Gogh's intention was to express the distasteful passions of humanity by using colors considered garish at the time. The painting is a clash of disparate, wildly contrasting, vivid colors. The ceiling is green, the upper walls red, the gas ceiling lamps give off an orange and green glow, and the floor is largely yellow. The paint is thickly applied and the perspective leads downward toward the floor. Today, this clash of disparate color is not thought of as ugly, but as vibrant and energizing. The ugly and distasteful passions Van Gogh sought to reveal in his painting would not be the interpretation viewers would have today when looking at it. Look up this artwork and see what you think for yourself. Even when an artist tries to make an ugly painting, it may not be considered ugly in a different time or place (context).

Beauty and Art

Beauty remains a mysterious concept. It is something everyone senses and no one has successfully defined. Artists are fascinated with beauty and turn to it again and again, although not always in forms we expect.

Since the eighteenth century, beauty and art have been connected because they were both thought to provide pleasure. Philosophers and art critics have thought that what makes a work of art "art" is that it is beautiful and pleasurable to experience. British art critic Clive Bell's theory of significant form, published in 1914, relates beauty and aesthetic emotions to formal elements of art such as lines, shapes, colors, and symmetry. Art can evoke sadness, horror, pity, awe, and a full range of emotions. It can evoke aesthetic emotions, create compelling visual power, and deliver urgent messages.

Art can be beautiful. Sometimes it is not. Beauty is not a requirement for art. Some art represents the visible world. This is called the Mimetic Theory

in philosophy (see Chapter 3) and Representation, Realism, or Naturalism in terms of style used by art historians. Sometimes the ideas or emotions artists wish to convey cannot be expressed using representational forms so they are simplified, exaggerated, or distorted. This is called abstraction. Abstract art focuses on visual art elements that can be beautiful or ugly and evoke pleasurable or not so pleasurable aesthetic emotions.

> *Aesthetic theory is a theory not of beauty but of art.*
> R. G. Collingwood

> *To define beauty…is the aim of the student of aesthetics.*
> Walter Pater

Aesthetic Value and the Sublime

Beauty continues to be one of the more interesting discussions of aesthetic value. Some theorists think pleasure is the key to aesthetic value. Nineteenth-century British art critic John Ruskin said beauty is: "Any material object that can give us pleasure in contemplation of its outward qualities without any direct and definite exertion of the intellect" (Ruskin 1906: 101, cited in Battin et al. 1989: 33). Ruskin thinks beauty subsumes the sublime, the elegant, the comical, the delightful, the dainty, the picturesque, and an array of other concepts.

Twentieth-century British art critic and philosopher R. G. Collingwood thought that "the highest beauty somehow contains within itself subordinate and contributory elements, both the sublime and the comic, and indeed all other forms of beauty, so that these forms appear as parts of a whole, the whole being beauty. … Between these two poles of sublimity and comedy lies the whole of that experience which is the contemplation of perfect beauty" (Collingwood 1964: 75, 85–6, cited in Battin et al. 1989: 33).

In aesthetics, sublime is the quality of greatness or vast magnitude, whether physical, moral, intellectual, metaphysical, aesthetic, spiritual, or artistic. The term refers to a greatness with which nothing else can be compared and that is beyond all possibility of calculation, measurement, or imitation.

Qualities of Beauty in Works of Art

The late French artist Louise Bourgeois (d. 2010) didn't think beauty was a noun. She thought if people have intense aesthetic pleasure they take that experience and project it into the object. She thought experiences are a kind of pleasure that involves verbs. Beauty is only a mystified expression of our own emotion.

Beauty is what stirs the heart, she said. It can be a beautiful woman, a beautiful building, or a beautiful cloud. Beauty is not just a pleasure of the senses, it is a pleasure of the soul. Intellectual pleasure may be satisfying, but it is not beautiful. "Beautiful changes for me from day to day and I am divided between the rational and the emotional. I am a total rational person, but prone to ecstasy, like religious ecstasy" (Beckley with Shapiro 1998: 334).

Indescribable Beauty

"Oh! That is so beautiful it takes my breath away!" exclaimed the first-time visitor to the South Rim of the Grand Canyon. Anyone who visits the Grand Canyon in Arizona, in any weather condition, will witness indescribable natural beauty and perhaps have an aesthetic, emotional, or spiritual experience. For some people the sensation will be one of awe-inspiring beauty; some may even experience the sublime. The feelings evoked by the Grand Canyon can be indescribable or ineffable.

Some artists have been so taken with the beauty of the Grand Canyon that they have created works of art to enchant viewers with its beauty or to evoke aesthetic emotions. The Grand Canyon has been sketched, drawn, and painted many times and photographed too. Nineteenth-century landscape painter Thomas Moran and contemporary painter David Hockney took on the challenge of the Grand Canyon and attempted to interpret aspects of it. Hockney was inspired to depict the Grand Canyon after seeing a Thomas Moran Exhibition at the National Gallery in Washington, D.C., that included a poster of an early advertisement of the Santa Fe Railroad characterizing the Grand Canyon as the "despair of the painter."

Figure 4.1 Thomas Moran, American (b. England, 1837–1926). *Grand Canyon*, 1912. Oil on pressboard, 15⅞ × 23⅞ inches.

Moran was part of a group of artists sometimes called the Rocky Mountain School who painted Western landscapes. He attempted to capture the grandeur and document the extraordinary terrain and natural features of the Yellowstone region. His paintings contributed to the United States Congress establishing the National Park System in 1916. These romantic paintings were powerful tools in preserving the natural wonders of the United States.

Nineteenth century-photographers found transcendence in the vastness of the American West and celebrated its grandeur with references to ideas of time and space and how both humans and nature mark the landscape. Timothy O'Sullivan and William Henry Jackson photographed for U.S. Geological Surveys during the westward expansion in the 1860s and 1870s. Despite the difficulties of preparing, exposing, developing, fixing, washing, and drying a single photographic image that could take hours to make, along with the weight of heavy glass plates and darkroom equipment carried by mules through untracked Rocky Mountain landscapes, William Henry Jackson returned to the East Coast with spectacular images, photographic evidence, of Western landmarks that had previously been only rumor. Because photographs had "believability," the evidence of fact that

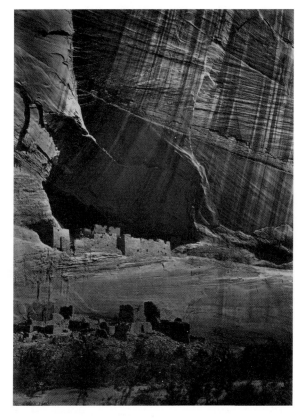

Figure 4.2 Timothy O'Sullivan, American (b. Ireland, 1842–1882). *Ancient Ruins in the Cañon de Chelle, New Mexico Territory,* 1873. Albumen print, 10½ × 7⅞ inches.

paintings didn't have, Jackson's photographs of Yellowstone helped convince the United States Congress to declare the first National Park in 1872.

Timothy O'Sullivan was the official photographer on the U.S. Geological Exploration of the 40th Parallel from 1867 to 1869. His job was to photograph the West and attract settlers. O'Sullivan's photographs were images of nature as untamed and unindustrialized without the use of romantic landscape painting conventions. He combined science and art to make exact records of extraordinary beauty. Photography had scientific believability in the nineteenth century, being seen as showing the "truth" (a view that today has come into question), while painting was viewed as romantic.

Points of View

What could influence the way we think of the Grand Canyon? Consider British anthropologist Frederick Turner's secular point of view about nature. He wondered what our experience would be if we found out the Grand Canyon was human-made. What if we learned it was formed by agricultural or industrial erosion or the results of poor farming methods? What if the Grand Canyon were artificial badlands? Would it still be a national park? Turner wondered if anyone would visit it other than groups of schoolchildren studying environmental destruction, absorbing the dreadful lesson of what happens to an environment raped by human exploiters. Would these schoolchildren learn that strip mining could produce spectacular and dramatic landscapes?

British poet W.H. Auden loved the lead mining landscapes of Cornwall in England. He loved the hillsides of the Mediterranean, too, with their olives, sages, thyme, and conifers, even though they are a result of centuries of deforestation, goat herding, and the construction of roads and cities. Could the hillsides of the Mediterranean that Auden so loved be seen as less beautiful in light of their origins in human exploitation?

If beauty is a judgment of the appearance of things, could the Grand Canyon appear as a "hideous scar on the fair face of the earth" to someone? Could a man-made Grand Canyon be as beautiful and as inspiring as the original? What about reconstructed Pyramids or human-made beaches (Biloxi, MS) or lakes (Lake of the Ozarks, MO)?

Recreating Beauty

Contemporary British artist David Hockney created 60 paintings of different views of the Grand Canyon and installed them in a gallery at the Royal Academy of Art in London for the Summer Exhibition in 1998. There was a platform in the middle of the gallery for viewers to climb up on and look into life-size mirrors reflecting the paintings all around the room, engulfing the viewer in a richly colorful and abstracted Grand Canyon. These reflections encompassed viewers in a very different kind of beauty and awe than the one of standing on the rim of the Grand Canyon looking into it.

Few major artists have chosen to take on the challenge of the Grand Canyon because it is notoriously difficult, partially owing to its vast scale. In the nineteenth century the Grand Canyon was considered a place of terror and later it came to represent the great majesty and heroism of the westward expansion. Over time, the extraordinary site of the Grand Canyon came to symbolize different values and ideas for different generations.

While the pedigree of Hockney's *A Bigger Grand Canyon* is within the European romantic landscape tradition, the experience of being in the landscape and the sense of the universal imbue the painting with levels of meaning. It suggests a landscape of almost unimaginable, or ineffable, space and color. Brilliance of color and vastness of space characterize a world of dreams for Hockney, who grew up in industrialized North England and frequented the cinema. He was fascinated by the big-screen scale and intensity of colors. Vast space is the principal subject of *A Bigger Grand Canyon*. Emotionally loaded in its color and scale, the painting extends the boundaries of the landscape genre and moves beyond beauty toward an art movement called Expressionism, explored in Chapter 5.

Artistic Point of View

David Hockney thought the challenge and the thrill of the Grand Canyon was spatial. "It is the biggest space you can look out over that has an edge." His solution to this problem of translating three-dimensional spatial experience into a two-dimensional image was to make a series of photographs, with their multiple vanishing points, and place them together as a collage. He made a photo collage of the Grand Canyon in 1982. It was one of several photo collages he made at the time and it turned out to be a crucial step in creating *A Bigger Grand Canyon*.

For Hockney, the problem with photography was that the composition was a single point of view and could not adequately deal with the subject at hand. His decision to make photo collages of the Grand Canyon is akin to the Cubist ideas of placing two pieces of an object together and creating space: for instance, painting a frontal view of a face for a portrait directly on top of a side view of the same face. The result may be a nose growing out of an ear, but it also creates a sense of three-dimensional space. Hockney thought his photographs were pieces of time. When he placed them together in a photo collage he thought he was also creating space. From these experiments he came to think of time and space as the same thing. This is

both a scientific and a creative concept explored in a variety of ways by artists and scientists. In 1986 Hockney revisited his earlier photo collages of the Grand Canyon and produced a large-scale photo collage with 60 photographs called *Grand Canyon with Ledge, Arizona, 1982, Collage #2*. This photo collage was a major influence for the painting that would come to fruition more than a decade later.

Hockney had been thinking about making a large landscape of the West. He was contemplating vast spaces and used that motivation to paint the Grand Canyon. First he made two studies, one of nine canvases and the other of 15. He studied these canvases along with the two related photo collages. In 1998 these became the basis for what finally ended up as the 60 canvases titled *A Bigger Grand Canyon*. The subject, according to the Hockney, is "Looking at the Grand Canyon," not just "the Grand Canyon."

Hockney's point of view differed greatly from the poet Auden and naturalist Turner. Hockney said that *A Bigger Grand Canyon* is about the depiction of space and the experience of being within a space. He drew from his personal knowledge and experiences. He used aspects of Cubism in which a subject is depicted with multiple viewpoints and aspects of Chinese scroll painting in which different time sequences, different elements of a landscape, form an apparent whole. He learned significant lessons driving his car through vast landscapes in the West and personally experiencing the Grand Canyon. Hockney's point of view was about the experience of time and space.

A Bigger Grand Canyon is work with several viewpoints and points in time. Hockney wove together what he saw with what he imagined. The painting is supposed to be like being in the landscape, traveling around in it, and viewing details of its beauty – its dramatic vistas and changing light. The Grand Canyon is beautiful, specific, and different from any other place on earth. It is a challenging subject, especially for an artist obsessed with space and time and questions about how people perceive it and how to depict it.

A Bigger Grand Canyon and the Sublime

This beauty and greatness is often used when referring to nature and its vastness, connecting Hockney's ideas embodied in *A Bigger Grand Canyon* to the sublime. *A Bigger Grand Canyon* includes elements of the English Romantic artistic tradition of landscape painting (John Constable) that has been important to Hockney since the beginning of his professional career and the emotionally charged European Symbolist (William Blake)

landscapes with ideas of the universal and the symbolic. It also includes Hockney's personal experience, empathy, spontaneity, and magical feelings aroused by the beauty of the Grand Canyon.

Hypocritical Beauty

Pope Benedict XVI warned more than 250 artists (painters, sculptors, architects, writers, dancers, musicians, actors, and directors), gathered amid the frescoed beauty of the Sistine Chapel in the Vatican on November 21, 2009, to guard against "seductive but hypocritical" beauty that creates "indecency, transgression or gratuitous provocation." He urged artists to inject spirituality into their work, saying contemporary beauty was often "illusory and deceitful." "Beauty ... can become a path toward the transcendent, toward the ultimate Mystery, toward God."

That day's event marked both the 10th anniversary of Pope John Paul II's *Letter to Artists* in 1999, which spoke of the Church's "need for art," and the 45th anniversary of Pope Paul VI's meeting with artists in 1964. Benedict lamented the once-close cooperation between the Church and the artistic community. The Pope said he wanted to "renew the Church's friendship with the world of art." In a sign of efforts at reconciliation, the Vatican said it plans to participate in the 2011 Venice Biennale, one of the world's major art festivals held every two years.

5

Expression and Aesthetic Experience

Of all the concepts that dominate traditional aesthetics, like beauty and representation, expressionism and aesthetic experience is probably the most complex and difficult to understand. This text does not explain expression and aesthetic experience in depth, but it does present a framework for further thinking. Expressive philosophy refers to the question of why art is created and why so many people think expression answers that question. When people are asked what they think art is, they usually say something like art is the expression of the artist's imagination, feelings, or ideas. For instance:

Expressive Definitions of Art
(Developed by University Students)

Art is the creation and expression of an artist's feelings, thoughts or ideas.

Art is a feeling that artists have inside them and they have to get out.

Art is expression – a way to show who we are and what we believe.

Art is an attitude expressed through objects or experiences.

Art expresses feelings in a way that is pleasant to the eye.

Art is composed of 80 percent feelings and 20 percent materials.

Art expresses human feelings, beliefs, or ideas.

Art is an experience.

Ideas About Art, First Edition. Kathleen K. Desmond.
© 2011 Kathleen K. Desmond. Published 2011 by Blackwell Publishing Ltd.

Although expression of emotion is quite familiar, it is actually a rather difficult phenomenon to conceptualize when applied to artworks. This partly explains the reluctance of some philosophers to address expressive theories of art. To some philosophers, expressive theories seem like attempts to explain something incomprehensible with the inexplicable. To some thinkers, expression of emotion seems too simple a phenomenon to account for the subtleties and sophistication of art. To others, expression of emotion seems far too complex, too obscure, and unfamiliar to provide a satisfactory explanation of art. The difficulty of understanding expression explains why expressive theorists do not agree even among themselves about the nature of artistic expression.

Some art critics and philosophers think various artworks are created through a process of artists' expressing their emotions. Expressive theories in art and philosophy attempt to explain expressive objects, the process of expression, and statements about expression and the artist. Some expressive theories follow.

Expressive Theories

Expressive ideas about art have been an element of aesthetics since Aristotle argued that one of the most important functions of art was to evoke emotions in its audience. Several kinds of expressive theories contribute to this philosophical dialogue. One theory promotes the idea that art communicates or evokes emotions in its audience. The theories of the nineteenth-century Russian writer and thinker Leo Tolstoy are a good example. Another expressive theory supports the concept that works of art are symbolic representations but not necessarily personal expressions or emotions. Twentieth-century American philosopher Susanne Langer's theory of art – art is the creation of forms symbolic of human feeling – helps explain this. Several philosophers support theories of art as the self-expression of the artist, emphasizing the imagination of the artist as the source of originality and creativity and, further, that the essential characteristics of art are personal and unique, brought about by the imaginative expressiveness of the artist.

Central to expressive theories of art are ideas that the important elements in art are what is expressed rather than what is represented. Artists express their emotions, thoughts, and ideas. Artists are innovators. Artists do not copy nature. Artists transform what they see and feel and imagine. The essential characteristic of art is its expressiveness. A good work of art is a unique expression of the artist's point of view.

The Apollonian and the Dionysian

Nineteenth-century German philosopher Friedrich Nietzsche was an advocate of expressionism. He studied previously neglected ancient Greek art and developed a theory based on the ancient dualism between two types of visual experience, which he termed the Apollonian and the Dionysian. In Greek mythology Apollo is the god of the sun, lightness, music, and poetry and Dionysus is the god of wine, ecstasy, and intoxication. According to Nietzsche, this dualism was between a world of the mind, order, regularity, and refinement and a world of intoxication, chaos, and ecstasy. For Nietzsche, the Apollonian represented an ordered ideal and the Dionysian represented individual artistic concepts derived from the human subconscious. He considered the fundamental characteristics of expressionism to be based on intense emotions rather than on rational thought.

The Apollonian and Dionysian is a philosophical and a literary concept. It is a dichotomy based on features of ancient Greek mythology. Several Western philosophical and literary figures have used this dichotomy in critical and creative works, including philosopher Plutarch, psychologist Carl Jung, singer Jim Morrison, and writers Ayn Rand and Stephen King. In contemporary literary usage, the contrast between Apollo and Dionysus symbolizes principles of wholeness versus individualism or civilization versus nature.

Name artworks, movies, performances, plays, books, or stories that use the concepts of the Apollonian and the Dionysian. Here are some descriptors of the Apollonian to support process: order, individuation, beauty, clarity, individuality, celebration of appearance, self-control, perfection, creativity, creation, the rational/logical and the reasonable. Descriptors of Dionysus (Dionysian) include: chaos, intoxication, celebration of nature, instinctual, intuitive, sensations of pleasure or pain, wholeness of existence, dissolution of boundaries, excess, glorification of art, destruction, the irrational and non-logical. Use this list of words and ideas and your own list of movies, performances, plays, and books to support your own ideas about art.

Art Evokes/Communicates Emotion

Some philosophers defined art simply as the expression of emotion while others, like Leo Tolstoy, formulated a moral interpretation of expressive art. Both notions maintained that art is the "language" of emotions. Tolstoy

thought art was the communication of emotion. He appreciated the power of art to mold human character. His writings were inspiring statements about his view that the value of art lies in its social usefulness. Others, such as Marxists, insisted on art as social utility, but there was no greater sincerity or passion than Tolstoy's in recognizing the value of art as a vehicle of emotional communication. Tolstoy thought there was no definition of beauty. He thought art makes beauty manifest and beauty pleases.

Georg Wilhelm Friedrich Hegel, a nineteenth-century German philosopher, argued that the central task of art was the expression of the spirit and the highest values held in common by a nation or people. Hegel considered art a cultural expression, with a shared sense of the most significant values having clear advantages. It enabled us to see collectively produced, culturally central works of art as expressive objects without having to specify any individual whose particular emotions or attitudes such works expressed.

Arthur Danto provided a theory of expression in his *The Transfiguration of the Commonplace* (1981). He argued that works of art, like language, had "aboutness" in that they present content. Danto said artworks contrast with real things similar to the way words do. Art differs from reality like language does when language is descriptive (i.e. when it is about something). This is not to say that art *is* a language, but only that the very nature of art is analogous to language. A contrast exists between art and reality and between reality and discourse.

Symbolic Emotion

Susanne Langer was one of the few philosophers who tackled issues of expressiveness and aesthetic experience. She thought the fundamental principles in every kind of art were few and that expressiveness, one of the principles of creation, is the same in all artworks of any kind. Langer argued that a work of art is an expressive form created for human "perception through sense or imagination, and what it expresses is human feeling" (Langer 1957: 169). She used "feeling" in the broadest sense, ranging from physical sensation, pain and comfort, excitement and peacefulness, to the most complex emotions, intellectual tensions, or feelings of a conscious human life. She thought form, expression, and creation kept human beings engaged.

What artists express, Langer said, were not their own personal feelings, but what they knew about human feelings. The artist is in possession of rich symbolism and a knowledge that exceeds personal feelings and experience.

A work of art can express ideas of life, emotion, and inward reality. Expressiveness in art "is neither a confessional nor a frozen tantrum; it is a metaphor, a non-discursive symbol that articulates what is verbally ineffable – the logic of consciousness itself" (Langer 1957: 175).

Self-Expressive Theories

Self-expressive theories of art suppose that the creative mind is the source of aesthetic activity. Eighteenth-century German philosopher Immanuel Kant was one of the most influential thinkers on this point of view. Kant claimed that the mind played an essential role in cognitive and creative experiences, that the self is not part of its experiences, and that there are subjective sources of knowledge: sense, imagination, and apperception. Sense provides the data for our experiences; imagination is a cognitive process of experiencing; and apperception accompanies and unifies experiences.

Nineteenth-century English poet and philosopher Samuel Taylor Coleridge extended Kant's theory of imagination and wrote about his own concept of "Organic Form," which translated into the important twentieth-century notion of organic unity. Twentieth-century formalists adopted organic unity as a criterion for great art, most notably British aesthetician Harold Osborne, who wrote an essay titled "Organic Unity." Probably one of the best examples of a modern expressive theory of art is that of British philosopher and art critic R. G. Collingwood, who wrote *The Principles of Art* in 1938.

Collingwood thought expression in art resulted from an artist and the viewer jointly coming to "know" certain psychological states. Expression is the achievement of clarity and of focus of mind that can intensify what is felt. Art is fundamentally expression, Collingwood thought, and he further reflected that a theory of the phenomenon of expression was needed to show it as an essential part of the life of the mind. Collingwood stressed the difference between passive responses to a reputed aesthetic quality and active engagement on the part of an audience. This active engagement has been extremely influential to art, artists, and education in the twenty-first century.

Clive Bell, another twentieth-century British art critic and philosopher, defended abstract art with his theory that focused on aesthetic emotion (not the same as aesthetic experience). He claimed in his 1914 book *Art* that

there were certain unique aesthetic qualities in an art object that evoked this aesthetic emotion. What aroused aesthetic emotion were "forms and relations of forms" that Bell called "significant form."

Aesthetic response (aesthetic emotion) to significant form is not the same as other emotional responses, according to Bell. For example, a photograph of a loved one might evoke fond memories and feelings, and while these are all perfectly appropriate responses, they are not aesthetic responses. The aesthetic response is a response to the forms and relations of forms themselves, regardless of other meanings they may have. It is a strong emotion, often a kind of ecstasy, akin to the ecstasy felt in religious contemplation. It is easy to see how Bell's aesthetic would enable him to defend abstract art. For him, the aesthetic value of a painting or sculpture had absolutely nothing to do with its success as a representation of something else and everything to do with the elements of line, shape, and color that evoked aesthetic emotion.

Philosophers like Collingwood, Bell, and Langer tried to explain as best they could exactly how it is that art can be expressive. But to many twentieth-century philosophers, especially those working in analytic styles, philosophical discussions of expression in art were puzzling. Nelson Goodman thought that some philosophers regarded expression as either sacred or obscure.

Soul-Shaking Wonder and Joy

The now "classic" 1999 movie *American Beauty* had as one of its themes the goal of getting the audience to "look closer." You may remember Ricky, who engaged in a lot of looking and thinking and feeling. He saw beauty in everything around him, even in the seemingly trivial details of everyday life. He captured as much of it as he could with his camera. He showed the audience what he considered the most beautiful thing he had ever seen: a plastic bag tossing in the wind in front of a wall. The piece went on for what seemed like a long time; the plastic bag floating up and down and around. He said that sometimes there was so much beauty in the world he felt he couldn't take it; he thought his heart was going to cave in. Ricky experienced an awe and splendor in today's world. He had an epiphany that infused him with soul-shaking wonder and joy. Ricky had an aesthetic experience, and if you were engaged in that movie, you may have had one, too.

Aesthetic Experience

Aesthetic experience is another of those elusive concepts that make many philosophers reticent. Aesthetic experience is difficult to isolate from the vast array of other kinds of experience partly because those who write about it have written such different things about it and compounded the confusion with vagueness and obscurity. Some say aesthetic experience is the amplification and intensification of sensuous awareness and that it consists of a complete focus on and attention to the object presented to the senses. Others think aesthetic experience refers to the psychological aspects of our association with an object we take to be an aesthetic object. Some use the term "aesthetic experience" to refer to the psychological phenomenon of a specific, recognizable, and special variety of thrills and tingles we prize for their own sake.

An aesthetic experience can result when several factors come together. The experience is pleasant. It is a heightened sensation, an overall positive feeling, a psychological state changed for the better. Sometimes we don't know why we have an aesthetic experience; it just happens. It is an irrational feeling, one that is nearly unexplainable or ineffable.

Ineffable is a word generally used to describe a feeling, concept, or aspect of existence that is too great to be adequately described in words, or that owing to its nature cannot be conveyed in language. Ineffable means that something cannot be expressed in spoken words. "Whereof one cannot speak, thereof one must be silent," said twentieth-century philosopher Ludwig Wittgenstein (1922: 189).

Twentieth-century American philosopher Virgil Aldrich thought that aesthetic experience begins with a trained and sometimes highly refined ability to see several facets of things. Another twentieth-century American philosopher, Monroe Beardsley, suggested that the key to aesthetic experience is the way we tie mental activity to the form and qualities of certain objects to render that activity unified, intense, complete, and pleasurable. One thing many contemporary writers have sought to explain is the cherished phenomenon of aesthetic experience as richly diverse rather than narrowly centered on a criterion of taste or a few fixed aspects of aesthetic attitude. Aesthetic experience remains a topic of lively and continuous debate.

One thing is for sure. There is all the difference in the world between what happens when we take in a beautiful landscape, like the Grand Canyon, thinking about meteorology or geology or the environment, and quite another when we simply savor the shadows, angles, and texture, the amazing

transformation in colors as the light changes from morning to evening to night and daybreak. Even though our pleasure in this experience may be different in various respects and even change from one moment to the next, there is a familiar, undeniable satisfaction that, upon reflection, stands apart from all other experiences. It is an experience we prize in a way all its own. As awesome as this aesthetic experience is, it is the root of endless controversies about how to account for it.

Strengths and Weaknesses of Expressive Theories

Expressionism is based on an obvious truism that art is about human feelings, that works of art typically engage emotions, and expressive art evokes emotions. While imitation theories account for art in terms of the external, objective world imitated in works of art, expressive theories direct attention to the inner, subjective world of human emotions and sentiments. Expressionism in art is a means of evoking and communicating unique, individual, and cultural emotions of the artist and their community.

The strengths of expressive theories of art lie in their commitment to the communication of the artist's or their community's feelings and emotions to others and their benchmark assertion that good art depends on successful communication to the viewer, who will be similarly affected by the same emotions or feelings. Proponents of expressive theories like twentieth-century Italian philosopher Benedetto Croce, Leo Tolstoy, R. G. Collingwood, and Susanne Langer emphasized that art can express not only emotions, but also ideas.

Weaknesses of expressive theories were noted by contemporary American philosopher Cynthia Freeland in her book *But Is It Art?* (2001). Expressive theories work well for Abstract Expressionism, she observed, but less well for other kinds of art, because they restrict artists to the expression of feelings and emotions.

Expressionism in Art

Expressionism is a term used to describe art that evokes highly emotional effects. Expressionism is exhibited in painting, literature, film, architecture, and music and is sometimes characterized by symbolic colors, distorted forms, and larger-than-life sound or imagery. Expressionism aims to reflect heightened human emotion rather than represent the external world. Perhaps the most balanced view of the place of expression in art came from

the nineteenth-century French artist Paul Cézanne, who was a man of few words about art but who certainly believed in the importance of expressing emotion in his artwork. He wrote that the necessary basis for all concepts of art rests on expressing emotion.

The shift in emphasis from imitation theories of art (representation) to expression and communication theories was one of the consequences of nineteenth-century Romanticism. Expressive theories claim that the function of art is to express the gamut of human emotions, even the sad and terrible, and that ugliness may be created for its own expressiveness, not merely as a foil to beauty. Romanticism was an attitude adopted by artists, poets, and musicians in response to the cold and scientific Neo-Classicism prevailing in the late eighteenth century and it was fueled by the turmoil of the American, French, and Industrial Revolutions, which changed culture, society, attitudes, ideas, and art. As this attitude moved through the nineteenth and into the twentieth century, imagination, passion, and expression (Romanticism) took on an importance that led into expressionism in art.

Expressionism became an overarching trend in art during the nineteenth and twentieth centuries in Europe and the United States, with qualities of highly subjective, personal, spontaneous self-expression, typical of a wide range of artists and art movements. With roots in Germany and Austria, the German Expressionist movement emerged around 1900 with a style called "Les Fauves" (French for "The Wild Beasts"), a short-lived and loose grouping of early twentieth-century Modern artists whose works emphasized painterly qualities of bright color rather than representational color. Fauve expressionist artists worked for the highest expressive intensity, from an aesthetic point of view.

There were many famed German Expressionist artists, like Max Beckmann, Otto Dix, Lyonel Feininger, and George Grosz, along with Austrian Oskar Kokoschka and Norwegian Edvard Munch, who were also related to the Expressionist movement. Artists Ernst Ludwig Kirchner and Emil Nolde added more sinister elements of the human state of mind to the German Expressionist repertoire. During his stay in Germany, Russian artist Wassily Kandinsky became an "Expressionism addict."

Expressive Qualities in Works of Art

Wassily Kandinsky was one of the first creators of abstract paintings. He participated in the Fauve movement and was a founder of "Der Blaue Reiter" (The Blue Rider) movement, which was interested in medieval and vernacular art as well as the movements of the time, Fauvism and Cubism.

Der Blaue Reiter group, specifically Kandinsky's work and his book *Concerning the Spiritual in Art* (1911), advocated the view that every person had an inner and an external reality of experience that were united by art.

Kandinsky's painted forms evolved from fluid and organic to geometric and, finally, pictographic. Kandinsky was an accomplished musician and once said, in effect, color is the keyboard, the eyes are the harmonies, and the soul is the piano, with many strings. Kandinsky thought artists were the hands that played, touching one key or another and causing vibrations in the soul. Kandinsky used color in a highly theoretical way, associating tone with timbre (the sound's character), hue with pitch, and saturation with the volume of sound. He even claimed that when he saw color he heard music.

Abstract Expressionism

Abstract Expressionism in the mid-twentieth century emphasized the depiction of emotions rather than objects. Painters favored large canvases, dramatic colors, and loose brushwork. Although Abstract Expressionism encompassed an array of stylistic approaches, several unifying themes were present in the movement. Abstract Expressionist paintings consisted of shapes, lines, and forms meant to create a separate reality from the visual world. Abstract Expressionist painters paid attention to surface quality and texture and used large canvases. They emphasized accident and chance in their work. Mistakes that did occur during the painting process were used to the artist's advantage. Artist's called attention to the physicality of paint and the potential for expression in abstraction.

Abstract Expressionists gave emphasis to painting as a pure expression of emotion and means of visual communication. The act of painting is considered as important as the finished product itself. The philosophy of Abstract Expressionism addressed personal psychological battles, the external struggle between humans and nature, and the hunt for spirituality. All of these concepts were expressed through abstraction, finding meaning in relating the act of painting with a release of subconscious feelings and desires. Abstract Expressionism included action painting, epitomized by Jackson Pollock, emphasizing paint texture and movement, and color field painting, exemplified by Mark Rothko, who was concerned with floating forms and color emphasizing a spiritual quest.

The title of Rothko's book *The Artist's Reality: Philosophies of Art* (2004) is self-explanatory, and, along with Wassily Kandinsky's *Concerning the*

Spiritual in Art (1911), it is important to an understanding of artists' philosophical views of expressionism. In their respective chapters Kandinsky addressed "The Language of Form and Color," "Theory," and "Art and Artists," while Rothko explored "Art as a Form of Action," "Art, Reality and Sensuality," and "The Artist's Dilemma."

Expressionism Today

Expressionism had a major impact on Western art. Abstract Expressionism had a profound impact on American art, allowing New York to replace Paris as the center of the artworld. Abstract Expressionism was prominent until the development of Pop Art in the 1960s, which some claim was the end of Modern art and the beginning of Postmodernism.

6

Art and Ethics
Morals and Religion

Bodies Revealed

Bodies Revealed is an exhibition that displays actual human body parts – 250 dead bodies, limbs, and other organs. Controversy about the exhibition stems from questions about where the bodies came from and the moral issues about displaying "real" human bodies rather than models of human bodies. The exhibit's medical director, Dr. Roy Glover, of Premiere Exhibitions, said the bodies came from people in China who had agreed to donate their bodies to medical schools before dying of natural causes. The preservation process involves infusing the bodies with silicone. "When we remove the skin and we look at the body, we're really looking in a mirror. We're looking at ourselves," said Dr. Glover. "We learn more about the body we live in."

Educational or Disrespectful?
(Edited from a Blog Posted February 18, 2008)

The first time I saw one of the bodies in *Bodies Revealed* I was amazed. I thought about how 3D printers were just making awesome things today. Pretty much anything can be made in 3D. CAD software can be reproduced in plastic. A friend actually works for a company that sells

and installs this technology. But I was wrong. The bodies in *Bodies Revealed* are actually real human bodies.

When I heard the exhibit was coming to my city, I was not very happy. I do not believe that science needs to be displayed in a freak show manner, especially since technology can reproduce life-like materials that are being used every day to train doctors. Gone are the days when you could only learn anatomy by dissecting cadavers.

Someone I know saw the exhibit and argued the point that it was interesting. He ignored completely my argument that computer 3D models were just as accurate and that displaying bodies like art was somewhat obscene. He even thought my wife would see it more from the scientific side of things because she is a biologist. So I asked her.

She completely agreed with me that it was creepy and disrespectful. She told me how some Catholic universities have Mass at the beginning of a semester for the people who donated their bodies to science. I have even considered donating my body for science. When I depart from this earth I would be glad that my organs could save someone's life. I want to donate bone marrow in the future and I have donated blood so many times I even got a t-shirt.

However, I cannot condone the display of human bodies as a spectacle. I do not see any scientific or artistic merit in this morbid display. I am not sufficiently satisfied that the company produced accurate documentation of the body donations. I call on everyone to just skip this exhibit all together. There are plenty of other exhibitions that can bring more than potentially unwilling human beings displayed as art. Even the willing people who donated their body for science probably did not know they were about to be displayed as if they were part of some sick freak sideshow. Let's boycott this event.

Moral Decomposition

It was reported by Reuters in March 2009 that Venezuelan President Hugo Chávez cited *Bodies Revealed*, which had sparked controversy elsewhere, as evidence of the world's moral decomposition. "We are in the midst of something macabre," Chávez said on his weekly TV show. "They are human bodies. Human bodies! ... This is a really clear sign of the huge moral decomposition that is hitting our planet."

Chávez ordered the closure of the exhibition in the country's capital, Caracas, and authorities confiscated the bodies from the show. His tax agency also said it was investigating whether the bodies had been illegally declared in customs as made of plastic.

Consider the Arguments

Much has been said about the exhibition of real human bodies. Exhibitions such as *Bodies Revealed* and *Body Worlds*, discussed below, that display cadavers using special techniques to dry out and then preserve them have set off debate about the scientific or artistic value of the exhibits. There are also controversies over the origin of the bodies and whether people gave permission for their cadavers to be used in such a way. These issues generate interdisciplinary discussions in and between science, politics, art, humanities, philosophy, psychology, sociology, and religious circles. These debates allow us to examine our own ideas and beliefs, consider others' ideas, and make up our own minds with added reasoned strength in support of our positions.

Philosophy to the Rescue

Philosophy can provide a framework for thinking critically and supporting positions on a variety of issues. Philosophical categories are organized by the kinds of questions they address. Of the three main branches of philosophy, axiology (also called value theories), epistemology, and ontology (sometimes called metaphysics), which one could help answer these questions and support positions? These are not mutually exclusive categories and they cannot be rigidly maintained; they overlap.

While axiology is the study of values, epistemology is the study of the nature of values and value judgments. It is the investigation of values, criteria, and metaphysical status. Value studies include the nature of value, the value of desire, pleasure, preference, behavioral dispositions, and human interests. Ethics, aesthetics, religion, and politics are all value theories that ask questions like: How are values applied? Subjectively? Objectively? Scientifically?

A subdivision of axiology is aesthetics: the study of value in the arts and inquiry into the senses, emotions, taste, and standards of beauty. Aesthetics asks questions like: Is art an intellectual or an emotional activity? Is artistic value objective? Are there standards of beauty or taste or expressiveness?

Ethics is also a value theory. It is the study of values in human behavior, or the study of moral problems like the rightness or wrongness of actions, or the kinds of things that are good or desirable and whether actions are blameworthy or praiseworthy.

While axiology is the study of values, epistemology is the study of the nature, scope, and limits of human knowledge. Epistemology investigates the origin, structure, methods, and integrity of knowledge. Ontology or metaphysics is the study of what is real and attempts to establish relationships between categories of the types of "real." What kinds of things exist? How is existence possible?

Questions of identity are ontological questions. Many contemporary artworks address ontological issues of identity, as do cultural studies and visual culture. Are you the same person today as you were yesterday? How does your culture define you? Or does it define you? How does your gender define you, or how does society define you because of your gender? How do ideas exist if they have no physical form? What are space and time? What is spirit, soul, or matter? Epistemological and value theories overlap, requiring us to consider our positions by using all the philosophy we can muster.

Ethics

Like aesthetics, ethics is a value system studied and discussed by philosophers. Ethical values are thought of as moral principles that control or influence human behavior. The field of ethics (sometimes called moral philosophy) involves organizing, defending, and supporting concepts of right and wrong behavior. Philosophers today usually divide ethical theories into three general areas: meta-ethics, normative ethics, and applied ethics.

Meta-ethics is the most abstract area of moral philosophy. It deals with questions about the nature of morality, about what morality is and what moral language means. Meta-ethics investigates where ethical principles come from and what they mean. Are they social inventions? Are they expressions of our individual emotions? Is there some higher power moral code? Meta-ethical answers to these questions focus on the issues of universal truths, the will of God, the role of reason in ethical judgments, and the meaning of ethical terms themselves, like moral relativism.

Normative ethics is concerned with providing a moral framework that can be used to work out behaviors or decisions that are good and bad or right and wrong. Normative ethics takes on the practical task of coming to moral standards that regulate right and wrong conduct. This may involve

articulating the good habits that we should acquire, the duties that we should follow, or the consequences of our behavior on others.

Applied ethics seek to apply normative ethical theories to specific cases so we can tell what is right and what is wrong. It examines specific controversial issues such as abortion, capital punishment, euthanasia, animal rights, environmental concerns, war, and nuclear weapons. It is the most practical area of moral philosophy.

The lines of distinction among meta-ethics, normative ethics, and applied ethics are often unclear. For example, the issue of abortion is an applied ethical topic since it involves a specific type of controversial behavior, but it also depends on normative principles such as the right of self-rule and the right to life, determinants for the morality of that procedure. The issue also rests on meta-ethical issues such as "Where do rights come from?" and "What kind of beings have rights?" By using the conceptual tools of meta-ethics and normative ethics, discussions in applied ethics attempt to resolve controversial issues.

Thinking philosophically is a refusal to take traditional answers for granted, thought the Greeks. Some Greek thinkers thought the gods of the Greeks were not good moral role models. Since there were no "Ten Commandments" in Greek mythology, and most Greek intellectuals did not take religion seriously, ethics had to be found outside of religion – thus the study of ethics.

Art and Religion

Good and moral behavior is a foundation for religions. Christians would say their ethical beliefs and behaviors are based on the Ten Commandments because six of the Ten Commandments are ethical values. Buddhists follow the Eight Fold Path to guide their "right" behaviors. Some people live by the "Golden Rule." They treat others as they wish others would treat them. The Golden Rule has a long track record and is found in many religions worldwide. It provides a sensible way of getting along in the world.

We have a sense of what is right or wrong, good or bad from our experience and knowledge. As two sources of such experience and knowledge, art and religion are thus closely linked. There are acceptable and unacceptable behaviors in every social group, and although ethical values vary from culture to culture, some moral values, like respecting others and not harming others, are supported by many societies.

Ethical values in a society affect the aesthetic values of artworks viewed by that society. Some people think ethics are inextricable from aesthetics.

Art can show the spiritual and religious values of whole societies before they were literate. Images were understandable when written words were not. For example, stained-glass windows of biblical stories in European cathedrals taught illiterate Christians about their faith. Because art affects human behavior, some societies censor art they deem bad or poor models of human behavior. Plato, an essentialist philosopher, supported censorship of anything that did not contribute to good and moral citizens. (See also Chapter 7 on censorship.)

Essentialism in ethics, like aesthetics, claims that a single set of characteristics defines it. Essentialist ethics deems wrong as an absolute. For example, murder is always wrong; it breaks a universal, objective, and natural moral law and is not extrinsic, socially or ethically constructed.

Returning Human Remains

While a story like this could be the basis for a mystery novel by Tony Hillerman, this real headline appeared in the *Kansas City Star* in 2007: "Smithsonian Will Return Skeletal Remains to Tribe" (Blumenthal 2007) The skeletal remains of six members of the Nisqually tribe had been stored in wooden boxes in the Smithsonian Institution's National Museum of Natural History. No one knew their names. No one knew the stories of their lives. Some of these remains were donated to the Smithsonian 152 years ago after a naturalist working with the Pacific Railroad surveys found them. After a federal law in 1989 was enacted, the Smithsonian "repatriated" (offered to return) nearly one-third of the 18,000 sets of skeletal remains of American Indians. "While it would be unthinkable now, the remains were donated to the Smithsonian at a time when naturalists were exploring the West, and the bodies of American Indians, along with thousands of other items, were collected and cataloged. Part of a naturalist's interest in the world involves collecting things," a representative of the Smithsonian said. "There was a lot of interest in the differences among people and among tribes."

Similarly, in November 2009, Sweden returned 22 skulls that had been looted from a native Hawaiian community hundreds of years ago. The ceremony in an antiquities museum was part of Sweden's efforts to return indigenous remains collected by scientists across the world in the seventeenth and eighteenth centuries.

Consider This

Human beings in all cultures develop rituals surrounding their dead. Why do we have such strong feelings about the remains of the dead? Are our feelings about the return of indigenous human remains to their places of origin similar to those regarding the exhumation of human remains in Guatemala described in Chapter 4? Are photographs of human remains immoral or unethical? What about human bodies that are preserved, enhanced, and displayed? Is that art, science, or history? Is it moral or ethical?

What do you think about grave robbing? Or how about displaying dead bodies that have been preserved in plastic? Or what about made-up, photographed, and computer-enhanced images of impossibly thin young women? What do you think about Michelangelo and Leonardo da Vinci studying dead bodies to further their knowledge of anatomy? Is it acceptable if these activities are for science? Is it acceptable if the purpose is to make art? Is it acceptable if it adds to overall human knowledge?

What about when human remains are collected and catalogued and stored in museums? Is it acceptable to remove the remains of people from sacred burial grounds? Is it acceptable to exhume human remains to make a point, to provide scientific evidence for a study, or to provide some essential medical knowledge?

Who owns human remains? Family? Tribe? Individual? Museum? Medical school? Should human remains become the property of a scientific laboratory or a museum so they can be studied? What should happen when studies are completed? Where should human remains remain? Are there laws about collecting and keeping human remains? Are laws universal or culture-specific? Are the remains of certain peoples, but not others, "cultural property"? Who is responsible for forming societal concepts about death and the treatment of human remains?

Who decides the standards for human behaviors? Is murder acceptable in some cultures or in certain situations but not in others? Can you think of situations when murder is acceptable? Or is murder wrong all the time in all places and in every situation? Is any human behavior universally wrong? These are all ethical questions. Take a moment and think about your position on some of these questions.

In several chapters in this text, the underlying questions are about priorities. Does one value take priority over another? Is ethics always more important than, say, politics? Or religion? Or aesthetics? All of the time? Some of the time? In certain situations but not in others? How do we decide?

Body Revealed Years Ago

With all the controversy surrounding the exhibit of dead bodies in *Bodies Revealed*, it is interesting to note that, for over 80 years, the Soviet and then the Russian people have lined up on Moscow's Red Square to view the embalmed body of the leader of the Socialist Revolution, Vladimir Ilyich Lenin. Lenin died on January 21, 1924 and his body has been on display ever since, with the exception of World War II and some maintenance downtime. While the author of this memory prompt had been to Moscow many times and visited the Kremlin and Red Square, he said he never "had any desire to stand in line for many hours for a brief moment with the famous stiff. There were plenty of schmucks willing to do it without me."

Body Worlds

The *Bodies Revealed* exhibition discussed above is different from *Body Worlds*, an exhibition created by Gunther von Hagens, a German scientist who displays corpses for educational purposes, "to help us to understand ourselves." *Body Worlds* has been called macabre and has also fascinated millions of people around the world. One academic cited Dante's *Inferno* in describing the *Body Worlds* exhibit as "dead body porn."

Professor Gunther von Hagens meticulously arranges preserved body parts in suspended animation using his own preservation technique called "plastination," a polymer chemical technique that replaces water in cells with plastic material. The process requires 1,500 hours of work and costs up to $45,000. The result is an odorless corpse that endures.

Some 25 corpses, along with 175 body parts, are displayed in an anatomical exhibition called *Body Worlds* or *Körperwelten*. Professor von Hagens explains that the exhibition provides "unique insights into the human body for a culture deprived of the public spectacle of anatomical theatres." It democratizes anatomy, he claims, helping us understand our bodies better and it may well have significant benefits in terms of public health. However, one British politician insisted, "What possible benefit can a normal person gain from looking at dead bodies?" (Jeffries 2002).

In the same article in London's *The Guardian* newspaper, von Hagens declared: "It is an honor to cause this controversy." The paper commented

that he was a dead ringer for the German artist Joseph Beuys in his black fedora, many-pocketed sleeveless jacket, and deep-socketed stare.

> Like Beuys, he is part shaman and part showman. He is an anatomical scientist bent on shaking up a western society that he regards as living in denial of its corporeality and of death, and a PT Barnum basking in the media hoopla aware that part of the appeal of *Body Worlds* is the same as that which drew our ancestors to public executions and freak shows.

"I don't mind if you're sensationalist in your article," he said to *The Guardian's* reporter. "More people will come if you are."

Von Hagens continued: "I want to bring the life back to anatomy. I am making the dead lifeful again. This exhibition is a place where the dead and the living mix." It is also a place where visitors sometimes faint or become very upset. To view a mutilated body is difficult. We have deep anxiety because we have feelings about ourselves, explains von Hagens. At the same time, "many people who have seen the exhibition have discovered a new respect for their bodies." One young woman said she had tried to commit suicide twice, but after seeing the bodies in the exhibition she would never think of harming herself again. Among the many people who have seen the exhibition, comments are included from singer Tina Turner ("Thank you for such an examination of the human body") and tennis players Steffi Graf ("I am now able to understand my body in a much better way!") and André Agassi ("What an incredible learning experience!").

Von Hagens sees himself on a global mission to end the elitism of the medical profession. He is aware of art history and the centuries when anatomists and artists explored the workings of the human body and made their workings public at anatomical theatres. The presentation of medical scholarship profoundly affected human understanding of the world and inspired artists like Leonardo da Vinci and Michelangelo. Dürer and Rembrandt were repeatedly drawn to the theme of groups huddled around a corpse, as in Rembrandt's 1632 painting *The Anatomy Lesson of Dr. Nicolaes Tulp*. Does von Hagens consider himself an artist like Rembrandt or da Vinci? "There are obviously aesthetic elements to what I am doing, but I am chiefly a scientist who wants to enlighten people by means of aesthetic shock rather than cruelty shock" (Jeffries 2002).

There is a visual flourish to von Hagens' plastinations that many artists would "die for," like contemporary British artists Damien Hirst, who made art of a shark in formaldehyde, *The Physical Impossibility of Death in the*

Mind of Someone Living (1991), and bisected cows and sheep, and Marc Quinn, who made a sculpture of his head, *Self* (1991), out of his own frozen blood. All of these works were exhibited in the *Sensation* show at London's Royal Academy in 1997.

Body Worlds includes a skinned male body crouched over a chessboard with his cranium split open to show his brain, seemingly contemplating a move that he will never make. *The Horseman* is a rider with his skull chopped in two and his body flayed to show the underlying musculature. He sits with his brain in one hand and a whip in the other, astride the posed and flayed cadaver of a horse, frozen forever in its leap. There is another figure chopped up and vertically expanded so that his body looks like a chest of drawers. There is the erect, flayed cadaver of a man holding his own skin aloft as though it was a precious trophy. The last part of the exhibition includes the bisected cadaver of an eight-months pregnant woman with her womb opened to reveal the fetus.

All the bodies von Hagens preserves have been donated, mostly by people who declared while living that they would like their bodies to be plastinated in order to advance human knowledge. Von Hagens now has a registry of 3,200 donors. "I know I will feel better this way rather than being eaten up and digested by worms," said one. "Of course I will be plastinated," said von Hagens. "I like idea that my human body will continue to teach" (Jeffries 2002). Like Joseph Beuys, the German artist who considered his teaching to be his art, von Hagens' own plastinated body will continue to teach after he dies.

Speaking of Bodies

Today's female models are painfully thin, sometimes to the point of being unhealthy. Society not only buys into this socially constructed body image, it supports it. Society supports unrealistic body images by buying the products advertised and by trying to look just like those models. Young girls foil their developing years by going on weight reduction diets when they are as young as 10 or 12 years old. Even while Americans are struggling with obesity, there is a whole segment of the population who are starving themselves to death in order to have an unrealistic body. Psychologists have their hands full counseling adolescents about body image and identity. Young graphic designers and artists ask themselves how ethics and morals figure

into advertising. It is not just a matter of ontology (What is real and what is not?), and about identity (Who am I?), it is a matter of ethics and overlapping value theories.

What kind of ethics can be employed in advertising? Are graphic designers' ethics personal? Situational? Static? Fixed? Graphic designers are responsible to many people and the commercial aspect of their work can confuse loyalties. Is it possible to arrive at an ethical code of practice for an activity like graphic design?

Ethics in Advertising

Like everyone else, designers find themselves in a web of duties: contractual duties, duties to the client, to colleagues, to themselves and their work and to society at large. Sometimes it's difficult to fulfill all duties well while at the same time fulfilling duties to society.

A code that commands "thou shalt" or "thou shalt not" is inflexible and doesn't fit real life very well because real life is complex and changeable. A strict list of rules would be very difficult to observe in practice. This is the problem with "top-down" ethics. The alternative is a "bottom-up" approach that rests on the individual being conscious of their involvement in society and the impact they have in it.

The 9/11 Attacks – A Work of Art?

Damien Hirst said the images of the burning Twin Towers in New York City on September 11, 2001 were "a kind of artwork." He believed the terrorists responsible for the September 11 attacks "need congratulating" because they achieved something "nobody would ever have thought possible" on an artistic level. "The thing about 9/11 is that it's kind of an artwork in its own right. It was wicked, but it was devised in this way for this kind of impact. It was devised visually." In the article in *The Guardian* (Allison 2002), Hirst described the image of the hijacked planes crashing into the Twin Towers as "visually

stunning." Referring to how the event changed perceptions, Hirst said, "I think our visual language has been changed by what happened on September 11: an aeroplane became a weapon. Our visual language is constantly changing in this way and I think as an artist you're constantly on the lookout for things like that."

These comments are shocking, on the one hand, and not surprising, on the other, given they were made by Damien Hirst, the star and promoter of the Young British Artists. Hirst has made a career of making controversial art. Is Damien Hirst right? Is it possible to appreciate the visual images of the attack on the Twin Towers from an aesthetic point of view divorced from the horror of the event? Should the terrorists who planned the attack be congratulated for changing our perception? Are the images of the attacks works of art?

Other Ethical Issues

Finally, the age-old dilemma of whether to save a quintessential valuable cultural object or a human life is the ultimate ethical question. Everyone recognizes Leonardo da Vinci's *Mona Lisa* as a representation of artistic genius, or the Venus of Willendorf figures as the oldest artworks, or the ever popular Impressionist *Water Lilies* by Claude Monet, or any one of the awe-inspiring Ansel Adams photographs. If any of these important cultural objects were in danger of being destroyed, by a fire, perhaps, in the museum where these objects are preserved, would you save the valuable cultural object or the elderly, injured museum guard? (You can't save both, no matter how strong or creative you are.) If the preservation of human life is an essential ethical value, the elderly museum guard would be saved. If aesthetic value is an essential value, then the preservation of a cultural object that reflects quintessential aesthetic value would be saved. In one discussion of this question, a 10-year-old boy thought the cultural object was more important to save because it would benefit more people for all time. How would you defend your position?

Preservation in Los Angeles and Beyond

The Los Angeles County Museum of Art planned to sell one of three Alberto Giacometti's sculptures of standing women, the one that was a likeness of the artist's wife. Also slated for sale was one of 42 Impressionist and Modern pieces from the permanent collection. They would be sold to Sotheby's. "These sales are the latest sign that we can no longer depend on our cultural institutions to protect and preserve the public patrimony," claimed Lee Rosenblum, author of an opinion piece in the *New York Times* in November 2005.

The *Los Angeles Times* characterized the sale as the museum's "boldest collection-culling since 1982," when it sold nearly 600 objects at auction (Rosenblum 2005). At least the 1982 sale was of objects that were no longer being shown by the museum. Some of those works had long been admired by curators and visitors, like Modigliani's *Portrait of Manuel Humbert Esteve*, which was expected to fetch $4–$6 million, frequently displayed at the museum and lent to special exhibits around the world, and Max Ernst's *La Mer*, which toured New York, Chicago, and Houston.

"We have to look at what may be appropriate to sacrifice in order to reinvest in the collection," said Nancy Thomas, the museum's deputy director (Rosenblum 2005). She said the museum planned to cull its contemporary collection from the 1950s and 1960s.

The Los Angeles County Museum of Art is not alone in thinking about its collections as "investments." In 2004 the New York Public Library sold its most admired painting, Asher B. Durand's *Kindred Spirits* (1849), to a Wal Mart heir for a reported $35 million. In 2003 the Museum of Modern Art privately sold a seminal Cubist Picasso of superlative quality and the Boston Museum of Fine Arts sent two important Degas pastels to market. Curators use such sales to fund new purchases. Major building projects' capital campaigns tap out donors so collections become a source of financing.

Museums justify disposing of high-quality art on the grounds that it is not shown often; however, research reveals this to be untrue. Another rationale for disposal is redundancy: for example, when the Guggenheim Museum sold a major Kandinsky in 1990 because they

had so many. "This explanation disregards a museum's responsibility to collect artists' work in depth" (Rosenblum 2005).

Many museums say their missions have changed. Works valued by previous curators and visitors are no longer deemed part of the "proper scope" of the institution's collecting. For example, the New York Public Library decided that it should still collect drawings and prints but not the paintings and sculptures it had displayed for generations.

Should these public institutions be held to some regulation about what they can sell and what they can't sell? Should legislators step in? Should public institutions be required to trade their work with other public institutions rather than sell them? What about private museums? Should they be regulated? Who should be involved in decisions to sell art in a public collection? Who should be involved in deciding to sell private institutional holdings?

Preservation? Appropriation? Identity Theft?
Is Reproducing Someone's Innermost Thoughts Ethical, If It Is in the Name of Art?

An artist's son found an adolescent girl's diary in front of a McDonald's. The artist wanted to reproduce the diary, down to its spiral binding, drawings, and coffee stains, in a limited edition because it was an amazing psychological, sociological, and cultural document. The artist said this was a Postmodern position (appropriation) and she could do whatever she wanted with this "found object." The artist said she would respect the diarist's privacy and change any identifying factors.

An ethicist wrote: "In the name of neither art nor commerce nor the Spanish Inquisition" is it permissible to publish someone else's innermost thoughts without their consent. "It is disturbing" that the artist apparently made no effort to return the diary to its owner (*Kansas City Star* 2006). While the artist's editing may protect the diarist from some embarrassment, the artist may not peremptorily publish it.

How is this different from Sherrie Levine re-photographing famous artists' works and claiming them as her own? What does this say about identity (ontology), both in the case of the young woman keeping a diary, the artist who was going to publish this "found art," and Sherrie Levine? Ethical, political, and aesthetic value theories are in play here.

7

Political Art, Censorship, and Pornography

When Art Is Too Powerful, Cover It Up

Real events inspire aesthetic dilemmas reported in newspapers and on websites such as Artdaily.org (*www.artdaily.org/index.asp*). Every day we can read about art and politics, censorship and pornography, art and morality, art and religion, art and the government, and art issues in our global community.

Picasso's anti-war painting *Guernica* made the news in Kansas City a while back, and again several years later in New York City at the United Nations. A sculpture titled *Spirit of Justice* in the U.S. Capitol Rotunda made the news. Photographer Robert Mapplethorpe's exhibition called *The Perfect Moment* created a controversy in Washington, D.C., and Cincinnati. Artist Suzanne Klotz created images about religious and political actions in Israel and Palestine, where she lived and taught for several years, which caused a fuss in a small town in Arizona that brought the FBI into the mix. (All of these examples are discussed below.) World events have long inspired artists to create art intended to move us to action. At the same time, they have faced opposition when creating art that provokes. People for the American Way compiled *Artistic Freedom under Attack* (1995), which lists examples of violations of First Amendment rights to freedom of speech/expression in all 50 of the United States.

Cover That Up!

In 1995 an Arizona interior design group chose Pablo Picasso's *Guernica* to be reproduced as a tapestry for the lobby and as prints for guest suites in a new Omni Hotel in Kansas City (now a Doubletree Inn).

Ideas About Art, First Edition. Kathleen K. Desmond.
© 2011 Kathleen K. Desmond. Published 2011 by Blackwell Publishing Ltd.

According to the design company's principal, "*Guernica* will help create the ambiance we want for the Omni: a mixture of Midwestern warmth and European sophistication. We're trying to create almost a European, worldly type feel, an eclectic blend that says you're in the heartland in Kansas City, but with a very up-scale feel. That's picked up in the art-work." The designer admitted she was unaware of the work's historical significance. Her choice of *Guernica* had "nothing to do with what it means" (Karash 1995).

Picasso's *Guernica*, a 1937 Cubist depiction of the horrors of war, commemorates the small Basque village bombed by German forces in April 1937 during the Spanish Civil War. In black, white, and grey, the painting depicts a nightmarish scene of men, women, and children under bombardment. The twisted, writhing forms include a dead soldier, a severed head and arm, a screaming woman holding a dead child, a bull and a horse. "Midwestern warmth?" "European sophistication?" Editorial letters to the *Kansas City Star* included "Picasso's Angry Protest," "Back to School," and "*Guernica* is to Cows as Kansas City is to …" Is it possible to consider a work of art like *Guernica* without regard to its meaning or historical significance? Write your own letter to the editor.

Powerful Art

In February 2003 a tapestry reproduction of *Guernica*, donated to the United Nations Headquarters in New York City by the estate of Nelson A. Rockefeller and hung outside the Security Council chambers since its donation in 1985, was covered up.

In an act with extraordinary historical significance, officials covered up the reproduction of Pablo Picasso's anti-war mural during U.S. Secretary of State Colin Powell's presentation of the American case for war against Iraq. Workers placed a blue curtain and flags of council member countries in front of the tapestry, acknowledging that a plea for war in front of such a moving anti-war statement would be impossible.

And Cover *That* Up Too!

In 2002, $8,000 was spent on drapes to cover a sculpture in the Great Hall in the Justice Department, a two-storey room used for events and ceremonies in the United States Capitol Rotunda in Washington, D.C. The art deco aluminum female sculpture, C. Paul Jennewein's *Spirit of Justice* (1933), has been in the Capitol Rotunda since the 1930s. The female figure wears a toga-like cloth that reveals one breast and was a favorite background for photographing politicians. John Ashcroft, then United States Attorney General, was offended by the sculpture's exposed breast and ordered the taxpayer-funded "cover-up." He claimed the drapes were installed for "aesthetic purposes," but no one in the Justice Department was available for comment (Bunscombe 2002).

An Italian Cover-Up

In 2008, the *International Herald Tribune* reported that an allegorical figure in an eighteenth-century painting by Giovanni Battista Tiepolo, serving as a backdrop for government news conferences in Italian Prime Minister Silvio Berlusconi's official residence, was retouched to cover an exposed breast that "might have upset the sensitivity of some viewers" (Povoledo 2008). Paolo Bonaiuti, the prime minister's spokesperson, said "that breast, that little nipple, ends up in the TV shots made during press conferences." Bonaiuti went on to explain that the touch-up had been the "initiative of those who look after the prime minister's image."

The painting, titled *The Truth Unveiled by Time*, "is a wonderful concept, that the passing of time will show who is right and who is wrong," said Anton Paolucci, the director of the Vatican Museums. "It's the perfect choice of a message for a government." There is a traditional iconographic point of view that "truth is usually depicted nude. It's kind of pointless to have wanted this allegory and then to cover it up," said Alessandra Bertuzzo-Lomazzi, a manager of the museum housed in the Palazzo Chiericati in Vicenza where the original painting hangs.

Instrumentalism

A philosophy called instrumentalism inspires artwork intended to move viewers to action for the betterment of society. Instrumentalist art serves as an "instrument" for furthering a point of view that might be moral, social, religious, or political. It takes expressionism one step further by attempting to provoke viewers to some sort of action. This is exactly what Plato feared and why he thought art could be dangerous and should be censored. We may want to cover it up, clean it up, paint over it, paint on it, or generally make it go away, or we may want to support seemingly offensive art because it is right and just and important to freedom. Consider the aesthetic dilemmas in this chapter. What philosophies support your position on these issues?

Marxism

A philosophy important to the visual arts is Marxism, the political, economic, and social principles and policies advocated by Karl Marx, especially the theories and practices of socialism, including the labor theory of value, dialectical materialism, class struggle, and the dictatorship of the proletariat until the establishment of a classless society. Marxists believe an artwork's value depends on its function in its social setting. Art is a tool. Art is a shaper of political attitudes. The function of art is social. Marxists believe a work of art is both an expression of and a reaction against social conditions.

Art or Vandalism?

Graffiti artists, sometimes called tag artists, have been active in many cities. Two young men were arrested in Kansas City in 1994 and felony charges were filed against them for property damage in the first degree. One of the tagger's marks, FCC, stands for "Forever Causing Chaos." This young man was part of a larger "tagger crew" called CST, "Can't Stop This." Similarities were drawn between these Kansas City tag artists and those in Los Angeles and New York, and to the famous artist Keith Haring, who was a graffiti artist in the New York City subways. Kansas City police said tagging is a nuisance but not a violent crime, "They need to find another way to express their artistic

visions" (Lambe 1994). This encouraged a local art gallery owner to offer an exhibition to these artists, on the walls inside of the gallery.

Does graffiti art change when it is shown in a legitimate art gallery? How? Explain.

The *Kansas City Star* reported, "Tag Art wizards are still painting their messages even though their art is illegal" and published a photograph of one tagger's work (Lambe 1994). Readers were asked, "What do you think the punishment should be for convicted tag artists? A. Pay fine, B. Receive scholarship for art school, C. Jail, or D. Paint over art." (University students voted 37 percent for D, 35 percent for A, with the fine being community service and 28 percent for B.)

Teaching Young Graffiti Artists a Lesson

In 2009, police in Monterrey, Mexico, attempted to teach young graffiti artists not to spray-paint graffiti on public property by spray-painting their hair, shoes, and buttocks (Associated Press 2009). Emilio Alfaro of Nuevo Leon state's Human Rights Commission filed a complaint and presented evidence alleging that police sprayed the youths, ages 14 to 16, with paint after detaining them for vandalism. The teens were fined $200. Several officers were suspended while the matter was being investigated.

Silent Protest

Aaron Hughes (*www.aarhughes.org*) was deployed as an American soldier to Kuwait in April 2003, where he spent one year, three months, and seven days. When he returned to the U.S. he enrolled in the University of Chicago as a painting major. He used photographs he had made in the Middle East to create abstract paintings depicting the reality of war. Hughes thinks art is a tool that can express experiences.

"Art can shatter the systems, cultures and spaces of oppression and obedience," he wrote in *Centerings*, a quarterly publication of the 8th Day Center for Justice. "Art makes room for voices that have been silenced and marginalized; room to ask questions, tell stories, share dreams, allow for meditation and create an understanding of the fragile walls of dehumanization that society has constructed around us" (Hughes 2008). Strategies for social change that use symbolic and direct action have the greatest potential to create change, said Hughes. His *Drawing for Peace* project (*www.drawingforpeace.org*) attempted to do just that and to inspire thought about how a simple act of expression can impact society and demand change.

Drawing for Peace was a Performance piece. Hughes stepped into an intersection, placed barricades in the lane of traffic, and started drawing for peace. The drawing was of a dove on barbed wire. Hughes continued working on the drawing as pedestrians stopped and stared, drivers honked their horns, and a police officer demanded he get out of the street. Hughes continued to draw until the officer dragged him away. When the officer went to remove the barricades, Hughes went back into the street to finish the drawing. The symbolic act of drawing, a veteran's simple gesture combined with direct action in taking over an intersection during rush hour, forced confrontation between silence of a city during war and a veteran demanding peace. Hughes, a member of Iraq Veterans against the War, wrote:

I AM AN IRAQ WAR VETERAN.
I AM GUILTY.
I AM ALONE.
I AM DRAWING FOR PEACE.

Political Philosophy

Political philosophy is concerned with the knowledge and value of politics. In the philosophical company of metaphysics, epistemology, and aesthetics, political philosophy is a value system (axiology) like ethics and aesthetics. Controversial political issues are suggested in the stories and aesthetic dilemmas in this chapter.

Figure 7.1 Matthew Zupnick, American (b. 1961). *Chain of Command*, 2006. Bronze, steel, 30 × 12 × 8 inches.

Political philosophy includes questions about government, liberty, justice, property, rights and laws, and includes arguments about the definitions of these terms, why or if they are needed, what rights and freedoms a government should protect and why, what form government should take and why, what the law is, what duties, if any, citizens owe to a government, and when or if a government may be overthrown.

The word "political" is sometimes defined as "relating to, or dealing with the structure or affairs of government, politics, or the state, or relating to, involving, or characteristic of politics or politicians." Or it can be defined as:

The science of government; that part of ethics which has to do with the regulation and government of a nation or state, the preservation of its safety,

peace, and prosperity, the defense of its existence and rights against foreign control or conquest, the augmentation of its strength and resources, and the protection of its citizens in their rights, with the preservation and improvement of their morals.

The word "political" can also be applied to almost any group of two or more human beings gathered together, whether it is a church group, in a workplace, on a sports field, in a classroom or studio.

Censorship

Censorship is the suppression of speech or communicative material that may be considered objectionable, harmful, or sensitive. The rationale for censorship is different for various types of information depending on whether this relates to education censorship, music and popular culture, politics, religion, or pornography.

Censorship exists to some extent in most all societies. Plato was a fan of censorship for the purpose of maintaining a moral citizenry. Political censorship occurs when a government holds back information from its citizens. Censorship seeks to exert control and prevent free expression that might lead to rebellion. Religious censorship suppresses objectionable material to a certain faith. This can happen when a dominant religion enforces limitations on a minor one, or when one religion rejects the works of another because the content is inappropriate for their faith.

In 2001, the Bamiyan Buddhas, enormous sculptures cut into the mountains of Aghanistan that were important to the Buddhist religion and significant to world culture and religions, were destroyed by the Taliban, a radical Muslim group, because they violated their fundamentalist Muslim beliefs. This destruction was also a political gesture meant to exert control and demonstrate political power in Afghanistan. This was an example of one religion inflicting limitations on another religion for political control, and in this case the destruction of the Bamiyan Buddhas had far-reaching consequences in terms of the tremendous loss of art and world culture.

Moral censorship seeks to remove materials or images thought to be obscene or otherwise morally objectionable. Pornography is often censored using morals as the rationale. Pornography is sometimes explained as the explicit depiction of sexual subject matter with the sole purpose of sexually exciting the viewer. Pornography is similar to, and sometimes hard to

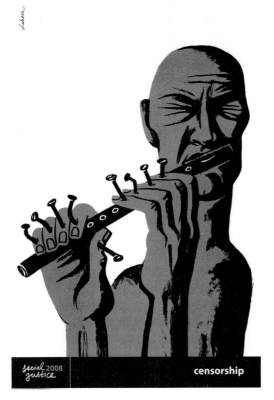

Figure 7.2 Luba Lukova, American. *censorship* from *Social Justice*, 2008. Silk screen, 27 ½ × 39 ⅜ inches.

separate from, erotica, which is the use of sexually arousing imagery. Over the past few decades a huge industry dedicated to the production and consumption of pornography has grown due to emergence of the VCRs, DVDs, and the Internet, as well as changing social attitudes becoming more tolerant of sexual portrayals. Pornography makes use of a variety of media: printed literature, photographs, sculpture, drawing, painting, animation, film, video, and even video games.

The legal status of pornography varies widely from country to country. When sexual acts are performed for a live audience it is not pornography because the term applies to the depiction of the act, rather than the act itself. So sex shows and striptease shows are not pornographic. In most countries pornography is treated as a separate entity, both culturally and

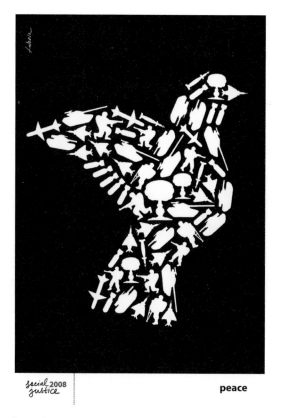

social 2008
justice **peace**

Figure 7.3 Luba Lukova, American. *peace* from *Social Justice*, 2008. Silk screen, 27 ½ × 39 ⅜ inches.

legally. Pornography producer Larry Flynt, writer Salman Rushdie, art gallery owner Mary Boone, and the American Civil Liberties Union have argued that pornography is vital to freedom and that a free and civilized society should be judged by its willingness to accept all forms of expression, including pornography.

Politics and Pornography

The Corcoran Gallery of Art in Washington, D.C., agreed to host a traveling solo exhibit of Robert Mapplethorpe's work without making a stipulation as to the subject matter. Mapplethorpe decided to show a new series he had

been working on called the *X Portfolio*, which became part of the exhibition *Robert Mapplethorpe: The Perfect Moment*, curated by Janet Kardon of the Institute of Contemporary Art. "Mapplethorpe captures the peak of bloom, the apogee of power, the most seductive instant, the ultimate present that stops time and delivers the perfect moment into history," wrote Kardon in the Exhibition Catalog. The hierarchy of the Corcoran and several members of Congress, most famously Jesse Helms, were horrified when the works were revealed to them. The Corcoran Gallery of Art refused to go forth with the exhibit. After the Corcoran refused the Mapplethorpe exhibition, underwriters sought another venue. The nonprofit Washington Project for the Arts showed the controversial *The Perfect Moment* images in its own space from July 21 to August 13, 1989, attracting large crowds.

Robert Mapplethorpe studied at the Pratt Institute in Brooklyn, where he produced artwork in a variety of media, but photography became his sole means of expression during the mid-1970s. He began making photographs of a wide circle of friends and acquaintances, including artists Andy Warhol, Richard Gere, Peter Gabriel, Grace Jones, and Patti Smith, composers, socialites, pornographic film stars, as well as members of the S & M (sadomasochistic) underground.

In the early 1980s, Mapplethorpe shifted to studies of formal beauty. He photographed flowers, especially orchids and calla lilies, statuesque male and female nudes, and made formal portraits of artists and celebrities. Graphic homosexual eroticism in some of this work triggered a controversy about the public funding of artworks.

Mapplethorpe's *X Portfolio*, which, as noted above, was included in *The Perfect Moment*, a traveling exhibition funded by the National Endowment for the Arts, sparked national attention in the 1990s. The portfolio included some of Mapplethorpe's most explicit imagery. Although his work had been regularly displayed in publicly funded exhibitions, conservative and religious organizations, such as the American Family Association, vocally opposed government support for what they called "nothing more than the sensational presentation of potentially obscene material." As a result, Mapplethorpe's work ignited the American Culture War. The installation of *The Perfect Moment* in Cincinnati resulted in the unsuccessful prosecution of the Contemporary Arts Center of Cincinnati and its director, Dennis Barrie, on charges of "pandering obscenity."

Art critic Arthur Danto (1996) wrote, "Pornography played a central role in Mapplethorpe's artistic mission, and it made him an artist of his own time in a particular way, perhaps THE artist of his own time." His work

focused on balance and perfection and established him in the top rank of twentieth-century artists. Art critic Kay Larson wrote that Mapplethorpe "invests this beautiful thing-in-the-world with an erotic charge that transforms it and ennobles it by the passionate entwining of its nature with the artist's." About Mapplethorpe's influence on photography, she said that "photography will never be the same" (Danto 1996).

In 1986 Robert Mapplethorpe was diagnosed HIV-positive. In 1987 he established the Robert Mapplethorpe Foundation to promote photography, support museums that exhibit photographic art, and fund medical research and finance projects in the fight against AIDS and HIV-related infection. Since his death from AIDS in 1989, museums throughout the world have made his work the subject of numerous exhibitions.

United States' Bill of Rights, First Amendment

Congress shall make no law respecting an establishment of religion, or prohibiting the free exercise thereof; or abridging the freedom of speech, or of the press; or the right of the people peaceably to assemble, and to petition the government for a redress of grievances.

Artists Suzanne Klotz and Jonathan Moller (Chapter 4) reach beyond the United States' Bill of Rights. "Each of the concepts in my work are formulated around specific laws in the Universal Declaration of Human Rights," said Klotz. She wanted viewers to realize that violations of specific items in the Universal Declaration of Human Rights constitute criminal acts – war crimes. She reminds us "these rights apply during times of PEACE and WAR, with no exceptions!"

The Universal Declaration of Human Rights

The United Nations Universal Declaration of Human Rights was adopted by the General Assembly of the United Nations in 1948 and is available in hundreds of languages (*www.un.org/en/documents/udhr/index.shtml#a19*). It proclaims a common standard of achievements for all peoples and all nations and sets out fundamental human rights to be universally protected. "The laws and regulations of the Universal Declaration of Human Rights apply to all countries during times of war and peace. If they are broken the

offenders who are committing crimes against humanity/war crimes will be held accountable." Article 19 speaks specifically to media and the arts: "Everyone has the right to freedom of opinion and expression; this right includes freedom to hold opinions without interference and to seek, receive and impart information and ideas through any media and regardless of frontiers."

Censored: The Case of Suzanne Klotz

When Suzanne Klotz showed her digital 'zine, *A Pocket Guide to the Holy Land*, in Sedona, Arizona in 2004, the FBI came knocking on her door. She learned digital techniques at Yavapai College in a course that was funded, in part, by the Sedona Arts and Culture Commission. The vice-chair of the Commission voiced his objections to Klotz's work, walked out during the presentation of her work, and sparked a heated controversy that earned a place on the *Democracy Wall* at the College Art Association conference in Atlanta in 2005. Because many CAA members felt the impact of the Patriot Act, the CAA Services to Artists Committee wanted to provide a safe way for artists to relay their stories to others. Interestingly, three of the "testimonies" on the *Democracy Wall* were from Arizona: Klotz's and two from Arizona State University.

Suzanne Klotz's work can be found in the Smithsonian American Art Museum, Phoenix, El Paso, and Scottsdale (AZ) Museums of Art, and in international collections in Australia and Israel. She served in artist residencies in Australia, Mexico, Burkina Faso, Taiwan, and Israel. From 1990 to 1996 she arranged collaborations between Israeli and Palestinian artists, educators, and young people at Mishkenot Sha'ananim, a nonprofit international cultural center in Jerusalem. Klotz worked with both Israelis and Palestinians making art toward a common, humane understanding. Because she made many friends in Jerusalem, the Israeli–Palestinian conflict has caused her great personal, psychological, spiritual, and political conflict, as seen in her work, like *Two Sides to Every Wall* (*Wall Diary*) (2004), a collaboration with Palestinian artist Yacoub Al-Kurd, who lives and works in the Occupied Territories.

Currently Suzanne Klotz lives and works in Arizona. She is the 2004 recipient of the prestigious Pollock-Krasner Foundation grant and a Puffin Foundation grant to continue a "dialogue between art and ordinary people." The Puffin Foundation was established to counteract censorship of socially

Figure 7.4 Suzanne Klotz, American (b. 1944). *House of Demolition*, 2007. Paper, ink, watercolour, 18 × 24 inches.

relevant art. Toward those efforts, Klotz enrolled in Yavapai College's digital storytelling workshop in June 2004 and learned how to create digital images that she incorporated into *A Pocket Guide to the Holy Land*. The content of the 'zine consisted of Palestinian human rights violations that she witnessed between 1990 and 1995 along with quotes from Rabbis and excerpts from letters written to Ariel Sharon by Israeli soldiers who refused to participate in the occupation of Palestine. Knowing this was a "sensitive subject," Klotz requested the college president to view the story before she credited the college with its production. Klotz was assured that it had been viewed and approved and that the college wanted to be credited. *A Pocket Guide to the Holy Land* was shown to class members and their invited guests. It was later shown to members of the Sedona City Arts and Culture Commission, with the story making the front page of *Red Rock News*, on June 9, 2004.

Student's Story Ignites Controversy About the Use of Public Funds

An emotional exchange flared up at a meeting of the Sedona Arts and Culture Commission after viewing Klotz's *A Pocket Guide to the Holy Land*. Voicing his objections, Marty Herman, the vice-chairman of the Arts and Culture Commission and owner of a local art gallery, walked out of the meeting in protest.

Klotz created *A Pocket Guide to the Holy Land* in a digital storytelling class partially funded by a grant to Yavapai College by the Sedona Arts and Culture Commission. The story Klotz told in the short digital piece was about the oppression of Palestinians by Israeli authorities in Palestine. Following the showing, some Commission members praised the teacher of the class for facilitating students' expression of difficult issues. But the vice-chairman had a different reaction. He said that the work was "a political point of view under the guise of a story" that was "inaccurate, inflammatory and offensive" and "completely unacceptable" for public funding. Herman said that as the owner of an art gallery, "I'm very sensitive to art expression and am very supportive of free speech. At the same time, I have a healthy respect for other people and wouldn't have an item that would purposefully offend someone."

The vice-chairman of the Arts and Culture Commission and chairman of the Commission's grants committee said he didn't really understand what the college was going to do with the money awarded to them. There was an obligation of good judgment and good taste that was not met, he said. Because the city cannot anticipate everything that might be done as a result of the grants it awards, it requires agencies receiving such funds to sign a "release of liability" form. This was done. There is a "bitter irony" in the grants committee chair having recommended awarding this grant. He said Klotz's work was "anti-Semitic, anti-Jewish and anti-Israel." He wanted a change in the way grant money was awarded. "We need to look at how to prevent this," he said.

Shortly after the article was published in the *Red Rock News*, Klotz was contacted by a FBI agent who requested a meeting with her. It had been reported anonymously to him that she was an Israeli Intelligence

spy. Klotz refused to meet with the FBI agent and retained the services of a Federal Defense Attorney. She was harassed by obscene phone calls for the next month. She was told by college representatives to have the CD of the *Pocket Guide* reproduced elsewhere and not to discuss any of this with anyone. She was told not to show it in Sedona or contact media outlets in Arizona. College faculty received memos telling them not to discuss Klotz's story because the situation was "political."

Since 1990, Klotz has prepared exhibits, presented lectures, and conducted workshops addressing the information in *A Pocket Guide to the Holy Land*. These activities were supported and applauded for their social relevance and informed delivery, even in Israel, where anything even remotely anti-Semitic would be condemned and banned. Klotz was disconcerted to find that the false accusations of one person, responsible for upholding and ensuring the protection and preservation of the arts, could be granted the power to censor the arts and education of so many people. (The vice-chair, the newspaper, the college, or the Sedona Arts and Culture Commission never apologized or contacted Klotz.)

Art against the Wall: Ramallah, Tel Aviv, and New York

Klotz continued her work in an international collaborative exhibition, *Art against the Wall: Ramallah, Tel Aviv, and New York*, with plans to open, in 2005, simultaneously in those three cities. Twenty-five artists from Palestine, 25 from Israel, and 25 from the U.S. and Canada were selected for the show. Curators in each city invited artists to provide three works, one to be shown in each city. The aim of *Art against the Wall* was to build networks and solidify relationships among artists in these three cultures. The exhibition goal was to demonstrate that art transcends borders imposed by governments and that shared concerns enable people from different backgrounds to come together in peace and inspire change in the world. Principles and practices of nonviolent social change would be demonstrated through art.

Content of the exhibition illustrated realities like the fact that 300,000 Palestinians in 72 communities would be isolated from their livelihoods, along with schools and markets with the construction of a Wall, called by Israel a "security fence." Construction had already uprooted thousands of

olive and fruit trees and led to the seizure or destruction of thousands of acres of agricultural land and personal property. The Wall itself is made of fencing, barbed wire, and concrete barriers, a military patrol road, guard towers, trenches on both sides, and electronic warning fences.

Art against the Wall addressed the cultural divide symbolized by the separation wall in occupied Palestine. The exhibition demonstrated that art can rise above outwardly imposed borders and can be an expression of hope. Organizers wanted to address the inaccurate and incomplete (censored) information disseminated by the U.S. press. As a result of this project, artists had the opportunity to work together in a manner previously unimagined and join forces in a unified display against injustice.

Two Sides to Every Wall (Wall Diary), the collaborative work of Yacoub Al-Kurd mentioned above, consists of 26 mixed-media framed images recessed into four painted polyurethane panels. The panels are suspended from the ceiling to form a U. The framed imagery incorporates Al-Kurd's dated diary entries. This two-sided display documents the effects that the Israeli separation barrier has on the lives of Palestinians, and, in particular, the life of Al-Kurd, a Palestinian artist and teacher living in Jerusalem. Twelve of the framed images highlight excerpts from Al-Kurd's email correspondence to Klotz and her illustrations. On the reverse side of Al-Kurd's pages are facts and imagery related to the construction of the Israeli barrier.

Al-Kurd's participation in this project meant concentrating on the conceptual and structural elements of the work in spite of house arrest for weeks and months, curfews, daily searches by German Shepherd dogs and soldiers, loss of income owing to prevention of passage to work, taxes levied by patrolling soldiers, destruction of household property, beatings of family members during midnight house searches, house demolitions, and the fear of both staying in his home and leaving it.

Challenges to Artistic Freedom

Art is censored for a variety of reasons, but usually it's because it threatens control of one group over another group. Art is powerful and can influence people's thoughts and actions. Sometimes art is censored because it is misunderstood and feared. Sometimes art is censored because it *is* understood and it is willfully, with complete understanding, censored. Censorship has its consequences in the United States, as it did in the early 1990s with the initiation of the Culture Wars and as it escalated in the twenty-first century

with the Patriot Act, acknowledged by College Art Association sessions and the *Democracy Wall* at the Annual Conference in 2005.

These stories document challenges to artistic expression in the United States and in the world. They are evidence of a growing jeopardy of freedom of artistic expression with continued political attacks and a rising rate of censorship success. The arts have become a prime scapegoat for public anger and frustration with the perceived erosion of moral values in America, and, in some cases, art that has stirred controversy has been the target of vandalism.

When art touches a political or moral nerve, it can become the target of censors. During the past decade in America, art has generated controversies generated by right-wing religious organizations. These attacks were distorted and lacked serious discussion about the role of art in a free society. In a "State of the Arts" study conducted by the People for the American Way in 1995, it was found that the debate over art in America was not driven by economics, but rather the ideas of pluralism and diversity that previously enabled the arts to flourish over the years were what was challenged. The study found that art censorship was fueled by politics and anger. National attacks on art often originated with right-wing political groups, while local controversies about art were often sparked by individual resentment of broader cultural trends and issues in society. In some cases, art was demonized as a perpetrator of social ills.

Increasingly, art controversies involve legal actions either by the artist or by the arts institution. The rate at which artists were forced to seek legal means to defend their work, or faced legal challenges to their work, almost doubled in the last decade. Artists were not alone in seeking legal aid. Challengers in many battles invoked obscenity laws to get artwork removed. Many examples are documented in *Artistic Freedom under Attack* (People for the American Way 1995), and you can probably think of examples that have happened in your home town or near where you live.

There have been valuable models for upholding free expression and drawing communities into positive dialogue about art. These examples include courageous anti-censorship stands by exhibition curators and support for free expression in community forums that use controversies over art as a starting point for a more searching dialogue about cultural expression, ideals, and values.

Artistic Freedom under Attack concluded that the arts were an invaluable part of any culture's heritage and deserve vigorous defense against political attacks. Artists continue to embody the ideal of freedom of expression and a culture's shared ideals. No matter what the politics of any member of any culture, most cultures take pride in their artistic heritage.

8

Art and Economics

Economics of Art

William Grampp, Professor Emeritus of Economics, suggested in his book *Pricing the Priceless* (1989) that visual art could be studied from an economic point of view. The activity of making, acquiring, and using art are all behaviors that "entail choices and all choices entail returns and costs" (Grampp 1989: 4). Behaviors and choices are what economics is about. Some people think certain behaviors involve the higher values of truth, beauty, and goodness and do not belong in the realm of economics. Grampp thinks these higher values call for searching thought and careful comparisons for the "rationality that economics attributes to people in everything they do whether they address themselves to lower values or to higher ones" (Grampp 1989: 5). Grampp seeks to clarify certain features of visual art, its history, and its current conditions by employing microeconomics. Economics here is no different from any other academic discipline, in that there is a methodology for studying the problem and developing an argument.

A basic economic concept is buying art at one price and selling it for a higher price at a later date while enjoying the artwork in the meantime. Collectors can buy art as speculation, as an investment, or for art's sake, the latter having firm grounding in neo-classical economics and socio-political views espoused by contemporary art historians. That the art market is subject to huge variations among the rates at which art prices change, from appreciating 100 percent to depreciating 100 percent, together with the need to compare art prices to other objects or investments,

Ideas About Art, First Edition. Kathleen K. Desmond.

are important economic factors for collectors, artists, dealers, gallery owners, and art lovers to consider.

Setting the Price of Art

Like most of us, artists wonder how the price of art is decided. Ann Landi, writing for *ARTnews*, said the answer "is often an alchemy as strange and ineffable as your grandmother's recipe for spaghetti sauce." New York art dealer Richard Feigen added that "it's an inexact science involving a finite commodity, and somehow we have to struggle to transmute that inexactitude into something concrete" (Landi 1998: 118).

There are some "formulas" generally followed by New York art galleries like pricing emerging artists' work low so collectors will buy. Then gradually the prices are raised as the artist gains more exposure in museum and solo gallery exhibitions, acquires published reviews and articles about their work, and is included in public and private collections. New York dealer André Emmerich said: "You could make a mathematical formula having to do with a work's size, quality, desirability and so on, but all of these are secondary to the crucial factor, which is the level of reputation and recognition the artist currently enjoys" (Landi 1998: 118).

When pricing mid-career or established artists, dealers take into account the exposure the artist is currently receiving along with museums expressing interest or planning shows and where they are located. An artist showing in major cities like New York and London is going to fetch sums higher than an artist who is only seen in local or regional venues. Dealers consult with artists to determine realistic prices. They take into account the cost of materials, and the size and number of works an artist creates each year. There is always the worry, on the part of both artists and dealers, that they are pricing too high or too low. Dealers know negotiating accounts for about 10 percent of the price. There is no point in pricing something too high and then bargaining to a much lower price, said one gallery owner. Special pricing considerations are given to museums and prestigious collectors. As with any good sale, the dealer wants to feel they got a good price and they want the artist and the collector to feel the same.

Artists with long and successful careers steadily build their reputations and the market value of their work. Gallery owners/dealers help artists do just that in a variety of ways. Old-school-sorry-they-are-gone gallery owners like Elaine Horowitch in Scottsdale, AZ, and Myra Morgan in Kansas

City supported artists financially so they could make art. Of course then the dealer owned the work created and could hold it and sell it after they had helped the artist build a reputation. This was controversial to some because if the dealer waited long enough, they could sell one work of art for the amount of money they had paid the artist for an entire year of work. On the other hand, if the artist wasn't making art because they needed to make money to pay the rent instead, the artist would never have earned a reputation and the gallery owner's investment would be a deficit. An artist's career could be as short-lived and brutal as an athlete's or a movie star's. Andy Warhol's "fifteen minutes of fame" comes to mind. Even so, this arrangement appealed to many mid-career and emerging artists who wanted to spend their time making art rather than on public relations and developing a marketing plan.

Financing Art

In the late 1980s, before the current woeful economic situation, a practice of financing art by banks and auction houses gave collectors financial flexibility in their pursuit of artworks. Money was available to big spenders from New York to Chicago. If a regular customer wanted to finance a piece of artwork, banks would consider it. In the 1970s, the auction house Sotheby's formally advised clients of Citibank on art purchases and Citibank emerged as a formidable factor in the art market, frequently bidding at auction for clients. Citibank was unique in this program, but other banks like Chase and Credit Suisse in New York developed programs that made money available for financing art. Sotheby's became a major player in art financing beginning in 1984, even though it was very conservative in its lending practices. Christie's, the main rival to Sotheby's, loaned money to consignors from time to time but was philosophically opposed to the practice. Even though the impact of financing art was relatively small, it gave auction houses an edge over dealers, making buying art a more competitive activity.

Savvy Kansas City gallery owner Myra Morgan developed a practice in the 1970s of inviting potential buyers/collectors and bankers to dinner to talk about and learn about art. As potential buyers turned into knowledgeable art collectors, local bankers were available to make loans to buy art. This developed a strong collector base in the city and supported the Morgan Gallery. This activity may well be the foundation of the current dynamic art scene in a seemingly unlikely place like Kansas City. In 2005 viewers couldn't

help but be impressed by the fact that every artwork in the Belger Arts Center's world-class exhibition *Manipulated Realities: From Pop Art to New Realism* was owned by Kansas City collectors. It was during the late 1960s and 1970s, when the Pop Art and Photorealism movements were flourishing, that these works were collected. Myra Morgan was not only a gallery owner, she was an art advocate and art educator who can be credited for developing many a potential collector's knowledge and encouraging them to learn about art and develop their own collections.

As economic markets fell at the beginning of the twenty-first century, collectors moved their assets to their art collections and bought more art. The art market remained strong and art auctions were very busy, especially Sotheby's and Christie's, who reported record-breaking sales, dwarfing the 1987 purchase by a Japanese company (before Japan's economy declined) of Van Gogh's *Sunflowers* for $39.9 million, the highest price paid for an artwork to that date. New tax laws were developed regarding tax deductions for both artists and collectors in selling or donating art. The world economy contributed to a bit of a slowdown in art sales, but new wealth and art collectors were found in Georgia, the Middle East, and China. In fact, art sales boomed at the beginning of a global recession. What do astounding prices of works of art tell us about the aesthetic value of those artworks, or about the way we value art in general?

Is economic value (cost/price) based on aesthetic value?

Collectors, gallery owners, dealers, and auction houses are important not only to the artworld but to the overall economy. They are as important as artists, critics, and curators. Chapter 14 addresses more fully the roles of artists, critics, and curators, who think primarily about the aesthetic, rather than economic values. As we see in this chapter, the economic value of an artwork is not determined by aesthetic values. In fact, there is little connection between the aesthetic values and the economic values of art.

What if economic value is one of the concepts an artist addresses in their artwork? Examples include French Performance artist Yves Klein, who, working in the 1950s and 1960s, demanded payment for his art in gold and then threw the gold into the Seine; the Earthwork artists of the 1970s (see below), who made their work in inaccessible places, making

them impossible to 'own' or at least take home; and, most currently, contemporary British artist Damien Hirst. The *Sensation* exhibition, featuring Hirst and other Young British Artists (YBAs), was not art at all, said then Mayor of New York City Rudy Giuliani when the exhibition was on display at the Brooklyn Museum of Art in 1999; it was really commerce. The sponsors of the exhibition, Christie's International and Charles Saatchi, had a financial interest in pumping up the value of the art, and so did the artists. Damien Hirst knew that.

Sensational Status, Price, and Worth

Damien Hirst is the most prominent of the Young British Artists and is known for making a sensation in almost everything he does. Hirst and a group of young artists, many of whom graduated from Goldsmith's College of Art in London, put the artworld at the forefront of the news with the *Sensation* show in 1997 (Adams et al. 1997). What created the sensation was not the prices of the artworks; it was the "violations" of traditional art and practices. All the artwork in the *Sensation* show was owned by Charles Saatchi, a British advertising mogul and art collector with his own gallery/museum in London near Abbey Road (near where the Beatles made their records in the 1960s). The exhibition was held in the Royal Academy of Art in London, where it was unheard of for all the work in an exhibition to be owned by one person. The Royal Academy of Art is a very old and prestigious keeper of very conservative art. One has to be elected to the Royal Academy. You can't just pay your dues and become a member. By contrast, all of the work in *Sensation*, owned by Saatchi and created by the Young British Artists, was far from conservative; some of it was rather shocking and sensational, thus the exhibition title.

So, the sensations of the *Sensation* show were threefold: (1) all the work was owned by one person; (2) it was shown at the conservative Royal Academy of Art; and (3) the work itself created a sensation, like Damien Hirst's *A Thousand Years* (1997), a cow's head rotting in a large plexiglass enclosure divided by another piece of plexiglass with holes large enough for flies to get through. The rotting head, sugar, and water sustained a life-cycle of life of maggots and flies. It was kind of a stinky display, this piece, and somewhat disgusting, but with significant content, like Hirst's shark in formaldehyde titled *The Physical Impossibility of Death in the Mind of Someone Living* (1991), also in *Sensation*.

Artists Take Back Control

Charles Saatchi supported young British artists, many of whom lived in the East End of London. Supporting the arts and artists, especially young artists just starting out, is all very good. But, as one story goes, Saatchi would visit artists in their studios to see what they were making and talk to them about their work (Arthur Danto would approve of talking to the artist, while Monroe Beardsley thought artists couldn't really tell you what they were thinking when they made their work anyway.) If Saatchi liked artists' work enough to buy it, he would buy *all* of it! Wow! Great for the young, formerly poor starving artists, right?

Saatchi would keep the work and show it in his gallery, making it more valuable and giving it credibility and the artist a reputation and a "name." Then, when Saatchi sold the artist's work he had collected, he sold all of it, bringing an immediate end to the artist's reputation and credibility. Artists could no longer say their work was in the prestigious Saatchi collection. So, these young artists decided that if Charles Saatchi came around to buy their work, they would only sell one or two pieces to him so no one person would have control over their entire body of work – and their reputation. Artists wanted to be able to place their work in the collections of others, to show it in a variety of galleries and museums and maintain their credibility them-selves rather than giving gallery owners, dealers, or collectors control.

This isn't the first time artists took economics into their own hands. During the 1960s and 1970s in New York, the capital of the artworld at that time, gallery owners enjoyed an economic boom. Gallery owners controlled artwork prices and placement (collectors) of art. Some artists thought gallery owners had too much control over their artistic integrity, somewhat like the Young British Artists felt about Saatchi. Artists didn't want their careers con-trolled by gallery owners, so they made work that didn't fit into art galleries and could not be easily sold. Robert Smithson started filling geometric shaped boxes with rocks to focus on nature and use it as his "canvas."

Earthworks

Walter De Maria's *The Lightning Field* (1977) is in the New Mexico desert. Directions are needed from the Dia Foundation, who owns this piece, to find it. De Maria's *The Lightning Field* consists of 400 stainless steel posts arranged in a grid over an area of 1 mile by 1,094 yards (1 km). It becomes an amazing electrical display during storms because the stainless steel poles act as conductors and attract the lightning.

Michael Heizer cut *Double Negative* into the eastern edge of a mesa in the Nevada desert northwest of Overton, in 1969–70. It is so large that you cannot see it from the ground alone. You have to experience it by walking down into it or renting a plane and flying over it. The decline is so steep that it's inaccessible to vehicles.

Robert Smithson's *Spiral Jetty* (1970) was built in the Great Salt Lake in Utah, where Smithson meant it to be reclaimed by the nature. You can't see it from the ground either. In fact, you can't see it at all anymore because it has been reclaimed by the Great Salt Lake.

Some people didn't think Smithson's work was art or that it possessed aesthetic or economic value. In 1970 Smithson illustrated "geological time consuming human history" in his piece *Partially Buried Woodshed* on the campus of Kent State University in Ohio. This piece consisted of piles of dirt covering a woodshed. In the 1980s, University groundskeepers cleaned up the "unsightly mess," to the dismay of the University Foundation, who considered the $250,000 value of the work to be a financial asset. Out of the gallery, indeed!

Earthwork sculptures were not placed in the landscape, but rather the landscape was the very means of their creation. Earthworks frequently existed outside, in the open, and were located well away from civilization. The intent was that they would change and erode under natural conditions. Many of the first earthworks were created in the deserts of the Southwest and were ephemeral in nature. Now they exist as video recordings or photographic documents. From an art historical point of view, Earthworks have roots in Minimalism and Conceptual Art (indeed some of the artists have been involved in those fields) as well as in De Stijl and Cubism. The art of Constantin Brancusi and Joseph Beuys were also influential on Earthwork art.

Earthworks were a protest, by artists, against a variety of issues, including what they thought of as artificial aesthetics and the commercialization of art. Their monumental landscape projects reached beyond the commercial art market, or so they thought. These artists set out to go beyond the galleries and reclaim their integrity and careers as artists and in the process developed a new genre of art making.

Mind-Blowing Market-Breaking Sensation

You probably heard how Damien Hirst's formaldehyde shark (mentioned above) was auctioned off for $12 million, along with 222 of his other works at Sotheby's in 2008. It made newspaper and artworld headlines. It wasn't the prices that made the news; it was the way the art was sold that caused debates.

"Talented, greedy and utterly confident, Britain's biggest-selling artist hopes to overturn the basic laws of economics as well as the rules of the art market," reported the *Economist* on September 11, 2008. "It's risky I know," said Hirst of the auction (Vogel 2008). The auction was so big the accompanying catalogue came in three volumes and was encased in its own slip-cover. Such a sale had never been attempted before. Auction houses like Sotheby's and rival Christie's traditionally sell only art that has been bought and sold before and usually exclude anything less than five years old.

The risk of selling at auction is that it is impossible to control who buys or what price they will pay. Hirst flooded the market with hopes his prices would rise, thereby challenging one of the basic laws of economics.

Further, Hirst broke the art market's traditional rules. For nearly 20 years his dealers had nurtured his career, placed his work in high-profile museums and in the hands of carefully selected wealthy collectors. By selling at an auction house, Hirst cut them out. Hirst credited Frank Dunphy, a sprightly 70-year-old accountant, for dreaming up this sale. "Frank has my best interests at heart. Dealers say they do, but they don't" (Vogel 2008).

Larry Gagosian, one of Hirst's dealers said, "It sounds like bad business to me. It'll be confusing to collectors. It's a bad move." Gagosian is a flamboyant New Yorker who first gave Hirst an exhibition in 1996 and controls more art space than any dealer in the world: three galleries in New York, one in Los Angeles, two in London, one in Rome. He has plans to take on a temporary space in Moscow and he has an office in Hong Kong.

If Hirst's dealers, Gagosian and Jay Jopling, founder of the White Cube gallery in London, had chosen to turn against him, lot after lot could have failed to reach the prices his work had come to command. "We've come to expect the unexpected from Damien. He can certainly count on us to be in the room with paddle in hand," said Gagosian. This auction had the potential to change the face of art dealing. It is another sensation, the kind Hirst is fond of making every year or so. "Ours has never been a traditional marriage and I look forward to many more adventures to come," said Jopling (*Economist*, September 11, 2008).

Sotheby's motives are easy to understand. In recent years leading auction houses had aggressively turned their businesses into global operations, chasing new wealth in Russia, China, and the Middle East, expanding their services to include "art advice," finance, shipping, and insurance, and moved into the primary market that had traditionally been the dealers' turf. "The final frontier protecting contemporary art galleries from the relentless encroachment of the auction houses has

been emphatically breached," wrote Roger Bevan, art historian and critic, in an editorial in the *Art Newspaper* (Bevan 2008).

The auction was a huge success. The record-breaking $198.7 million was 10 times more than previous prices for art by a single artist. The former Exhibitions Secretary at the Royal Academy, Sir Norman Rosenthal, told London's *Guardian*, "Banks fall over, art triumphs." Hirst said, "I guess it means that people would rather put money into butterflies [referring to his works of butterfly collections] than banks."

The Contemporary Art Market

In the past 25 years more than 100 major new museums have been built around the world, and each one has intentions of acquiring about 2,000 pieces, said Don Thompson, author of a book about the economics of contemporary art (Thompson 2008). With fewer, ever popular, Old Masters or Impressionist paintings coming onto the market, many institutions are buying contemporary art to make their mark. The number of wealthy collectors has multiplied 20 times, and many of them are focusing on contemporary art, the only sector where supply is growing. Collectors want an iconic work, which explains the constantly rising prices. It's the economic principle of supply and demand.

Both Sotheby and Christie's had placed considerable effort into becoming brokers – getting buyers and sellers together. Many pieces that fail to sell at auction are quietly sold afterwards in "private-treaty" deals negotiated by the auction houses. In 2007, Christie's chalked up $542 million and Sotheby's $730 million worth of private after-auction sales, ranking the auction houses among the biggest dealers in the world.

While the timing and reasoning behind Sotheby's decision to have the Hirst auction are obvious, the reasons Hirst wanted to risk his reputation are more subtle. Much of it had to do with his natural impatience, his fondness of breaking the rules and breaking down boundaries, like the very content of his work. Although he had benefited from the contacts and clout that his dealers provided, he was irked by their habit of making potential new buyers prove themselves by waiting before they were allowed to purchase a work of art. "Dealers are gatekeepers who permit artists' access to serious collectors," explained Thompson. "Auction rooms, by contrast, are more democratic. Anyone with enough money can buy what they want immediately."

"I want artists in the future to think I'm cool," says Hirst. "It's like you see this doorway, and you've just got to go through it. My whole career has been like that." As his British dealer and long-time friend Jay Jopling says: "Damien has always been a mould-breaker." Michael Joo, a New York artist said, "This is not life-draining greed; it's another example of Damien maximizing things to their fullest" (*Economist*, September 11, 2008).

Branding Damien Hirst

In 1988, when Damien Hirst curated his first show, he drove his own car to pick up Norman Rosenthal, who was, as noted, the Exhibitions Secretary of the Royal Academy of Arts, to ensure it would be seen by the "right" people. Hirst has produced five basic categories of work. The "natural history" pieces include the sharks in formaldehyde that first caught Charles Saatchi's eye over 20 years ago and made Hirst's reputation. There are also the "cabinet series," of cigarette butts, pills, and medical packages, "spin" paintings, "spot" paintings, and cathedral windows of butterfly wings. That Hirst produced enough work to fill 223 lots in auction at Sotheby's in 2008 had to do with the fact that he was "no longer an artist, in the normal sense of the word, but the head of a global brand selling instantly recognizable work that is made in factories."

Hirst is president of two large industrial units producing the butterfly-wing pictures and his photo-realist paintings in London. In the Gloucestershire countryside he leases two wartime aircraft hangars for the manufacture of the "spot" paintings, the "spin" works, and the formaldehyde tanks. He also has a large workshop and an exhibition studio. More than 180 people work for him, creating Damien Hirsts. Two specialists oversee the formaldehyde unit, which in 2008 contained four dead ponies, a wild boar, an upended cow, and a horse's head in a plastic bag.

In the workshop a device attached to a vacuum cleaner has a small plastic tube with 20 holes cut into it. Cut-down cigarettes, some ringed with lipstick, are inserted into it. When the vacuum cleaner is switched on instant cigarette butts are made (these constituted lot 134 of the Sotheby's auction). In another workshop, three fabricators paint precisely measured round circles at regular intervals on a white background. These are the famed spot paintings that Hirst said were inspired by playing snooker.

The fabricators choose the color of each spot and apply ordinary household paint. The butterfly pictures are made by fabricators who are given the dimensions for the work but who choose their own colors and designs. Hirst gives his final approval, sometimes by only looking at a photograph, before he signs and dates the back of the work. This is reminiscent of guilds in the Middle Ages, or Renaissance Master Studios, or more recently of Andy Warhol's Factory.

Damien Hirst is a wealthy man. His fortune has been estimated at $400 million; his last exhibition at White Cube fetched $260 million. Thanks to his manager, Frank Dunphy, he retains 70 to 90 percent of the galleries' sale prices, rather than the normal 50 percent. Hirst is as famous for being rich and famous as he is for his art.

Recession Reaches Hirst's Studios

The *Guardian* reported, on Saturday, November 22, 2008, that "17 of the 22 people who make the pills for Damien Hirst's drug cabinet series were told their contracts were not being renewed." They are paid about $36,000 a year, sources said. In June 2007, *Lullaby Spring*, a cabinet filled with hand-painted pills, sold for $17.5 million.

Damien Hirst is one of the world's richest artists, whose 2008 Sotheby's sales defied the credit crunch. But even he was not immune to the economic climate.

Hirst is finishing a number of works that required temporary contracts that have not been renewed. A manager of one of the studios said, "We have to be mindful of the current economic climate and how this may affect us in the future." One source noted that the staff seemed unprepared for their job losses. "It was unexpected, especially after Hirst made a killing from the Sotheby's sale."

Hirst said that he would stop making the spin and butterfly paintings, plus the medicine cabinets – a decision that was welcomed by many in the artworld who worried about overproduction of these series.

At another of Hirst's studios where the pill cabinets and butterfly paintings are made, workers would not talk about the job losses. One woman, wearing the Hirst "uniform" of a red sweatshirt with a skull on the back of it (inspired by Hirst's $100 million diamond sculpture *For the Love of God*, 2007), said she didn't know anything about it. A worker

at the Newport Street studio where the spot paintings are produced said she had been told not to talk to the press.

Hirst admitted that art had probably become too expensive in recent years and said he welcomed the prospect of selling his work at cheaper rates in the present climate of recession. Yes, indeed, it's a fine line between art and commerce with discussions to be had about art, aesthetics, and economics.

Feminist Art, Aesthetics, and Art Criticism

Where Were the Women in My Art History Books?

This is so good you would not know it was painted by a woman.
Hans Hoffmann about his student, Lee Krasner in 1937
(Heartney et al. 2007: 10)

Excluded from Art History

Major art history survey textbooks in the 1970s minimized art by women, if they acknowledged them at all. H. W. Janson's *History of Art* contained no women artists or artworks made by women. Not one. Even in the 1986, revised edition only 19 illustrations of women's art (in black and white) appeared along with the 1,060 reproductions of work by men. These exclusions were a catalyst for studying the history and ideas of women artists and for a new approach to art history.

Art historians sometimes discover that an artwork attributed to one artist should instead be attributed to another. For instance, in 1893 the Louvre purchased a painting thought to be one of Frans Hals's finest until the signature of the painter Judith Leyster was discovered. Critical treatment of the painting radically changed and the painting was soon considered inferior to the work of Hals. According to one critic, the painting exhibited "the weakness of the feminine hand." This critic insisted that it was an unsuccessful attempt to copy

Ideas About Art, First Edition. Kathleen K. Desmond.
© 2011 Kathleen K. Desmond. Published 2011 by Blackwell Publishing Ltd.

Hals's style and that "the vigorous brush strokes of the master were beyond their [women's] capability" (Battin et al. 1989: 87).

In 1922, the Metropolitan Museum of Art paid $200,000 for a work it believed to have been painted by Jacques-Louis David. In the 1950s, however, it was determined that the work was probably attributable to Constance Charpentier, a student of David who exhibited in the salons and won prizes in the late eighteenth and early nineteenth centuries. After the painting, *Portrait of Mademoiselle Charlotte du Val d'Ognes,* was attributed to Charpentier, a critic wrote: "Its poetry … its very evident charms and its cleverly concealed weaknesses … all seem to reveal the feminine spirit."

How do we account for the fact that one painting was not seen as expressing a lack of vigor and the other painting not seen as revealing the feminine spirit until each was attributed to a woman? Do you think the critics in these cases noticed properties that previously went unrecognized, or did their beliefs about the gender of the artist determine their perception of the work? Are there stylistic characteristics, expressive properties, and/or special subjects that constitute evidence that a painting should be attributed to a woman rather than a man? Are there some kinds of weaknesses or mistakes that are clues to the gender of the artist? Does the identity of the artist affect how we see and value a painting?

It is absurd to argue from an analogy with wild animals and say that men and women ought to engage in the same occupations. For animals do not do housework.

Aristotle, *Politics,* fourth century B.C.E.
(Guerrilla Girls 1998: 11)

Every woman would prefer to be a man, just as every deformed wretch would prefer to be whole and fair and every idiot would prefer to be learned and wise.

Torquato Tasso, 1573 (Guerrilla Girls 1998: 29)

> *Instead of calling them beautiful, there would be more warrant for describing women as the unaesthetic sex. Neither for music, nor for poetry, nor for fine art, have they really and truly any sense or susceptibility.*
> Arthur Schopenhauer, 1851 (Guerrilla Girls 1998: 7)

In the January 1971 issue of *ARTnews*, Linda Nochlin, professor and art historian, posed the now infamous question, "Why Have There Been No Great Women Artists?" Her essay posed a question that would spearhead an entirely new approach to art history. Nochlin's article offered reasons why no woman had achieved the kind of artistic accomplishment described as "great" like male "geniuses" Michelangelo, Raphael, and Da Vinci had. Nochlin argued that restrictions on educating women, as well as general social expectations of women throughout history, seriously precluded any emergence of "great" artists. Further, she explained, the term "great" had been defined by men and was not particularly applicable to the kind of accomplishments achieved by women.

Feminist Art History

The Feminist approach to art history researched the women who had been discriminated against as artists in the past. Feminist art historians recovered information about the contributions of women artists and patrons and added their accomplishments to history. Not much was known about women artists before this concentrated research effort by Feminist art historians and critics began in the 1970s.

Feminist researchers faced several problems in recovering data about women: for instance, women were married around age 14 in medieval times and were preoccupied with children, child rearing, and household chores, and they made unsigned objects like altar cloths, embroideries, and manuscripts. One of the most significant problems faced by women in history was their lack of education. Women could not travel freely to study art in other parts of the world, nor could they study math or science, and they were most definitely not allowed to study anatomy or work from nude models. Women and girls were not educated like boys and men in the

Western world, as evidenced from documents that date to the time of Socrates. Early women artists had in common male relatives with studios who provided them with space, art materials, and training, including studies from still life models, the only models at hand.

Key issues contributing to the difficulties of constructing a history of women artists included the scarcity of biographical information and anonymity. Even when the names of women artists were discovered, women changed their names to their husband's name when they married, and they were sometimes lost and difficult to "find" again. Women's changed last names, combined with a research system based on patriarchal surnames, created difficulties in identifying women and problems trying to establish individual artistic careers of women. This is why nuns or wealthy, literate women were the only names of women artists that could be found up until about the sixteenth century.

Incorrect attribution is also a problem. During the eighteenth and nineteenth centuries, work by women was often reassigned. Some dealers even went so far as to alter signatures, as in the case of some paintings by Judith Leyster. And, as one saying goes, "Anon. was a woman." Women artists made works that were typically unsigned, like weaving, embroidery, lace, altar cloths, and illuminated manuscripts. The impermanence of these media and the fact these objects were functional meant they were used and they wore out. Further, women worked in workshops and guilds under a male "master." Guild rules disallowed women from attaining the rank of master, so women were "unofficial," unacknowledged, and excluded. Work signed by the workshop master made it difficult to authenticate art made by male and female artists.

Wendy Williams, a law professor, explained that we tend to notice the people we identify with the most, and because white men have written Western history, white men are noted in those histories (Jacobs 2007). If men define greatness, it's less likely that women are going to fit the bill, noted Anne Dawson, a professor of art history (Landi 2003). Once researchers figured out who some of the women artists were in history, would it be accurate to talk about them in the same terms as men? For instance, "great"? Currently, we don't talk about artists being great because we don't know how to define "great" or how to justify it. Traditional critics and art historians claimed art by women or people of color didn't meet their "impartial" criteria for "quality," which place a high value on art that expresses white male experiences and a low value on everything else.

In 1528 the Italian diplomat Baldassare Castiglione published the radical pronouncement that all aristocrats, male and female, should be trained in the social arts, in the popular *The Book of the Courtier.* Previously it had been considered dangerous to teach females to read and write. Women should know how to write poetry, dance, sing, play a musical instrument, make witty conversation, and paint, proclaimed Castiglione. These skills would prepare them to be interesting companions for aristocratic Renaissance men, he said. Of course Castiglione's ideas were irrelevant to lower-class women, but they were significant for nobility and ambitious members of the middle class. In the sixteenth century, Castiglione's advice was taken to heart, primarily in Italy and the Netherlands and then in England, where women artists emerged and their careers flourished.

The Guerrilla Girls are a group of contemporary women artists who remain anonymous by dressing up like dead women artists with gorilla masks and picket galleries and museums around the world with humorous signs supported by research about the representation of women and people of color in museum and gallery exhibitions. The Guerrilla Girls claim to be "the conscience of the artworld." For instance, they ask, "Do women have to be naked to get into the Met Museum?" and they explain, "Less than 5% of the artists in the Modern Art sections of the Metropolitan Museum are women, but 85% of the nudes are female" on their posters (Guerrilla Girls n.d.). The Guerrilla Girls restate Linda Nochlin's question about "great women artists" and ask instead, "Why haven't more women been considered great artists throughout Western history?" They conclude, "The history of Western art has been a history of discrimination … both of women and of people of color" (Guerrilla Girls 1998).

The Guerrilla Girls ask, "If February is Black History Month and March is Women's History Month, what happens the rest of the year? "Discrimination" is their answer. In a public service message they opine, "When Racism & Sexism are No Longer Fashionable, What will Your Art Collection Be Worth? The art market won't bestow mega-buck prices on the work of a few white males forever. For the 17.7 million you just spent on a single Jasper Johns painting, you could have bought at least one work" by each of the 67 women and artists of color listed. They further report, "Women in America earn only 2/3 of what men do and Women Artists earn only 1/3 of what men do." The Guerrilla Girls point out, "You're seeing less than half the picture without the vision of women artists and artists of color" (Guerrilla Girls 1998).

The Guerrilla Girls applaud Feminists (and themselves as well) for transforming the field of art, history, and philosophy, making room for the point of view of the "other." They have made people aware that what most of us learned as objective reality was actually white male reality. Further, they claim, more women's art has been exhibited, reviewed, and collected than ever before. Dealers, critics, curators, and collectors are fighting their own prejudices against women and artists of color, and the Guerrilla Girls take some of the credit for this. Recently, they documented exhibitions of openly gay and lesbian artists and exhibitions that attempt to explore homosexual sensibility. Few art historians cling to the idea that there is a mainstream and that art develops in a linear direction from artist A to artist B. In the current Postmodern era, more kinds of art practice and more kinds of artists are accepted and written into the historical record. This is a creating a truer, richer picture of the present and the past.

The Feminist Movement

The Feminist Movement corresponds to an intellectual and scholarly movement that began in the 1960s and continues to the present. It includes philosophers with interests in aesthetics, ethics, social/political philosophy, and epistemology. Feminist philosophers pursue the primary questions of their individual fields, with an eye on biases based on gender, race, class, sexual orientation, or ethnicity. Women's experiences play a crucial role in the discussion of basic philosophical issues, especially if they differ from those of the dominant male society.

The Feminist Art Movement

The Feminist Art Movement established the prominence of women artists identified in art history and the recognition of Feminist artists currently working. Feminist aestheticians study primary questions about aesthetics and underlying assumptions both historically and conceptually. Feminist art historians seek to correct the historical record, and Feminist art critics provide a context for Feminist art.

Feminist art is not just art made by women. It has as its content issues and ideas specific to women in a patriarchal society. Such art encompasses the narratives of uniquely female experiences. These expressive narratives

of women's lives and experiences have previously gone unrecognized by male art critics and art historians because they did not fit the male-made "canon" or criteria for art. Feminist content becomes paramount in assessing standard questions in art and philosophy as well as traditional art historical methodologies.

The Feminist Art Movement changed women's status and the "ways we look at our field," claimed Laura Hoptman, Curator in the Department of Painting and Sculpture at the Museum of Modern Art, New York (Landi 2003). We no longer think of art history as a monolithic story that has to be told and retold, but as a series of stories, she argued. Feminist art historians, philosophers, critics and scholars look at the art object or art experience in the context of the time and place in which it was produced. They study not only who produced the work and what she was thinking, but where and when she lived, who she was hanging out with, what schools she went to, whether she was rich or poor, whether she was making work for her boudoir, whether she was going to sell it, or whether she was making it for a commission. All of these matters create the context.

From 1973 to 1991, the Los Angeles Woman's Building, a non-profit public art and educational center, focused on showcasing women's art and culture. In 1976 Ann Sutherland Harris and Linda Nochlin curated *Women Artists: 1550–1950*, which was exhibited at the Los Angeles Museum of Art. In 2005 the Feminist Art Project began documenting the achievements of the Feminist Art Movement from its beginnings in the 1970s. The Feminist Art Project (*feministartproject.rutgers.edu*) is a national collaboration celebrating the Feminist Art Movement and the aesthetic, intellectual, and political impact of women on the visual arts, art history, and art practice, past and present. Its mission is the strategic intervention against ongoing erasure of women from the cultural record and re-focusing public attention on the achievements of the Feminist Art Movement. It catalogs current Feminist art influences, accomplishments, and trends in the archives of the Foster Center-Douglass Library, Rutgers University, in New Jersey.

In 2007 the Los Angeles Museum of Contemporary Art featured *Wack! Art and the Feminist Revolution*, a comprehensive, historical exhibition that examined the international foundations and legacy of Feminist art. It advanced the Harris and Nochlin exhibition, and focused on the period 1965–80. *Wack!* included 120 artists from the United States, Central and Eastern Europe, Latin America, Asia, Canada, Australia, and New Zealand. Also in 2007, the Brooklyn Museum presented *Global Feminisms, New Directions in Contemporary Art*, an international exhibition exclusively

dedicated to Feminist art from 1990 to the present. The show consisted of work by women artists from around the world and included painting, sculpture, photography, film, video, installation, and performance. Its goal was to showcase a large sampling of contemporary Feminist art from a global perspective.

Global Feminisms used the year 1990 as a marker for when race, class, sex and gender, and, more importantly, the intersections of these social factors, emerged from 1970s research and became the inclusive focus of contemporary art influenced by a Feminism no longer defined exclusively by Western Feminist articulations. The plural use of the word "Feminisms" and "activisms," the exhibition catalog claimed, constituted "not only a revelation of the creative energy of women and their art throughout the world, but equally, a reclamation of difference as a major positive force in the human situation." It is only through the acceptance of difference in its many varieties that art and society can change. *Global Feminisms* helped articulate terms that move beyond endless teasing and misunderstanding of the word "Feminism."

Excerpts of these books and exhibition catalogs are available on-line. Look up one of these catalogs like *Wack! Art and the Feminist Revolution* or *Global Feminisms, New Directions in Contemporary Art*. Make a list of the artists whose work interests you the most. Note some facts about each artist along with why her work caught your attention. Use this chapter to help you develop your own ideas for explaining women artists and their art.

Feminist Art Historians and Feminist Art Critics

The Feminist approach to art history is based on the idea that gender is an essential element in understanding the creation, content, and evaluation of art. Like other art historians (Marxists, for instance), Feminist art historians objected to evaluating art on formalist terms and thought instead that works of art, as well as artists, reflect their cultural context. Neither art nor artists could be understood apart from their context, thought Feminists. Feminist art critics questioned Clive Bell's early twentieth-century essentialist, formalist theory of "significant form," and asked: to whom must the form be "significant" to count as art? This question challenged traditional assumptions about art history and the nature of art and the criteria by which art had been judged.

At the center of both Feminist art history and art criticism was the question of the traditional canon of the "Old Masters." Should that canon be

rejected? Replaced? Reformed? What differences could Feminist interventions in art histories make? Should the all-male succession of "great artists" be rejected in favor of a litany of women artists? Leaders in Feminist art history, like Griselda Pollock, took a hard look at male canons and avoided the unexamined celebration of women artists. Pollock (1999) drew on theories of psychoanalysis and deconstruction to scrutinize the signs of difference that might be in art made by a woman artist. She argued that in order for differences to be understood as more than the patriarchal binary of Man/ Woman, differences between women that are shaped by the racist and colonial hierarchies of Modernity must also be acknowledged.

Feminists often serve both art criticism and art history by seeking knowledge about overlooked meanings of art and examining assumptions and biases of previous art historians and art critics. They develop ways of writing about art that can serve as models for art critical discourse. Traditionally, art historical methodology answers questions about art like "Who made it? Where? When? How?" Traditional art historians do not often satisfactorily answer the question "Why?" because they try to maintain "intellectual neutrality." Art critics, on the other hand, primarily write about the art of their own time and attempt to analyze and interpret the social and conceptual contexts of the artwork.

Feminist art critics join art historical and art critical practice by linking art with factual information such as the artist's biography, sources of the individual artist's work, and stylistic connections with other artists and art movements. While some think Feminist art criticism lacks intellectual neutrality, Feminist historian/critics like Arlene Raven believe in an intimacy with art (Frueh 1991). Raven works for complete identification with the art, through it and its creator. The subject, the object, the artwork, other human beings, the artist, and the critic are not detached at all. The object no longer exists as an object. In this kind of criticism, the term "art object" doesn't make sense. Nancy Marmar explained that this kind of "criticism weaves the fabric of its content out of the critic's subjective, psychological response to the work thus absorbing the artist into the critic's mental universe" (Frueh 1991: 51).

Feminist Criticism

While there were exemplary practitioners of Feminist art criticism (Lucy Lippard, Roszika Parker, Griselda Pollock, and Arlene Raven), Feminist literary criticism was more evolved and went through several stages that

served as models for Feminist art criticism. Too simply put, the first stage was the restoration of lost or ignored women artists and their works to the historical record. The second stage considered a women's tradition as either counter to or related to the male tradition and added women to the historical mix rather than keeping women and their contributions separate. A third stage was more theoretical and attempted to connect the literary text or art object, experience, or performance with its historical context and culture. Feminist criticism is significant and necessary because it challenged the "dog-eared myth," as Annette Kolodny called it, of "intellectual neutrality" (Frueh 1991: 54). If Feminism is a politics rather than a methodology, it is legitimate to utilize and transform all available tools, including male theory and methodology. Feminist engagement with theory has been rich and fruitful. These very brief explanations of Feminist criticism require further consideration gleaned from your own research.

Feminist Art Criticism

Lucy Lippard was one of the first Feminist art critics. She admitted to responding to other women artists' insecurity and sense of inferiority, as well as her own, when she disregarded women's work in favor of men's in the late 1960s and early 1970s, thinking her reputation depended on male support and respect.

In the early 1970s, questions about women's art included "is there such a thing as women's art and if so what is it like?" Lucy Lippard thought the debates about Feminist art theories and their refutations in the early 1970s were rewarding because they helped artists and art critics develop aesthetic directions and define more clearly the fabric formed by the many threads of individual maturity. It seems politically and aesthetically crucial, she said, that the work done in the 1970s not be forgotten and that connections to succeeding decades be clarified.

Art critic and performance artist Suzanne Lacy (1994) said her recollection of the impetus of 1970s Feminist art came from the larger world of political action. The goals were to align cultural production with a clearly defined set of political values. There was no distinction between art based on identity investigations of being a woman and art that explored new relationships with its audience. It was all from the same political agenda: the transformation of the power differential between men and women. This agenda also included an activist approach to racial inequality and class

inequality, even if naïve by today's standards in its lack of theory in Feminist art analysis. Norma Broude and Mary Garrard bring a significant understanding of the historical and theoretical impact of the American Feminist Art Movement of the 1970s in their 1994 book *The Power of Feminist Art*.

Arlene Raven published what she jokingly thought would be "the last essay on feminist criticism" in an anthology of *Feminist Art Criticism* in 1988. The essay is a discerning look at the history of Feminist art and Feminist art criticism that includes insightful statements by artists, curators, art historians, and art critics along with illuminating visual descriptions and responses to performances and exhibitions of Feminist art through the end of the 1980s. Raven described the art and ideas of the Feminist essentialists of the 1970s, who focused on the art of women's bodies, and the Postmodern deconstructionists and appropriationists of the 1980s, who focused on femininity as a social construction, and the battle that both waged during the misogynistic Reagan administration in the 1980s. Conceptual and sensual Feminist perspectives coexisted during the 1960s and 1970s and "sexism in the art world as elsewhere went hand in hand with racism and prejudice, as it always had," she said (Raven 1988: 235). Raven acknowledged that the 1976 *Women Artists: 1550–1950* exhibition curated by Linda Nochlin and Ann Harris gave Feminists the opportunity to assess progress and address the deficiencies that still existed.

Art historian, critic, and performance artist Joanna Frueh chided-super intellectualized Feminists of deconstruction as "being too cold." Frueh thought Feminism should not be assimilated into the artwork as a marginal voice. Money, male stardom, and heroism represent conservative values she said, and "feminism can never, must never be conservative" (Raven 1988: 234).

Lucy Lippard noticed that "Feminism, and the changes it has wrought, are taken for granted by most of the younger generation – either dismissed as accomplished or dismissed as irrelevant to their lives (which of course they'll find out it isn't…)" (Raven 1988: 237). Heartney, Posner, Princenthal and Scott, in their 2007 "Introduction" to *After the Revolution*, wrote that younger women artists are disconnected from and even uncomfortable with Feminism generally and the Feminist Art Movement in particular. "When they hear the 'f-word' this generation of women artists tends to think of the early stages of activism and essentialism, of a feminism they reject for its associations with anger and a sense of victimization, and for being devoted to simplistic, retrograde representations of the female body" (Heartney et al. 2007: 21), and even the caricature of rejecting all that was

male and a disapproval of heterosexuality. Some of these young women artists seem unaware of the profound impact Feminism and its subtle influences have had and tend to dismiss Feminism as an outmoded ideology.

Linda Nochlin posed the question about what had changed as a result of the Feminist Art Movement/revolution in the "Foreword" of *After the Revolution*. The results of the Feminist Art Movement have been so profound and that they have become so assimilated and normalized that they are no longer noticed, she wrote. "Changes have become part of the unconscious fabric of our lives" (Nochlin 2007: 7). In cultural terms the powerful presence of women artists in contemporary art has become an accepted fact. The broader social and cultural revolutions –black, gay, Feminist, post-colonial – that have taken place since the 1970s are still going on today. Women are nowhere near equally represented in art journals, art galleries, art museums, sales, or commissions, and equality of opportunity across gender (and race and class) remains an elusive goal, but the barricades are gradually coming down and work proceeds on all fronts. Lucy Lippard's wish of the Guerrilla Girls for "more acknowledgement of the diversity of activist feminist art that is not just art world-centered" (Raven 1998: 237) is worth noting here.

As inspiration to future generations of artists, contemporary women artists bear witness to the revolution that has taken place in art. The range and variety of stylistic and expressive projects of women artists are understood for their difference rather than their similarity. Whether they are "great" or not is a stodgy and fixed question of the past that is dead and gone, said Nochlin. The women artists in *After the Revolution* – Louise Bourgeois, Nancy Spero, Elizabeth Murray, Marina Abromovic, Judy Pfaff, Jenny Holzer, Cindy Sherman, Kiki Smith, Ann Hamilton, Shirin Neshat, Ellen Gallagher, and Dana Shultz – "show a vitality, originality, malleability and incisive relationship to the present and all that it implies" (Nochlin 2007: 8). These women artists' ability to deal with darkness, negativity, and ambiguity rather than some mythic status that would confine them to fixed eternal truth is a testament to their sense of being both revolutionaries and post-revolutionaries at the same time.

> *The history of all times, and of today especially, teaches that … women will be forgotten if they forget to think about themselves.*
> Louise Otto-Peters

Feminist Aesthetics

Aesthetics as an area within philosophy owes much to Plato and Aristotle, and in the resurgence of aesthetics in the eighteenth century it owes much to Kant. In previous eras comparatively little work was done in aesthetic theory, but today it is burgeoning. Thus, the time is ripe for new twists and turns and Feminist aesthetics can be one of the ways of reviving aesthetic thought. Like all philosophy, Feminism questions authority. Instead of simply replicating past methodologies and topics of interest, new questions are posed. Such investigations offer ideal ways to investigate gender within aesthetics, particularly as it relates to aesthetic power.

Art is gendered in a significant way, so it must be taken into account in order to understand it fully. The influence of gender has not been adequately accounted for within aesthetics. Feminist aesthetics is not a way of evaluating art or experiences of it – the role of art criticism – but rather it is a way of examining and questioning aesthetic theory and its attitudes toward gender. Sarah Worth wrote about the main tenets of Feminist aesthetics and showed how it can serve as a useful critique of historically dominant aesthetic theories in her chapter "Feminist Aesthetics" in *The Routledge Companion to Aesthetics* (Gaut and Lopes 2001).

In 2007 the Feminist Caucus session "What is the Future of Feminist Art in a Post-Feminist Age?" at the American Society of Aesthetics conference in Los Angeles, session chair Peggy Brand posed questions to participants such as: "What does it mean to say we live in a postfeminist (or post-post-feminist) age?"; "Are feminist artists reliquaries of the past?"; "How do we teach 1970s feminist art to new generations of women who shun the F-word?"; "What is the future of feminist and aesthetics?"; and "Is there a(ny) significant future for feminism *within* aesthetics?" Brand's pithy summary is significant: "I'll be Post-Feminist in the Post-Patriarchy."

Why So Few Women?

Peggy Brand, artist and Feminist aesthetician, initiated the stories at the beginning of this chapter and also wrote "Mining Aesthetics for Deep Gender" in 2005 for the American Society for Aesthetics. She related another story and current statistics to explain why there are so few women philosophers.

In 1771, artist Johann Zoffany was commissioned to execute a group portrait of the 36 founding members of the prestigious and conservative British Royal Academy. Two of the founding members were women. Zoffany was faced with the challenge of depicting these two women in the official portrait celebrating the academy's historical beginnings that would teach future generations about the traditional ideals of academic art and artists.

Even though both Angelica Kauffman and Mary Moser were well respected for their artistic talents and their productive output was considered comparable to that of their male colleagues, Zoffany excluded them from the main depiction of the male artists grouped around two nude male models. Instead of being pictured with artists talking about the heroic male nude, Kauffman and Moser were relegated to architectural niches in the wall above the main scene. (Everyone knew that women had been prohibited from working from nude models since the sixteenth century.) Portrayed as busts, with less than accurate likenesses, they lost any sense of identity, agency and creativity. Art historian Whitney Chadwick observed that the artists had became objects of art rather than producers of art. Kauffman and Moser were denied their rightful pictorial role and were relegated to the plaster casts that were objects of contemplation and inspiration for male artists.

Zoffany's depiction of female absence is a powerful starting point in thinking about the role of gender in the history of aesthetics. The painting captured the long-held male sentiment that only males were granted the accolade of "genius" and only male artists created "master" pieces. Women artists were an aberration, but not more than women philosophers, who were absent altogether. Only men wrote about nature, art, and beauty. Women were notably absent from modern aesthetics until the twentieth century.

Why So Few Women Philosophers?

The question of "why so few women?" requires a Feminist critique of art, art history, and the philosophy of art. The Feminist critique seeks to dismantle traditional philosophical aesthetics and question underlying assumptions both historically and conceptually. A simple answer to "why so few women?"

is that there were few educated women and few women in the arts, either as practitioners or as theoreticians.

For centuries, philosophical and theological teachings justified the exclusion of women from education and the professions. Today when women look for mentors they find the number of women in philosophy low, around 20 percent of the total faculty in institutions in the U.S. This under-representation of women philosophers in institutions of higher education calls for an analysis of the social conditions limiting women's access to education. Feminist philosophers seek meaningful explanations and solutions to the problem of female absence in philosophy. They are intent on pursuing the basic questions of their individual fields, with an eye toward biases based on gender, race, class, sexual orientation, or ethnicity.

Feminist aesthetics has been fruitful owing to the efforts of philosophers like Carolyn Korsmeyer, Hilde Hein, Peggy Brand, and Sarah Worth and art critics like Lucy Lippard, Joanna Frueh, and Arlene Raven, to name a few. Through these and many others' efforts, Feminist art scholarship has come to the forefront. Look up these philosophers and art critics on your own, in a Dictionary or Encyclopedia of Philosophy, not in a College or Webster's Dictionary. Make a list and jot down talking points to use in future discussions about Feminist aesthetics.

"Made in America"

Jaune Quick-to-See Smith, a Salish and Kootenai Indian woman, exhibited her work in a one-person show called *Made in America* at the Belger Arts Center in Kansas City in 2003 (Smith 2003a). Smith's story describes some of the challenges and oppression faced by an American Indian woman artist and how she became one of the most significant artists today.

In 2002 the Women's Caucus for Art presented Smith with a lifetime achievement award at the College Art Association Annual Meeting. Those who attended the ceremony just wanted to be in her quiet, confident, generous, gracious, warm, and supportive presence. She thanked many others – Native peoples, women, and the artworld – for the award.

Jaune Quick-to-See Smith made important art in remote places and under oppressive conditions. Her work is sold in galleries in New York, San Francisco, and Santa Fe. In fact, her work had representation in New York before her male art teacher, who, after she had studied with him for an entire year, called her to his office to tell her women couldn't be artists. That was in 1958. Even though

she didn't think that sounded right (she knew she had been drawing circles around the men in the class), she believed him and enrolled in the School of Social Work, University of Washington.

Almost everyone in the United States who has studied art has heard of Jaune Quick-to-See Smith and seen her work, even if they don't know how to pronounce her first name: not Jane, not Jean, not Juan; it's soft – a yawn with a J. J Awn. Her first name is French Cree and she is of Shoshone, Metis (French Cree), and Flathead Salish ancestry. Her middle name, from her grandmother, means "insight, perception." She is enrolled in the Confederated Salish and Kootenai Indian Nations. Her enrollment number is 07137. She's lucky to have enough blood from not more than six tribes to be officially recognized by the government as Native American and is eligible for federally sponsored programs. Less luckily, she also experiences the oppression that comes from colonial governance, like being forced to give up Indian language, culture, resources, and land. Her Tribal Nation employs 50 lawyers to protect tribal resources and treaty rights. Still, Indian people refer to the United States as "Indian Country," says Smith.

Thinking in her head, but not speaking the words, or the "sneak up," as she calls it and as her father taught her to do (and as many Indians have learned to do), Jaune Quick-to-See Smith set out to tell about her experiences as a Native American woman. With icons and symbols – Catholic, Native American, and Euro-American – Smith layers meaning using a variety of media. She paints, draws, makes prints, and uses collage. Recently she tried her hand at installation. Artists she studied, Andy Warhol and Jasper Johns, used these media and similar subject matter in their Pop Art pieces, but Smith takes these media and subject matter in her own direction. She appropriates images from art history (Pop Art) just as readily as from her Native culture. While Pop Art is a Modernist genre, Jaune Quick-to-See Smith's appropriations are Postmodern.

Lucy Lippard noted in her book *Mixed Blessings* (1990) that when non-Western cultures appropriate Western Modernism it is thought of as derivative. The dominant culture tends to filter local art history, seeing only what is familiar and marketable, and rejecting what does not fit into the "framework." Art made by "others" is still viewed as though it was made for export to the "real" U.S.A. It wasn't until the 1980s that exhibitions began to be organized by content rather than by object, making a suitable climate for Smith's work. Still, access to information about global art is often restricted to educated and well-traveled Western artists and not to the "dehistoricized cultures. This constitutes a dilemma for the nonwhite artist, whose work

may even be called derivative just because its authentic sources have already been skimmed off by white artists" (Lippard 1990: 26).

Jaune Quick-to-See Smith (2003a) says: "When Native Americans refer to Indian art, it is automatically assumed to be 'traditional' by white critics, even when it transcends tradition and is mixed with European styles." Smith denies that when Native peoples incorporate Modernism into their art they become, in the process, "inauthentic." She says they are acknowledging the reality that they live in two cultures: "Dying cultures do not make art. Cultures that do not change with the times will die. Sentence structure, accents and body language can be retained for as long as three generations before a language is lost." All 26 tribal colleges now teach their own languages, with textbooks, courses, and computer programs, for the preservation of Native languages.

When Smith (2003a) talked about her work in *Made in America* at the Belger Arts Center, she was very aware of language – both hers and Westerners' oral and body language. She thinks that her "right brain" thought process, with its dependence on imaging, relates to the sign language, glyphs, and pictograms that are complexly developed in pre-contact Native peoples. She has found many in her community who agree:

> My feelings about my ethnicity and the land build metaphors … a language of my own for events which take place on the prairie. I place my markings onto a framework in homage to the ancient *travois*: in a sense, piling my dreams on for a journey across the land. Smears and stains of pigments with the crudeness of charcoal are aboriginal and prehistoric to me.

The overall energy conveyed in Jaune Quick-to-See Smith's work is charged by constant motion and central stillness. It is more or less abstract and figurative, characterized by a vision of the world in which change reigns and hierarchies are absent. Smith utilizes what she describes as typical Native humor, which can be seen as "dark" or at least self-deprecating, together with ancient and popular Euro-American and Native and Catholic images. (She was reared on a Catholic Reservation in Montana.) Often her work depicts multi-perspective landscapes that are simultaneously structured and tumultuous with a vast geometricized space inhabited by stylized horses, coyotes, rabbits, indigenous plants, wells, water jars, and petroglyphs. She calls these "narrative landscapes." When you grow up in this environment, life is not romantic, and when it's as low income as Smith's was it centers on survival for food and shelter. Thus language and living are not embellished, they are simple and direct. "I paint in a stream of consciousness so that pictographs

rocks up behind me muddle together with shapes of rocks I find in
I, but all made over into my own expression. It's not copying what's
ᴜᴜᴄᴜᴇ, it's writing about it" (Smith 2003a).

Making the Self Extraordinary

Contemporary American artist Joyce Jablonski's primary attitude about art
making is her quest for understanding her world and its physical, psycho-
logical, and spiritual nature. It is about looking into herself and finding the
spiritual and psychological. It is about using ideas to make something
extraordinary and special.

Jablonski adheres to Ellen Dissanayake's claim that humans seek to
make their life experiences "special," so she engages in the process of art
making as ritual. Jablonski thinks music, mathematics, numbers, genetic
code, and art all have ritual processes. She actively engages in creating pat-
terns and rhythms from shapes. She thinks shapes evolve from geometric
and bilateral to biomorphic and anthropomorphic. She uses the ontology
of natural shapes and juxtaposes them in different contexts to change their

Figure 9.1 Joyce Jablonski, American (b. 1956). *OV #3*, 2001. Terracotta, slip,
glazes, plexiglass, steel, porcelain, insulator, 55 × 32 × 18 inches.

Figure 9.2 Joyce Jablonski, American (b. 1956). *Baker's Dozen*, 2001. Terracotta, slip, glazes, plexiglass, insulator, 56 × 20 × 18 inches.

meaning: for example, heart/passion/life, ovary/female/reproduction/ sexuality. Vessels are assumed to be female when they are open and male when they are closed, she says. Jablonski uses organic shapes like flowers, fruits, pods, body parts, and internal organs in her ceramic pieces, like *Baker's Dozen* (2001) and *OV #3* (2001), and notices how they revert to their "androgynous nature – the way things are in the world. It's duality, dichotomy, yin/yang, male/female. Female/internal. Male/external" (Desmond 2004a).

Conclusion: Plan of Action

What conclusions can you draw about the artworld after reading this chapter? List obstacles women and people of color face in the fine art and commercial art world. Engage in a discussion with two or three others and compare notes. Come up with some actions/solutions to address these problems that you think will work. List the steps necessary for implementation of your plan. Put your plan into action!

10

Postmodernist Art and Attitudes

Mona Lisa and the Museum Guard

In a story about "A Fire in the Louvre," readers are told the Louvre is on fire and asked to decide if they would save the original *Mona Lisa* painting by Leonardo da Vinci that is preserved there or the elderly, injured museum guard standing next to the painting. Only one can be saved, not both, no matter how creative a solution can be devised. This dilemma is intended to get readers to consider that values overlap – in this case, the aesthetic value of an extraordinary artwork that has become a symbol of Western human artistic achievement and the value of human life. Most young Americans have no trouble choosing to save the museum guard. No matter how much discussion ensues, even among art students, *Mona Lisa* rarely wins out. Do contemporary technology and Postmodern attitudes have something to do with this choice between values?

Another "Ism"

Changes in attitudes – political, economic, social, and psychological – are reflected in art and culture from Classical Greek and Roman to Renaissance and Baroque and in a variety of "isms," each reacting to the one before it, through the American, French, and Industrial Revolutions to Modernism, an attitude that adopted abstraction to express the new studies of psychology

Ideas About Art, First Edition. Kathleen K. Desmond.
© 2011 Kathleen K. Desmond. Published 2011 by Blackwell Publishing Ltd.

and sociology. *Post*modernism refers to a reaction against Modernism, or an adaptation of it, or just plain what came after it.

Postmodernism is a broad term that is difficult to explain because it is so all-encompassing, slippery, and, for some, even infuriating. Books, articles, and websites are devoted to every aspect of Postmodern attitudes and ideas. Sometimes Postmodernism is ridiculed and other times it is cool to drop the word into conversations. The term even shows up in commercials, television, radio programs, and movies. Garrison Keillor worked Post-modernism into his radio show *Prairie Home Companion* in 2009. Some intellectuals think we are beyond Postmodernism, others fail to acknowledge it in the first place, and still others treat it with suspicion, like Victor Burgin, who explains in his book that we are at *The End of Art Theory* (1986). No matter how annoying or engaging, or how critical or popular, Postmodernism seems to be, however, it cannot be ignored.

Postmodernism

Postmodernism refers to a plurality of theories, attitudes, ideas, and experiences (often conflicting) that came about in the mid-twentieth century. Postmodernism literally means after Modernism. It is also a set of perspectives used in critical theory that refers to a point of departure from Modernism for visual art, design, film, drama, literature, architecture, business, marketing, law, and culture. Postmodernism is also an aesthetic, literary, scientific, political, social, and cultural philosophy. It attempts to describe certain conditions, states of being, and points of view concerned with changes from previous conditions. It is a new way to understand a new world. Postmodernism is a global cultural and intellectual phenomenon. Attempting to define it violates a Postmodern premise that no definite terms, boundaries, or absolute truths exist.

As with previous "isms," Postmodernism tends to react to the principles and practices of its predecessor, Modernism. In visual art, Postmodernism was probably first seen in architecture as architects moved away from the unadorned, impersonal boxes of concrete, glass, and steel that defined Modernism to complex shapes and forms and appropriated styles from the past without regard to their original purpose or function. Postmodernism is also about philosophical relativity. Truth, culture, ethics, politics, art, and aesthetics are all relative. In Postmodernism, no idea or expression or belief can be more credible than any other. All ideas are equally valid.

The infuriating and slippery part of understanding Postmodernism may be due to the many and diverse theories, philosophies, attitudes, and ideas. These next pages prove the point. It's impossible to explain Postmodernism in this short chapter, but it is possible to explain a few of the facets of a few points of view.

Before Postmodernism There Was Modernism

Postmodern debates have dominated cultural and intellectual arenas throughout the world for the past few decades. Aesthetic and cultural theories question whether Modernism in the arts is dead or not and what sort of Postmodern art is succeeding it. Philosophical debates continue about whether or not modern philosophy has ended, and new Postmodern philosophies associated with Martin Heidegger, Jacques Derrida, Michel Foucault, and others have emerged, as have new social and political theories and explanations of the multifaceted aspects of Postmodern phenomena. Nevertheless, since there is no unified Postmodern theory or coherent set of positions, providing a decisive explanation of Postmodernism is impossible.

Both Modernism and Postmodernism include economic, political, social, and cultural transformations. To some thinkers, Modernity opposed traditional societies and is characterized by innovation, novelty, and dynamism. Theoretical discussions that began with René Descartes and continued through the Enlightenment in the seventeenth and eighteenth centuries advocated reason as the source of progress and knowledge in society. Reason was considered the theoretical and practical norm upon which systems of thought and action could be built and society could be reconstructed. This kind of Modernity was operative through the American, French, and Industrial Revolutions and into the twentieth century and attempted to produce a just and egalitarian social order that would embody reason and social progress.

Aesthetic Modernity emerged as twentieth-century avant-garde art movements rebelled against the alienation of the industrial world and modern "reason" and sought to transform culture through creative self-realization. Modernism was a term for exploring the individual, secular, urban, industrial, rational, and cultural differentiations that all formed part of the modern world. Modernity also had negative effects. It produced oppression of the working class (proletariat), of artists who were exploited by capitalism, of women who were excluded from the public sphere, and it led to the

genocide of imperialist colonization. Defenders of Modernity, however, claimed that these destructive effects could be overcome by potentials and resources that remained unfulfilled.

Some Postmodern Theories

Postmodern theorists claim that in today's high-tech society, processes of change are producing a new Postmodern society. Proponents claim Postmodernism is a new and novel stage of history and cultural transformation that requires new concepts and theories. French theorists such as Jean Baudrillard and Jean-François Lyotard claim that technologies like computers and media, new forms of knowledge, and changes in the socio-economic system are producing a Postmodern society, and they interpret these developments in terms of new types of information, knowledge, and technologies. American neo-Marxist Fredric Jameson interprets Postmodernism in terms of development of a higher stage of capitalism marked by a greater degree of asset diffusion and homogenization across the globe. These conditions produce cultural fragmentation, changes in experience of time and space, subjectivity, and culture, and new modes of experience. They create a basis for Postmodernist claims to be on the cutting edge of current ideas and experiences.

Some of these new ways of seeing the world include the loss of credibility of master narratives (or meta-narratives) like those of Kant, Hegel, and Marx, who argue that history is progressive and knowledge can liberate us and that all knowledge has a secret unity. Two main master narratives attacked by Jean-François Lyotard are the emancipation of humanity (as in Christian redemptive beliefs and Marxist Utopianism) and the triumph of science. Lyotard defined Postmodernism as skepticism toward meta-narratives. Another important Postmodern ethical argument is the relationship between traditionally recognized discourse (disciplines like law, medicine, and aesthetic judgment) and power. Power, in this case, is in the form of authority of the discourse, like those of doctors and lawyers. Fredric Jameson thinks a defining sense of the Postmodern is the disappearance of a sense of history in the culture, a pervasive depthlessness in which the memory of the tradition is gone. Michel Foucault was one of the French thinkers who wrote about the power of the use of language as one of the main intellectual disciplines. Foucault writes about how power and knowledge interact and become "signs." The politics of social, psychological, spiritual, gender, and cultural identity is a major Postmodern theoretical issue.

Lyotard thought it was the role of artists to question the role of the meta-narratives of Modernism that were used to legitimize certain kinds of modern artwork. He invited artists to question earlier painting traditions and the narratives that supported previous rules of painting that they had learned from predecessors.

Critical and cultural theories of Swiss linguist Ferdinand de Saussure and French intellectuals Roland Barthes, Jacques Derrida, Michel Foucault, and Jean Baudrillard have had major effects on visual art. These thinkers developed methods to describe their observations of contemporary ideas and human behaviors and developed theories like structuralism, deconstruction, post-structuralism, simulacra and simulation, under the umbrella of semiotics. Semiotics, the science of signs, attempts to explain world culture, rules of etiquette, codes of conduct. and all forms of art. The arts function on the basis of the use of signs, making semiotics a powerful tool for the analysis and practice of art.

Deconstruction was developed by philosopher Jacques Derrida and is the study of the structure of a language, or any other symbol system, as a cultural artifact called a text. Using Derrida's strategy of deconstruction, for example, post-structuralists analyze visual and verbal texts in terms of the underlying worldviews that give them meaning. This can expose biases and challenges to the worldviews as well as to the texts. Because different viewers bring their own worldviews to their looking, there is no single, correct interpretation. This brings us to an understanding that meanings change with the viewer, with the time, and with the context.

Psychologists weighed in on Postmodern theories, too, like French psychoanalyst Jacques Lacan, whose famous pronouncement "The unconscious is structured language" (Appignanesi and Garratt 1999: 88) led to more ideas to sort out. Julia Kristeva, a Bulgarian semiotician and psychoanalyst, developed theories of personal and cultural identity that artists address today in making their art. She refuted Lacan's accounts of male and female identity in support of a Feminist Postmodernism that supports contemporary Feminist art (see Chapter 9).

Copying Copies of Copies

French thinker Roland Barthes said that even the most painstaking realist only copies copies. "To depict is to ... refer not from a language to a referent, but from one code to another. Thus, realism ... consists not in copying

Figure 10.1 Kyle Martin, American (b. 1984). *Illustration of Baudrillard.* Ink wash, 20 × 24 inches.

the real but in copying a (depicted) copy of the real. ... [T]hrough secondary mimesis [realism] copies what is already a copy," wrote Barthes in *S/Z* (1990: 55). Postmodern artists who work with this phenomenon try to reduce the distance between art and the real thing, said Arthur Danto. Today, we seem content with the copy of a copy of the copy, according to Jean Baudrillard. Signs and symbols that represent the "real thing" are seen in popular media, TV, videos, and video games.

Jean Baudrillard, a sociologist and theorist, became a cult figure of Postmodern theory because he commented on these changes in culture and the mutating roles of art and aesthetics. Baudrillard was among the French theorists who tried to explain the changes they were noticing in society. Previous theories that included class-consciousness, the means and mode of production, historical materialism, and ideology seemed inadequate for analyzing and interpreting society's metamorphosis.

Baudrillard noticed that as a society we had lost our ability to distinguish nature from copies of nature. He termed this phenomenon simulacra and simulation. Simulacra are the profusion of culturally generated images that

constitute our paradigm for reality. These simulacra misrepresent and mask reality by imitating it so well that they threaten to replace reality. Simulation is prepared counterfeit reality, like Disneyland, edited war footage, and video games. In Postmodern media and consumer society, Baudrillard speculated that art is everywhere but that there are no more fundamental rules to differentiate art from other objects or experience. The disappearance of art, as we have known it, has turned into an art unto itself, he said. Far from lamenting the end of art, however, Baudrillard celebrated art's new function in the world.

Modern versus Postmodern Art

Modernist art movements endeavored to depict reality in terms of a singular fundamental truth that developed during the Modern era. Cubism, for instance, depicted objects as a composite of fragmented and discrete views of itself and presented it as a new way of seeing time that echoed the theories of Albert Einstein. Surrealism and Abstract Expressionism attempted to resolve the human psyche with the support of the psychological theories of Sigmund Freud and Carl Jung. Postmodernism champions the value of individual and personal interpretations rather than the social, psychological, or political. It requires viewers to add their own interpretations of a work to be meaningful. Rather than assert absolutes, as Modern art did, Postmodern art evokes many interpretations.

Postmodernism refutes the Modernist preoccupation with purity of form and technique. It seeks to eradicate divisions between art, popular culture, and the media. Postmodern artists appropriate past art and cultural and intellectual ideas and use them in their work. They embrace pluralism and diversity and reject distinctions between high art and low art. Postmodernism ignores boundaries and encourages a mix of ideas, techniques, and media and promotes parody, humor, and irony.

There is no Postmodern art style. It is easier to think of Postmodern art as joining various art forms used throughout art history for the purpose of separating it from the singularity of Modernist art. This results in forms of art coming together to create visually stimulating, unique, and original artworks. The overall impression of Postmodern art is one of imitation and appropriation. Postmodern art also aims to blur the boundaries between high art and low art.

Postmodern art departs from Modern art in not advocating a singular ideology. Modernists viewed art as a way to shape art movements of the

twentieth century. By the 1970s, however, ideals that fueled Modernism had given way to profound disillusionment. Artists began to use artistic style independent of original intentions. This appropriation of historic styles without regard to original contexts set Postmodern art apart from Modern art. Postmodern art could, for example, make liberal references to Modern art movements like Cubism, Surrealism, and Expressionism without adhering to the original style or ideas. Rather than using style to convey specific ideologies, Postmodernism undermined the Modernist ideologies by questioning the underlying singularity of style and ideas.

Some Postmodern Art Theories

Coming to an understanding of Postmodern art requires knowledge about artists and art movements like Duchamp and Dada and Fluxus, Andy Warhol and Pop Art, and about found objects and appropriated images and ideas, and blurring the distinctions between art and reality. Engaging with Postmodernism requires knowledge about theory and art history. Architecture embraced Postmodernism by combining diverse architectural styles into one building. If architects didn't know their architectural history, they would not have been able to design combination Postmodern structures.

Knowing the distinction between appropriation and plagiarism and about how words, images, issues, and identities got to be major art themes are steps to understanding Postmodern art. Some Postmodern art transforms the art object into installations, performances, and experiences. Some art focuses on physical, psychological, and spiritual aspects of being human. Postmodernism embraces pluralism rather than one style or idea. Postmodern art acknowledges equally valid ideas going on all at the same time and recognizes the globalization of art and ideas.

New rules, new conventions, and new theories governed art in the 1980s. The revolution against Modernism, a faith in universality, artistic progress, shared meaning and quality led to Body Art, Land Art, Performance Art, Conceptual Art, Neo-Expressionism, Fluxus, Pop Art, Feminism, and Multiculturalism all at the same time. Pluralism, a component of Postmodernism, increased interest in and use of a variety of theories and idea-driven art, and developed difficult and sometimes obscure references. Some Postmodern artists attached their names to the work of other artists and renamed what would once have been termed plagiarism as appropriation.

New theoretical perspectives supported a range of art and ideas, including semiotics, deconstruction, post-structuralism, Marxism, and feminism. These new perspectives studied visual culture, including art historical biases, the nature and operation of art marketing and economics, mass media influences, and the visual representation of all kinds of identities, like gender, race, sexuality, religion, and nationality.

Sherrie Levine's *Fountain*

American artist Sherrie Levine made *Fountain* in 1991. Her gleaming bronze reproduction of Marcel Duchamp's *Fountain* paid homage to the concepts in his original version and added a sacred value to his ideas with the bronze material. In fact, it was copied directly from Duchamp's 1917 *Fountain*, an ordinary porcelain urinal purchased from a plumbing supply store, hung at a 90 degree angle and signed. Levine's urinal was not just chosen by the artist; this time it was made by the artist. Levine did not acknowledge Duchamp by referencing him in the title of her work, as she did when she re-photographed the works of famous photographers Edward Weston and Walker Evans. She presented the bronze *Fountain* as her own. These re-creations, copies, or plagiarisms are a Postmodern practice known as appropriation, an artistic recycling of existing images and ideas.

How is Levine's *Fountain*, a copy of Duchamp's *Fountain*, art? Is Levine's *Fountain* art because she made it with her own hands? Or is it not art because it is plagiarism, a copy of Duchamp's *Fountain*? Levine's *Fountain* isn't signed. What about if it is written about in an art magazine? Does that make it art? How many ideas or theories can you think of to use in explaining whether Levine's *Fountain* is art?

Appropriation

Sherrie Levine re-photographed famed photographer Walker Evans' photographs made for the Farm Security Administration U.S. Department of Agriculture and reproduced in *Let Us Now Praise Famous Men*, a collaborative project between Evans and writer James Agee in 1936 that documented Southern tenant cotton farmers (Agee and Evans 1941). In 1981 Levine

titled her appropriated images *After Walker Evans,* and they became a land-mark of Postmodernism that was both praised and attacked as an elegy on the death of Modernism.

The term "Appropriation Art" came into common use in the 1980s with artists like Levine addressing the act of appropriation itself as a theme in art with her copies of Walker Evans and Edward Weston photographs. Levine challenged ideas of originality and sexism in the artworld by drawing atten-tion to issues of power, gender, creativity, consumerism, and commodity value. She challenged social sources and uses of art and entertained high-context concepts of "almost the same," "whose work is that, anyway?" and "male artist domination."

Appropriation acknowledges that images are currently in vast quantities the world over and have become a public resource for anyone to use. In a way, appropriation was what Duchamp did when he presented the urinal as his own and gave it a new meaning in 1917, before Postmodernism. Appropriation addresses some of the theories under the umbrella of Post-modernism that doubt whether artists are the sole creators of a work of art or have the final authority about what art means. All artists borrow ideas in one way or another. The creation of meaning and art can be a communal project according to some Postmodern theories. Or is all of this just copy-ing? Is it plagiarism?

To appropriate something involves taking possession of it. In the visual arts, the term "appropriation" often refers to the use of borrowed elements in the creation of a new work. The borrowed elements may include images, ideas, and styles from art history or popular culture. They can also include materials and techniques from non-art contexts. Since the 1980s the term has also referred more specifically to referencing the work of another artist to create a new work. The new work does not alter the original work – it actually uses the original work to create a new work. In most cases the origi-nal remains recognizable as the original, without change.

A Short Art History of Appropriation

Aspects of appropriation appear in many areas of art history if we consider the act of making art as borrowing images or ideas and re-interpreting them. If we broadly applied the term, we could classify Leonardo da Vinci as an appropriation artist because he borrowed elements from science, mathe-matics, engineering, and art and synthesized them into inventions and art.

Some art historians regard Pablo Picasso, Georges Braque, and Juan Gris to be the first Modern artists to appropriate items from non-art contexts into their work when they developed Synthetic Cubism. In 1912, Picasso pasted oil cloth and Juan Gris pasted newspaper onto canvases to create *Guitar, Sheet Music and Glass* (1912) and *Bottle of Rum and Newspaper* (1913), respectively. These artists incorporated aspects of the real world into their canvases, opening up Postmodern discussions about artistic representation and signification and perhaps appropriation.

In 1917, Marcel Duchamp introduced his readymades to the artworld and entered *Fountain* into the American Society of Independent Artists exhibition. He also used existing art when he appropriated an image of the *Mona Lisa*, penciled in a goatee and moustache, and gave it a new title *L.H.O.O.Q.* (1919), a vulgar pun in French comprehensible to those who hear the sound of the letters pronounced in French, roughly translated to "she has a hot tail." Duchamp's irreverence toward one of the Western world's most revered artistic icons was an attempt to rouse people out of a pattern of unthinking acceptance of cultural values. Could this be a precursor to Postmodernist ideas that could provide some support to the question about the "Fire in the Louvre" story?

The Dada movement continued Duchamp's appropriation of everyday objects, but other artists' appropriations did not attempt to elevate the "low" to "high" art status; rather they produced art in which chance and randomness formed the basis of the creation. A reaction to oppressive intellectual rigidity in both art and everyday society, Dada works featured deliberate irrationality and the rejection of the prevailing standards of art. German artist Kurt Schwitters created large constructions from found objects that later would be called an installation, opening the artistic door to Postmodern art. Dada performances in Zurich and Berlin in 1919 were the ancestor of 1960s Happenings and contemporary Performance Art.

Surrealists, coming after Dada, also incorporated the use of found objects in their work, like Swiss artist Meret Oppenheim's *Object* (1936): a fur-covered cup, saucer, and spoon. Surrealists' found objects took on new meaning when altered and combined with other unlikely and unsettling objects. Surrealists were fond of intellectual games that tested questions of reality, a major issue in Postmodern thought.

In the 1950s American artist Robert Rauschenberg created what he called "combines," literally combining readymade objects like tires and beds along with painting, silk screen printing, collage, and photography. Similarly, fellow American artist Jasper Johns, working at the same time, incorporated found objects into his work. Johns appropriated symbolic images such as

the American flag or the "target" symbol into his work. Both Rauschenberg's and Johns's work during this time were sometimes called Neo-Dada.

Fluxus was a loosely knit group of international artists who blended different artistic disciplines, including visual art, music, and literature. Throughout the 1960s and 1970s they staged events, engaged in politics and public speaking, and produced sculptures featuring unconventional materials. The group even appropriated the postal system by developing mail art, called the New York Correspondence School by artist Ray Johnson and documented in the 2002 film called *How to Draw a Bunny*. Both Dada and Fluxus performances had in common a goal of appropriating the banal and elevating it to art.

Manipulated Realities: From Pop Art to New Realism, an exhibition curated by Jan Schall at the Belger Arts Center in 2004, was accompanied by her talk "The Influence of the Photograph on Pop Art and Photorealism," which could have been titled "From a Copy of a Copy to a Hyper-Real Copy." It detailed how Pop artists Roy Lichtenstein and Andy Warhol appropriated images from commercial art and popular culture as well as the techniques of commercial industries. Pop artists saw mass popular culture as the main vernacular culture and fully engaged with mass-produced culture, embracing expendability and distancing themselves from the evidence of an artist's hand. Some art historians think Pop Art was the beginning of Postmodernist art that included appropriation in its repertoire.

Andy Warhol is perhaps best known for his appropriated multi-colored, repetitive images of iconographic objects and figures like Campbell's soup cans, Brillo soap boxes, dollar bills, Marilyn Monroe, John Wayne, and even himself. Warhol's main objective was to mimic the media in culture and demonstrate how the amount of cultural images produced is so overwhelming that there is a tendency to feel unaffected by them. Warhol tried to display a sense of cool aloofness, as opposed to a lively engagement that was a Modernist theme.

Appropriation artists comment on all aspects of culture and society. Contemporary American artist Joseph Kosuth appropriates images to engage with philosophy and theory of knowledge. He is called a Conceptual artist because his work is more about the idea than the object. Other contemporary artists who work with language and appropriate images in a conceptual way, testing our conventional thinking, include Jeff Koons, Barbara Kruger, and Jenny Holzer.

Jenny Holzer's installations display text messages she calls *Truisms*, which are short, pithy phrases. She uses media such as billboards or LED signs. You may have seen her work in Times Square or on the side of an art gallery or art building. Holzer's work, like most installation pieces, is Conceptual

and doesn't require craftsmanship so much as knowledge and application of sophisticated philosophical, linguistic, psychological, social, cultural, or political theories. Installation artists typically use manufactured or found objects – a popular Postmodernist feature. Barbara Kruger uses magazine "cutouts" and photography to address issues of personal and cultural identity. Kruger worked for a fashion magazine and her art incorporates appropriated images with strong, laconic phrases about the objectification of women and other cultural issues that face women.

Because Postmodernism is multifaceted, diverse, and pluralistic, art movements addressing a common idea have gone the way of Modernism. Today several ideas are being addressed at the same time. Authors Jean Robertson and Craig McDaniel describe a clustering of topics in terms of themes in *Themes of Contemporary Art* (2005), and focus on seven prominent themes that have occurred in recent decades. You will recognize these themes from the Postmodern ideas, theories, and manifestations already discussed. They are: identity, the body, time, place, language, science, and spirituality. Artists whose work exemplifies these themes are profiled in each chapter: for instance, Shirin Neshat (identity), Zhang Huan (the body), Cornelia Parker (time), Janet Cardiff (place), Ken Aptekar (language), Eduardo Kac (science), and Bill Viola (spirituality).

Twenty-first century artists continue to produce art using ideas as a medium to address theories and social issues, rather than focusing on the works themselves. Artists working today increasingly appropriate and incorporate both art and non-art elements. This chapter by no means offers an exhaustive look at Postmodern theories or Postmodern artists and their art. Instead, this brief overview provides a starting point for further research and thinking.

Back to That "Fire in the Louvre"

So here we are at the end of the chapter with our Postmodern attitude that no idea or expression or belief can be more credible than any other because all ideas are equally valid, and sophisticated technology can appropriate and reproduce anything – perfectly – even da Vinci's *Mona Lisa*. And because of the hyper-reality we are comfortable with today, explained by Baudrillard's simulacra and simulation, why would we hesitate to save the human being, who, so far, cannot be reproduced perfectly, instead of the *Mona Lisa*, which can?

Postscript

Check out this short Dove commercial called Dove Evolution on YouTube: *www.youtube.com/watch?v=iYhCn0jf46U*. See why we want to understand Baudrillard's observations? The remake of the woman who was made up, photographed, and remade again in a computer program was a copy (make-up) of the copy (photograph) of the copy (computer-enhanced) of the original model in this commercial, and we have come to accept this as reality. Artists have been making art that makes use of these ideas of simulacra and simulation for decades.

11

Photography and New Media

From Plato to Photography to Pop Art, Baudrillard, and New Media

When Jan Schall, Nelson-Atkins Museum of Art Curator, opened the exhibition she curated, *Manipulated Realities: From Pop Art to New Realism*, at the Belger Arts Center in Kansas City with her presentation titled "The Influence of the Photograph on Pop Art and Photorealism," she could have called it "From a Copy of a Copy [recalling Plato's Mimetic Theory, Chapter 3] to a Hyper-Real Copy [recalling Baudrillard's 'simulacra and simulation, Chapter 10]," or "From Plato to Photography to Pop Art, Baudrillard, and New Media."

Schall (2004) described the origins of photography, Pop Art, and Photorealism and made a case for Pop Art having advanced Photorealism. There is also evidence that Pop Art marked the beginning of Postmodern art. Schall gave examples of Pop artists Robert Rauschenberg, Andy Warhol, Roy Lichtenstein, James Rosenquist, and Tom Wessleman using photography as memory aids for copying, enlarging, and transferring photographic images onto a variety of surfaces. Photorealist artists in the exhibition – Chuck Close, Richard Estes, Don Eddy, Ralph Goings, and Richard McLean – used photography in similar ways.

Photography enjoyed an elevated status of art for several years after its discovery in the nineteenth century until a new attitude judged it to be a mechanical process with no artistic or creative characteristics. Photographs didn't find their rightful artistic identity or their way into art exhibitions or permanent collections in art museums until the mid-twentieth century. Art historical research documented the uses of photography to create different

art forms, like painters using photographs as reference for their work. Van Deren Coke and his graduate students at the University of New Mexico published *The Painter and the Photograph* in 1964, revealing some examples. Twentieth-century artists expanded ideas about the very nature of art (aesthetics) and challenged previously accepted artistic pursuits. Photography offered Pop artists opportunities to defy traditions of abstraction, for instance, particularly Abstract Expressionism, the art movement preceding Pop Art.

Unlike the emotionally charged features of Abstract Expressionism, Pop Art utilized the cool, detached, and mechanical characteristics of the photographic process. The new interest in a culture of images seen in magazines and newspapers, on billboards and television (televisions grew in number from 10,000 to 40 million in the 1950s and 1960s) provided a foundation for a new aesthetic that included popular imagery – Pop Art.

Robert Rauschenberg used the photo-transfer process in his work, as did Andy Warhol, who, along with Rauschenberg and Jim Dine, led the Pop Art movement. All three had worked in the Neo-Dadaist style before Pop Art, used mixed media and readymades to produce paintings, and experimented with Performance Art. Rauschenberg and Dine used traditional painting techniques incorporating collage and prints. Frequently Dine affixed everyday objects such as his own articles of clothing to his canvases. This autobiographical content is a recurrent theme of identity in Dine's *Self-Portraits* and *Two Dark Robes*.

American artist Richard McLean's paintings look like photographs. McLean worked for nearly 50 years in the Photorealist tradition with contemporaries Richard Estes, Ralph Goings, and Don Eddy. Even when viewed from close range the surfaces of McLean's paintings are so smooth that it is difficult to believe they were made by hand. "My work is about the largely undervalued pleasure … one takes from the sheer look of things," he said. Like most Photorealists, McLean worked from photographs, either his own or those he found. He made photographs into transparencies and projected them onto a canvas, where he made a tracing of the image in graphite. During the painting process he was guided by the photographic images.

The camera is myopic and can only focus on either close-up or far-away (depth of field) subject matter. Photorealist painters like McLean, Estes, Eddy, and Goings created hyper-real images by using two photographs, one made by focusing on the close-up view of the subject with limited depth of field and another made with great depth of field of the whole scene. They combined both photographs to make one painting. They could also focus on the reflections in a glass store window, for instance,

or on the objects behind the window, and combine those two photographs into one painting. Our eyes rapidly shift from close up to far away, but cannot focus on both fields at the same time. (Try it. Hold your finger in front of you and focus on your finger. Notice the background is out of focus. Focus on the background and you will notice your finger is out of focus.) This provides an abstraction in realistic-appearing images and brings us back to photography and the enduring challenge of artists attempting to "capture reality."

With the 1839 announcement of a process that permanently preserved camera images, called the daguerreotype, after its French inventor, Jacques Louis Mande Daguerre, it became the epitome of art. Artists, after all, had been attempting to mimic or copy reality since Classical Greece and now accurate scenes through a camera lens could be permanently "fixed." Rapid technical advancements during the nineteenth century made it possible to make portraits of famous and not-so-famous people, dead or alive, record far-away places, and even record the U.S. Civil War. Some artists declared upon learning of the discovery of photography, "From this day forward, painting is dead." Others immediately saw the potential of this new process as an artform in itself alongside but distinct from painting.

Artists who had been engaged in capturing reality could now do so with relative ease. Early daguerreotypists, as they were called, immediately set off on trips around the world documenting everything that didn't move. (The early daguerreotype process could not stop action.) These images brought cultures of the world to domestic parlors, some in the form of stereoscope images that whole families could enjoy by passing around a hand-held viewer. (This was the precursor to television and movie entertainment today.)

The daguerreotype wasn't Daguerre's discovery alone. The contributions of many others – astronomers and scientists – who developed the room-sized camera obscura, discovered the properties of silver salts (Johann Heinrich Schulze), the heliograph process (Joseph Nicéphore de Niépce), how to "fix" images on ceramics (Thomas Wedgwood) and, finally, on paper (William Henry Fox Talbot) made this discovery possible. Talbot's discovery, the Talbotype or Calotype, meant multiple prints could be made, on paper, unlike the one-of-a-kind daguerreotypes on silver-coated copper plates, protected from oxidation with glass in leather cases. Talbot's process was similar to the twentieth-century photographic practice. Both Talbot's and Wedgwood's discoveries were influential in contemporary practices of transferring images onto a variety of surfaces.

Enduring Artistic and Technical Challenge

Artists found aesthetic and technical challenges in capturing reality (called Realism, Naturalism, or Idealism in art historical terms), making the allure of permanently fixing images, coined photography – literally "light writing" – one that has lasted until today. Daguerreotypes (photographs) could accurately imitate reality (the Mimetic Theory – see Chapter 3).

Samuel B. Morse brought the process to America after seeing Daguerre's demonstration of how to make daguerreotypes in Paris in 1839. This began America's fascination with this new process and it was immediately embraced. The American entrepreneurial spirit was sparked and daguerreotype studios popped up all over the country. Even though daguerreotypes were cumbersome and sometimes dangerous to make – coating pieces of copper with silver, bringing the silver to a high polish, and then developing the image with mercury vapors – practitioners were not deterred. (In England, mercury was used in haberdashery, specifically in hatbands, and it sometimes caused mercury poisoning "madness." Lewis Carroll, author, mathematician, and noted photographer, made reference to this when he created the Mad Hatter for his book *Alice's Adventures in Wonderland*.)

It's difficult to view daguerreotypes because the image is on a highly polished silver-coated piece of copper. Looking at a daguerreotype is like looking into a mirror. You have to hold the daguerreotype just right to see the image float on top of the polished silver. If you don't angle it correctly, you will just see yourself.

Nineteenth-century viewers believed daguerreotypes were real, period. It was not acknowledged that daguerreotypes were copies of reality. They were, simply, the same as reality. Unlike today, people believed that everything in the photograph was real.

When photographers accompanied U.S. Geological Surveys to the West in the late nineteenth century their photographs provided reliable evidence to convince the U.S. Congress to preserve National Parks like Yellowstone. In the twentieth century, photographs of children working in coalmines and textile mills made by Lewis Hine provided the proof Congress needed to pass Child Labor Laws. Photographs were believable. They were fact. They were evidence that created laws and proved crimes.

Mathew Brady owned successful portrait studios and galleries that enabled him to hire photographers like Timothy O'Sullivan and Alexander Gardner and equip them with carts and chemicals to photograph the Civil

War. Brady required all photographs made by those in his employ to be signed with his name. This issue contributed to debates about aesthetics and ethics started in medieval guilds and Renaissance studios. It was common practice for paintings to be signed by the master painter in the studio in which it was produced during the Renaissance, even though 20 or more apprentice artists may have worked on it. Both O'Sullivan and Gardner objected to Brady's signature on their photographs so they left his employ, funded their own expenses, and took credit for their own work.

Aesthetic Debates

Aesthetic issues inspired by technical improvements incited significant debates about photography as art. The esteem with which photography was held as art came into question with claims that only technical competence was required to make daguerreotypes. Nathaniel Hawthorne's 1851 novel *The House of the Seven Gables* described the Daguerreotypist (he has his own chapter) as possessing physical strength and skills for handling the technicalities of camera equipment and the chemicals required to fix images on a silver-coated pieces of copper, but he was not considered an artist. He was regarded as "merely an operator." So, if photography isn't art because it is merely a technical accomplishment, when or how or does a photograph ever become art?

In 1869 Henry Peach Robinson, in an attempt to elevate photography to the status of art it had enjoyed in the immediate years after its discovery, wrote a book called *Pictorial Effect in Photography Being Hints on Composition and Chiaroscuro for Photographers*. He made a point of explaining how to "make" photographs, rather than "take" them. Painters and sculptors "make" art, so Robinson used similar language, including visual elements and principles of composition, to talk about photographs. Robinson was not entirely successful in changing attitudes about photography being art.

By 1888, with the invention of the affordable Kodak Camera loaded with film for 100 exposures, anyone could expose film and send the whole camera back to Rochester, N.Y., to have the film developed and prints made and new film loaded into the camera. "You press the button. We do the rest" was the Kodak motto. Indeed, now "anyone could do it." The idea that photography was art came under serious attack, again.

Alfred Stieglitz, sometimes called the father of art photography in America, and the group he founded, the Photo Secessionists, sought to develop a

"style" (soft focus, unusual points of view) and make one-of-a-kind art works by processing photographs with a hand- or fingerprint showing, making them hand-made works of art. Stieglitz and serious photographers considered what they did to be art. They promoted photography as art in journals like *Camera Work*, advocated "making" rather than "taking" photographs, and highlighted one-of-a-kind photographs and "schools" or "styles" of photography.

Late nineteenth-century formalist art critic Roger Fry thought the position of photography was uncertain. But by the middle of the twentieth century, Minor White, an iconic photographer, teacher, and founder of the Society for Photographic Education (a professional organization that still exists today), wrote that creativity and selectivity informed content and made a photograph art. He thought creativity was the key component to making a photograph art and wrote "When is Photography" for *American Photography* (1943), which was reproduced in *Exposure*, the Journal of the Society for Photographic Education.

Photography, Art, and Culture

Serious photographers were acutely conscious of the photograph as an instrument of culture and were aware, as were their successors, that photography was a large part of social, political, and cultural thought. Photography, its history, aesthetics, and practice, addressed cultural relativity and conventions of time and place, context, and philosophical relativity. Popular publications fueled these discussions, evidenced by the 1974 article "Is Photography Really Art?" published in *Newsweek* (Douglas 1974).

Photography historian, author, teacher, and critic Bill Jay (1968–2007) wrote passionately about what seemed to him to be a hopeless battle to establish photography as art in 1960s England. The battle was won in America, he thought, because photography purposefully stormed the art institution. While the battle may have been won, however, the casualties were too high, thought Jay forlornly.

What happened to photography when it became accepted as art (not too different from what happened to other forms of art in America at the same time) led to a variety of problems, according to Jay. For example, galleriest rather than photographers became the authorities on photographic merit; photographic criticism became riddled with unintelligible art jargon and clear, informative prose was hard to find; photographers' egos became so

inflated that individual integrity was lost; slickly presented triviality was touted as high-quality photography; media hype replaced consistency and commitment; instant "stars" were created with glitzy publicity and attention was stolen from the serious photographer who had struggled to maintain his or her vision over many years. Something intrinsically photographic had died in the fight for art acceptance, thought Jay.

Social critic Susan Sontag said the reason photography got attention was because it had finally found respectability. "The battle … for photography to be acknowledged as an art form had been won," she said in an interview (Simmons 1977). She thought people who had only been interested in painting and sculpture before were now interested in photography. With the inflated prices of painting and sculpture, photography became an affordable option for collectors. Understanding serious contemporary photography didn't involve knowledge of a long history (photography was only 130 years old then) like it was in order to understand serious contemporary painting that referenced all of art history.

Around the same time, art critic Hilton Kramer (1970) wrote about the new developments in photography shown in art galleries and museums being more than "photographic" and becoming "artistic." He claimed photography had joined the mainstream because of its new acceptance as part of the artworld.

In her 1973 book *On Photography*, Susan Sontag raised important questions about photography, art, aesthetics, and culture. She thought about how cultural reality had been interpreted through images in the past and how "philosophers since Plato have tried to loosen our dependence on images by evoking the standard of an image-free way of apprehending the real." She posited that by the mid-nineteenth century, an allegiance to images strengthened a modern age in which credibility was given to images, or illusions, rather than realities. Societies were "modern" when images had the power to determine social reality and became coveted substitutes for first-hand experience. Photographic images had earned unlimited authority, or believability, as was the nineteenth-century term, in modern society and the scope of that authority came from images made with a camera.

Art critic Clement Greenberg, who promoted Abstract Expressionism and Jackson Pollock with his formalist theories in the 1950s and 1960s, suggested that photography was a literary art because it was historical, anecdotal, reportorial, and observational rather than purely pictorial. The photograph had to tell a story if it was to work as art, said Greenberg. In choosing and approaching a story or subject, the artist-photographer

made decisions crucial to art. Everything else, such as pictorial values, composition, and its visual elements, drew from those decisions.

The fascination the world has with photography is referenced in popular literature, television and in movies like *Blow Up* (1966). All the images in one of Bill Jay's keynote presentations to the Society for Photographic Education in the 1980s were covers of popular novels featuring stories about photography or photographers. This interest in photography brings up many issues, like art vs. technical advancement, multiple photographs vs. the traditional art one-of-a-kind criterion, commercial profitability of photographs and discussions of aesthetic vs. economic values. These aesthetic questions make for provocative and engaging discussions. Bill Jay's website has hundreds of articles, essays, and books about nineteenth- and twentieth-century photography and its impact on aesthetics, society, and art, along with photographs of twentieth-century photographers (*www.billjayonphotography.com/*).

In an interview in the *Photo District News* in 2007, Jay (1968–2007) said he thought that photography as an international community of like-minded people who appreciate the unique characteristics of the medium had been in terminal decline for the last 30 years. There are no standards by which to judge the merit of a photograph, he asserted. "I am not disparaging that, but I think it is interesting." Photography as a unique enterprise is over.

The End of Photography? The Beginning of Visual
Culture and Postmodern Art?

When are photographs art? Sometimes? Never? What makes a photograph art? Are photographs that are used for functional purposes – like identification cards or driver's licenses – art? What about portraits? What about other functional objects, like pots and baskets? Are they art? Is the medium used to make something what makes it art? Or doesn't that matter? For instance, are oil paintings art and photographs not? Are marble sculptures art and plaster objects not? Are photographers merely technical operators? Does photography have to mimic painting styles or art movements in order to be art? What if the photographer manages to make the photograph one-of-a-kind? Is it art then? Art museums didn't collect photography

until the 1940s. Does the fact that art institutions now think photographs are art make them art? Does it mean photographs weren't art until art museums started collecting them? How can we tell the difference between photographs that are art and photographs that are not? What are/were "the unique characteristics, or standards by which to judge the merits of photographs?" Did Postmodernism "end photography," or was photography the beginning of Postmodern art?

There are many reasons people look at photographs. Sometimes they look at photographs for their own sake, not as a surrogate for something else, but as the principal object of attention. The elements of a photograph – light, pattern, shape, depth, values, line, texture, and space – could elicit aesthetic emotion described by Clive Bell as "significant form." Sometimes photographs can provide sociological, psychological, cultural, or scientific evidence.

Society has changed dramatically since 1839, from a culture of first-hand experiences that could be caught on silver-coated pieces of copper and then film and now digitally, and so have art, cultural and aesthetic theories, and criticism. Walter Benjamin wrote "The Work of Art in the Age of Mechanical Reproduction" in 1936 and Jean Baudrillard thought contemporary culture is composed of simulacra and simulation, images that have become symbols of a reality that we can't tell or don't care about being 'real.' Benjamin, Baudrillard, and Roland Barthes's study of signs (semiotics) can help make connections and clarify ideas about contemporary photography and art theory.

"The Work of Art in the Age of Its Technological Reproducibility"

Walter Benjamin, a Marxist literary critic, essayist, philosopher, and cultural critic, wrote several versions of "The Work of Art in the Age of Its Technological Reproducibility," popularly called "The Work of Art in the Age of Mechanical Reproduction," in the 1930s (Benjamin 1936). His essays remain influential today in media theory, cultural studies, film, art history, visual culture, the Postmodern art scene, and debates on the future of art, perception, and culture in the digital age.

Benjamin recorded the loss of aesthetic presence at the turn of the twentieth century, and explored a set of ideal possibilities in mechanical means of making art. His thinking about aesthetic questions revealed a background and consequences of our ever-changing image of the made world. He was associated with philosophers, film and cultural critics, architects, and a group of international avant-garde artists who shaped twentieth-century culture, including architect Ludwig Mies van der Rohe, painter and photographer László Moholy-Nagy, and former Dadaists Raoul Hausmann and Hans Richter.

"The Work of Art in the Age of Its Technological Reproducibility" explored theoretical extensions of relationships among technology, media, and human sensory apparatus in the context of the economic stability that succeeded the uncertainty of the 1920s. Hitler's rise to power created a traumatic change in Benjamin's personal and intellectual existence. Realizing there was no tolerance for his work or even his life (he was a German Jew), Benjamin left Berlin in 1933 and moved between Paris and a series of temporary quarters until his death in 1940.

Benjamin described what he hoped would be useful in the formulation of revolutionary demands in the politics of art. He thought that in the absence of any traditional value, art in the age of mechanical reproduction would inherently be based on the practice of politics. Benjamin's popularity has risen dramatically in the last few decades, making him an important twentieth-century thinker about modern aesthetic experience.

Benjamin's thoughts about the relationships between aesthetics and politics in "The Work of Art in the Age of Its Technological Reproducibility" made it clear he was attempting to develop a "media theory." If fascism could aestheticize politics, he mused, the future was bound to respond by politicizing art. Benjamin's thinking turned to history and a study of the emergence of Modernism. "Just as the entire mode of existence of human collectives changes over long historical periods, so does their mode of perception," he wrote. Benjamin concentrated on two questions: the capacity of art to encode information about its historical period and the way modern media effected changes in human sensory perception. László Moholy-Nagy's work, discussed in Chapter 12, was in consort with Benjamin's thinking.

Semiotics: Signs, Signifier, Signified

French literary theorist, philosopher, and critic Roland Barthes developed theories of structuralism, semiotics, and post-structuralism with studies of existentialism, social theory, and Marxism. Barthes studied culture to expose

how a dominant class, the bourgeois, could use it to assert values upon others. For instance, wine in French (bourgeois) society is deemed a robust and healthy habit, contradicting other realities; it can be unhealthy and inebriating.

Barthes founded semiotics, the study of signs; a useful theory for helping him answer questions about culture. He explained that cultural myths were second-order signs, or connotations. For example, a picture of a full, dark bottle is a sign, a signifier relating to the signified: a fermented alcoholic beverage – wine. Some societies take the signified and apply their own emphasis, making a new signifier relating to a new signified: healthy, robust, relaxing wine. Motivations for such manipulation vary from a desire to sell products to the simple desire to maintain the status quo. These ideas keep Barthes's thinking in line with Marxist theory.

With a lifelong interest in photography, Barthes considered the photograph to have a unique potential for presenting a completely real representation of the world. He wrote *Camera Lucida* in 1977, after his mother died, in an attempt to explain the unique significance that a photograph of her as a child carried for him (Barthes 1981). He thought about the relationship between the obvious symbolic meaning of a photograph and the purely personal meaning for an individual. He was troubled by the fact that such distinctions fell apart when personal significance is communicated to others and when symbolic logic is rationalized. He explained that the photograph created "a falseness" in the illusion of "what is" where "what was" was a more accurate description. His mother's childhood photograph was evidence of "what ceased to be." Because there is something uniquely personal in the photograph of his mother that could not be removed from the subjective state, the recurrent feeling of loss was experienced whenever he looked at it.

One of Barthes's final works before his death, *Camera Lucida* was both an ongoing reflection on the complicated relationships between subjectivity, meaning and culture as well as a touching dedication to his mother and a description of the depth of his grief. He attempted to show how a photographic image could represent implied meaning and be used to infer "naturalistic truth." Instead of making reality solid, the photographic image reminded him of the world's ever changing nature.

New Media

Observations of contemporary society by Benjamin, Barthes, Baudrillard, Jacques Derrida, and Michel Foucault, whose theories account for Postmodernism in a variety of disciplines (discussed in Chapter 12), can be

thought of as extensions of early philosophical thinking by Plato and Aristotle, who thought about imitation and reality. Baudrillard calls reality into question by thinking about hyper-reality – simulacra and simulation. Contemporary photographers and New Media artists are engaged by Postmodern theories and even operate on the idea that "reality" is up for grabs. Some New Media artists think it is up to them to remake reality.

New Media is a general term used to describe art created with technology available since the mid- to late twentieth century. Terms like New Media Art, Digital Art, Computer Art, Multimedia Art, and Interactive Art are often used interchangeably. New Media incorporates artistic practices and emerging technologies to address world cultural, political, and aesthetic possibilities. Photography was a new technology in the nineteenth century that addressed cultural issues developed by cultural theorists, philosophers, and critics of the period, and New Media behaves similarly in the twenty-first century.

While New Media is all about new cultural forms, new technologies, new views on familiar political issues, it is not without art historical foundations. Aesthetic and conceptual foundations of New Media art extend from the early twentieth-century Dadaists, who experimented with radically new artistic ideas and practices that resurfaced throughout the mid-twentieth century, some of which are described at the beginning of this chapter. Much of Dada was a reaction to the mechanization of warfare in World War I and the mechanical reproduction of texts and images in response to the information technology revolution and the digitization of cultural forms, *à la* Walter Benjamin. New Media's use of techniques, like photomontage, collage, readymades, political action, and Performance Art, as well as concepts of irony and absurdity, all have their roots in Dada.

Pop Art and Conceptual Art are also antecedents of New Media in their reference to commercial value, popular culture, and the elimination of the object from the experience of "reality." New Media includes contributions to Video and Internet Art as well. Distinct art movements no longer existed after the 1980s, replaced by themes addressing the new ideas and practices of New Media. The globalization of cultures and economies, advances in information technology, the familiarity of computing to the new generation, and the unprecedented level of Internet excitement in New Media brought painters, Performance artists, activist artists, filmmakers and Conceptual artists around the world together with emerging media technologies informed by the conceptual and formal qualities of their former discipline.

New Media includes collaboration and participation and moved from 1980s appropriation to twenty-first-century open source images, sounds, and texts. New Media themes include interventions, identity, telepresence, and surveillance, as well as independent initiatives. New Media will likely be absorbed into the culture at large, but will also probably remain a tendency, a set of ideas, sensibilities, and practices that appear unpredictably and in multiple forms.

New Media includes Time Art, Media and Performance Art, Video Art, Video Installation Art, and Digital Art, including digitally altered photography, as in the work of Victor Burgin, Jeff Wall, and Keith Cottingham. Cottingham created a digital montage that questions the nature of representation. His "fictitious portraits" represent subjects he created in his imagination in which he uses both generic and specific bodies.

Some argue that digital photography is a continuation of the key themes and practices of chemical photography, while others think it represents a radical break with the past. Since its development some 30 years ago, digital photography has not been clearly distinguished from chemical photography, and has given rise to new aesthetic and artistic questions. Certainly documentary photography faces a crisis of credibility and believability in this digital age when no evidence of manipulation or intervention of the image can be detected. Digital photography brings two questions to the forefront: one, to what extent are digital images photographs; and, two, what are the implications of this technology for photographic evidence, or "truth"? When Walter Benjamin and fellow Marxist Bertolt Brecht wrote about documentary images as artificial or invented or constructed 75 years ago, they begged the question of what can be learned from photographs. This reminds us that, historically, interesting uses of photographs have been built on photographic technology and produced a heightened, disturbing realism that is up to each new era and culture to figure out.

And just when you think you've got it all settled, twenty-first-century photographers are returning to the hand-made chemical photograph. Some photographers develop their own film and prints, by hand, use photographic paper, and cherish the darkroom process as much as they cherish the creativity involved in finding the "right" image to "make" their photographic artwork. These photographers look to historical processes for inspiration and make images that show the photographer's "hand." Examples include twenty-first-century daguerreotypes and ambrotypes in the Hallmark collection at the Nelson-Atkins Museum of Art, like Adam Fuss's daguerreotype *From the Series My Ghost*, made in 2000. Sally Mann turned her family van into a pinhole camera. Some contemporary photographers want the magic, the

Figure 11.1 Adam Fuss, English (b. 1961). *From the Series My Ghost*, 2000. Daguerreotype, 17 × 14⅞ inches.

Figure 11.2 Robert and Shana ParkeHarrison, American (Robert, b. 1968; Shana, b. 1964). *Pollination*, 1998. Gelatin silver print with mixed media, 36 × 47 inches.

experimentation, and the control that comes from using "antiquarian" processes with the addition of contemporary media like Robert and Shana ParkeHarrison's *Pollination*, created in 1998. These contemporary photographers have turned to the past to create art for the future.

The claim "anyone can do it," first made in the 1880s, continues today, especially in the age of digital photography. Just about everyone has a digital camera or a cell phone camera. Just about everyone can make exposures, load the images on to their computers, and print them out or send them to other computers or cell phones. Yes, it's true, anyone can do it, so the questions remain: Are photographs art? Can they be art? When are they art? What are the theories that support photography being art, or not?

Chemical or Digital Photograph?

Which would you rather have: a portrait of Plato (428/427 B.C.E.–348/347 B.C.E.) made by German photographer August Sander or one made by Keith Cottingham? Why?

August Sander (1876–1964) is known for his photographic catalog of archetypal representatives of German society called *Man in the Twentieth Century*, which included portraits of individuals and small groups in their working clothes and sometimes in their work environments. He titled his photographs by the subject's occupation, such as teacher, musician, student, farmer, peasant, or baker. Contemporary American artist Keith Cottingham digitally manipulates portrait photographs to highlight technological and biotechnological developments and examines relationships between identity and current possibilities for altering the human body.

What would the Sander portrait be likely to reveal? What would the digital photograph by Cottingham be likely to reveal? Does it matter that neither Sander nor Cottingham lived at the same time as Plato? If you have a desire to have known Plato, would that be a relevant criterion for choosing between the photographs? Which would be more believable, credible, or "truthful?" What would make you want the Sander photograph more than the Cottingham photograph, or vice versa?

12

(Re)Discovering Design

Discussion about design is ubiquitous these days. Newspapers and magazines carry on about design as if it were a new concept, even though it is an all-encompassing part of daily life. All forms of design are getting attention: graphic design, advertising design, illustration, product design, interior design, fashion design, industrial design, web design, motion design, and urban design. University art departments are changing their names from departments of art to departments of art and design to designate the inclusive nature of art and design. Art and design professors around the country agree, "Artists and designers are all artists – period."

> *The wall of a cave, the side of a pot, the vaulted ceiling, the printed page, the digital screen. The media have changed; the purpose has not. Designers and illustrators have a pivotal role in a process of visual communication that provides a sense of who we are as a culture, how we are perceived, where we have come from, and where we're heading.*
> Brochure from the Fashion Institute of Technology
> in New York City

Barbara Bloemink, art historian and curator of the 2004 Smithsonian Cooper-Hewitt National Design Museum exhibition *Design ≠ Art*, reminds us that the relationship between fine art and design has been both harmonious and fractious. "Modern Western society has found it necessary to

Ideas About Art, First Edition. Kathleen K. Desmond.
© 2011 Kathleen K. Desmond. Published 2011 by Blackwell Publishing Ltd.

distinguish between aesthetics and function, between the spiritual in art and the corporeal in design" (Bloemink and Cunningham 2004: 7). Disparaging comments like David Hockney's "Art has to move you and design does not, unless it's a good design for a bus" contribute to that fractious relationship between artists and designers.

Philosopher Arnold Berleant thinks every design decision affects people's daily experiences and that aesthetics is an essential part of those experiences rather than a "frill." Current philosophical discussions focus on understanding the pervasiveness and importance of aesthetic factors in art and design.

Artist/Designer

Design overlaps with fine art when it is exhibited in the context of an art museum and engages viewers with questions that challenge ideas about art and design. British designer Michael Cross created a wooden floor in the shape of hills and valleys, designed a chair that changes its height in response to a visitor's approach, and crafted tree branches into bookshelves. *Resting Places Living Things*, exhibited at the Nelson-Atkins Museum of Art in 2008–9, challenged the parameters of the space, using the museum gallery as a design laboratory, an environment where experimental forms could be developed, nurtured, and studied for useful characteristics that could be transplanted into the larger world. Known for designs that change viewer's preconceptions and deliberately confuse their expectations, Cross seeks new ways of considering space by eliminating the familiar and starting all over again. Cross was trained as a product designer, and all of his experimental designs can be industrially manufactured and utilized in everyday situations.

Questions inherent in the exhibition *Resting Places Living Things* include concepts that industrial designers, interior designers, and architects work with, such as:

> Where do you expect to live; where do you expect to rest?
> Do memories rest in places, or do they live in things?
> Does life guide innovation or does innovation guide life?

Interior Designer/Graphic Designer

Designers work with space. Some designers work with two-dimensional space and others with three-dimensional space. Specific designations are given to designers who focus on specific design problems in two- or three-dimensional space.

Interior designers study art, design, history, and safety codes and issues, and focus on design in three-dimensional space. After a minimum of two years of experience, interior design students take rigorous exams to become certified professional interior designers. In the United States, the National Council for Interior Design Qualification organizes examinations that earn those who pass them the title of interior designer. According to the NCIDQ website (*www.ncidq.org*), "It is more important than ever for clients and the public to expect interior design professionals to demonstrate their competency in all areas of interior design." This includes not only the beauty but also the safety of public and private spaces. The designation between interior designers and interior decorators has been compromised by popular "home decorating" programs on television that use the term "design" when they mean "decorate" and use the title "designer" regardless of credentials.

Graphic designers study art and design, design history and theory, focus on two-dimensional space, and earn fine art degrees. Graphic designers work in advertising firms, graphic design studios, and businesses that require effective visual communication, marketing, or branding. Some graphic designers prefer to freelance and run their own businesses. Professionals who study the procedures of layout and printing but do not study art, art history, or art theory are called graphic artists. Sometimes graphic artists are erroneously called graphic designers, just as interior decorators are sometimes erroneously called interior designers.

Designers as Cultural Agents

One designer referred to design as a "cultural force" in the late 1980s, repeating what progressive designers in the early twentieth century asserted about their role as communicators who influenced all facets of society. Designers developed mottos like "Good Design is Good Business" and influenced

culture in significant ways with the use of computers and the Internet, thus placing designers in the role of "cultural agent."

Graphic designers were in the forefront of new media that impacted consumer culture and new modes of communication. Some argued that graphic designers used this power as a tool for marketers and promoters to entice consumers into brand loyalties, resulting in wasteful indulgences, as Steven Heller did in *Looking Closer 4* (Bierut et al. 2002). *ARTnews* wrote about design exhibitions like Cooper-Hewitt's Inaugural National Design Triennial in an article titled "Sleeker, Thinner, Sexier" in 2000 (Cash 2000). Katherine McCoy considered what happens "When Designers Create Culture" in her article in *PRINT* magazine in 2002. McCoy explored how "communication design on a global basis often amounts to cultural imperialism, stifling local character." Also explored in the first of several books in the series *Looking Closer* (Bierut et al. 1994) was the issue of meaning in design, starting with the familiar phrase "all form, no content." Design history and theory are welcome contributions to the field because they help identify design as a discipline worth serious and thoughtful theoretical consideration along with practical and humanitarian practice.

Interior Design

Architectural principles and theories play a major role in many design practices. Austrian architect Christopher Alexander is noted for his theories of design (and for more than 200 building projects around the world) and his influence on interior designers in particular. Alexander developed a series of "pattern languages" in 1977, described in his more theoretical *Timeless Way of Building* (Alexander 1979) and accompanying *A Pattern Language* (Alexander et al. 1977) books, to help designers understand cultural uses of space and how the environment can be designed to support human experience.

Alexander spent most of his life developing these extensive language patterns based on scientific reasoning. His pattern language is a universal creative problem-solving framework. The elements of this language, each called a pattern, describe a problem that occurs over and over again in the environment. Pattern language describes the core of the solution to that problem in such a way that it can be used over and over without ever carrying it out the same way twice. Based on human functions in the environment, pattern language can be seen from both a macro and micro

viewpoint; using the same set of laws to determine the structure of a city, a building, or a single room.

Pattern language is completely different from previous architectural principles and planning approaches, which include grids, zones, roads, and buildings based on conceptual designs rather than on human activity. Alexander developed his pattern language for architects and designers and as a means of making environmental design accessible. He insisted that his philosophy and his architectural theories were inseparable, warning against a superficial application of his method and repeatedly stressing that achieving coherence between built forms and human beings had to be accompanied by changes in basic attitudes.

Form Follows Function

Architects have influenced designers even before the Bauhaus in the early to mid-twentieth century and Christopher Alexander in the late twentieth century. In the 1800s, architects were thinking in essentialist terms and took a functional approach, influenced by nature. Louis Sullivan was one such architect, with Frank Lloyd Wright and Paolo Soleri valuing and building upon these concepts. It was Sullivan who coined the famous phrase "form ever follows function," often shortened to "form follows function," in a piece he wrote in 1896 called "The Tall Office Building Artistically Considered."

> It is the pervading law of all things organic and inorganic,
> Of all things physical and metaphysical,
> Of all things human and all things super-human,
> Of all true manifestations of the head,
> Of the heart, of the soul,
> That life is recognizable in its expression,
> *That form ever follows function.* This is the law.

Form follows function is often heard in popular culture today in movies and television programs and even in cartoons and newspapers. It's good to know where this idea came from and to think about where it has led.

Bauhaus Prompts New Technologies

In 1919, architect Walter Gropius founded the Bauhaus ("Building School") in Germany, an art school that taught art, design, craft, and technology in ways that changed art and design theory and practice. The Bauhaus style is one of the most influential currents in modern architecture and design and had a profound influence on developments in art, architecture, graphic design, interior design, industrial design, and typography.

Walter Gropius and Bauhaus faculty member László Moholy-Nagy worked together in Britain after the Bauhaus closed in 1933 and before World War II caught up with them. Gropius went on to teach at the Harvard Graduate School of Design and Moholy-Nagy went to Chicago and founded the New Bauhaus School, which became the Institute of Design and then the Illinois Institute of Technology. Other former Bauhaus professors brought Bauhaus aesthetics to America and taught at Columbia University and Washington University in St. Louis. Still others founded another design school in Germany in 1953, called the Ulm School of Design, in the tradition of the Bauhaus. The Ulm School included the study of semiotics, signs, and symbols and how meaning is constructed and understood, and even though it closed in 1968 the ideas continue to influence international design education.

One of the main objectives of the Bauhaus was to unify art, craft, and technology. Technology was considered a positive element, making industrial and product design important components. Basic design was a core Bauhaus course, now offered in architectural, art, and design schools and departments across the globe. One of the most important contributions of the Bauhaus is modern furniture design.

Moholy-Nagy joined the Bauhaus in 1923 and reasserted its original aims as a school of design and industrial integration. Moholy-Nagy was a versatile artist who was innovative in creating and teaching photography, typography, sculpture, painting, printmaking, and industrial design. He experimented with the photographic process of exposing three-dimensional objects (no negative) to light-sensitive photographic paper, which he called photograms. He coined the term "New Vision" for his belief that photography could create a new way of seeing the outside world that the human eye could not see. His theories of art and teaching are explained in his book *The New Vision, from Material to Architecture.*

Ever the innovator, Moholy-Nagy was enthusiastic about employing new media for exploring new ideas of creative expression. Even before computers

and the Internet, he thought the reality of the twentieth century was technology, by which he meant the invention, construction, and maintenance of machines. To be a user of machines was to be of the spirit of the twentieth century, he said. He thought machines had replaced the transcendental spiritualism of past eras. Moholy-Nagy would probably delight in knowing the presentation of his images, in the Getty Museum collection, uses new technology and interactive computer systems.

Moholy-Nagy and Gropius's contributions to the Bauhaus, the Institute of Design, and the Illinois Institute of Technology provide a link to the ideas of György Kepes, John Dewey, and Paul Rand.

Design Theories

György Kepes, a painter, designer, educator, and theorist taught at the Bauhaus, the Institute of Design, and Illinois Institute of Technology with Moholy-Nagy and later at the Massachusetts Institute of Technology. While teaching at the Institute of Technology (or the New Bauhaus) from 1937 to 1943, he refined his ideas about design theory, form in relation to function, and (his own term) the "education of vision."

Kepes published *Language of Vision* in 1944, an influential book about design and design education in which he acknowledged his indebtedness to Gestalt psychologists. He asserted that "Visual communication is universal and international; it knows no limits of tongue, vocabulary, or grammar, and it can be perceived by the illiterate as well as by the literate ... [The visual arts, as] the optimum forms of the language of vision, are, therefore, an invaluable educational medium" (Kepes 1944: 13). *Language of Vision* was important because it predated three other influential texts on the same subject: Paul Rand's *Thoughts on Design* (1946), László Moholy-Nagy's *Vision in Motion* (1947), and Rudolf Arnheim's *Art and Visual Perception* (1954).

In 1942, Kepes had been one of several people (Moholy-Nagy was another) who were asked by the U.S. Army to offer advice on military and civilian urban camouflage. He alluded to this experience in *Language of Vision* when he talked about natural camouflage: "The numerous optical devices which nature employs in the animal world to conceal animals from their enemies reveal the workings of this law [i.e., perceptual grouping] of visual organization" (Kepes 1956: 45).

In 1947, Kepes accepted an invitation from the School of Architecture and Planning at MIT to initiate a program there in visual design. While at

MIT he was in contact with a wide assortment of artists, designers, architects, and social scientists, among them Buckminster Fuller, Rudolf Arnheim, Charles Eames, Erik Erikson, and Walter Gropius. While Kepes's own art had moved toward abstract painting, he developed a parallel interest in scientific imagery, in part because it, too, had grown increasingly abstract. He thought scientists had a clearer and richer horizon than most artists did. He founded the Center for Advanced Visual Studies in 1964, where scientists and artists could come together with the idea of breaking down barriers between art and technology.

In 1956, Kepes curated an exhibition that became a book called *The New Landscape in Art and Science*. Modern-era artwork was paired with scientific images that were made, not by hand, but with "high-tech" devices like x-ray machines, stroboscopic photography, electron microscopes, sonar, radar, high-powered telescopes, and infrared sensors. Kepes's theories on visual perception have had a profound influence on architecture, design and visual art.

Louis Sullivan's nineteenth-century (shortened) motto "form follows function," the ideas of the Bauhaus, Walter Gropius, László Moholy-Nagy, and György Kepes are easily connected to philosopher John Dewey and twentieth-century graphic designer Paul Rand.

Graphic Design

Recently books and articles about graphic design history and theory have started to appear. In the past, books and magazine articles were "how to" in nature. With the current popularity of design in all its forms, its history and theory are becoming more and more available. Steven Heller is an articulate spokesperson for graphic design theory and has authored several books and anthologies about graphic design. Along with top illustrator Marshall Arisman, Heller has also written about illustration. Histories and theories of graphic design and illustration are being taught with art history in art schools and universities, and designers are fluent in design theory as well as practice these days.

A major contributor to both the practice and theory of graphic design was Paul Rand, a graphic designer and teacher whose work was influential in the evolution of graphic design in the twentieth and twenty-first centuries. "Design is a relationship between form and content," said Rand (Kroeger 2008: 18), who also referenced philosopher John Dewey's book

Art as Experience (1934) as an essential component of design education. Designers and artists who have not read Dewey are, simply, not well enough educated, said Rand. Dewey espouses the artistic and the aesthetic as being intertwined.

Rand understood Dewey to explain that art is often identified with the object – the building, the book, the painting, or the sculpture – apart from human experience. The perfection of some of these objects, or products, as Rand calls them, possesses prestige because of a history of unquestioned admiration. This prestige created conventions that get in the way of fresh insight, he thought. Once art attains classical status, it becomes isolated from the human conditions that brought it into actual experience.

Dewey was not writing about graphic design when he wrote *Art as Experience*, but Kepes was when he wrote *Language of Vision*. Rand thought Dewey's writing was essential reading and Kepes's writing was "philosophical double talk" and did not recommend the renowned design scholar and artist Kepes to his students. So don't feel bad if some philosophers don't make sense to you – even Rand found at least one with whom he did not connect.

Twentieth-Century Corporate Design

Paul Rand is best known for his corporate identities and logo designs, especially those for IBM, UPS, Westinghouse, and ABC. Despite being educated at the Pratt Institute, the Parsons School of Design, and the Art Students League, Rand was largely self-taught as a designer, learning about the works of Moholy-Nagy, Kepes, and others from European magazines. He taught design at Yale University and was inducted into the New York Art Directors Club Hall of Fame.

Rand's early career began creating stock images for a syndicate supplying images to various newspapers and magazines. Between assignments Rand generated a large portfolio. He even re-branded himself by changing his name from Peretz Rosenbaum. He became Paul Rand. A friend noted that "four letters here, four letters there" created a nice symbol. German architect and designer Peter Behrens noted the importance of Rand's new persona, which served as the brand name for his many accomplishments. It was the first corporate identity he created, and it may also eventually prove to be the most enduring.

Rand rapidly moved to the forefront of graphic design, producing work that garnered international acclaim. He created designs for magazine

covers free of charge in exchange for full artistic freedom. Among the praise he received was that of Moholy-Nagy, who said that among young Americans, Rand was one of the best and most capable. As a painter, lecturer, industrial designer, and advertising artist he drew his knowledge and creativeness from the resources of the U.S. He thought in terms of need and function. He was able to analyze his problems but his fantasy was boundless. Rand's reputation rapidly increased over the years as his influential work and writing established him as paramount in his profession.

Even though Rand was famous for the corporate logos he created in the 1950s and 1960s, the initial source of his reputation was in page design. He set the page layout for an *Apparel Arts* magazine anniversary issue and transformed mundane photographs into dynamic compositions. This earned him the offer of art director for Esquire–Coronet magazines. At first, Rand refused this offer because he thought he was not yet at the level the job required. A year later he decided to take over the responsibilities for Esquire's fashion pages. He was 23. Rand experimented with themes normally found in fine art, further advancing his goal of bridging the gap between design and the European masters.

Corporate Consciousness/Public Awareness

Even though Paul Rand's best known contribution to graphic design are probably his corporate identities, many of which are still in use, many others owe their design heritage to him. One of his primary strengths, as László Moholy-Nagy pointed out, was his ability as a salesman to explain the needs his identities would address for the corporation. According to one graphic designer, Rand almost single-handedly convinced businesses that design was an effective tool. Designers in the 1950s and 1960s owed much to Rand because he made the profession reputable, moving the field from commercial art to graphic design largely on his merits.

Rand's 1956 IBM logo defined corporate identity and was more than an identity; it was a design philosophy permeating corporate consciousness and public awareness. Rand also designed packaging and marketing materials for IBM from the early 1970s until the 1980s, including the well-known Eye-Bee-M poster.

Rand remained vital as he aged, continuing to produce important corporate identities. He collaborated with Steve Jobs for the NeXT Computer identity by creating a simple black box that breaks the company name

into two lines, producing a visual harmony that endeared the logogram to Jobs. Just prior to Rand's death in 1996, Jobs said that he was "the greatest living graphic designer."

Design Criticism

Paul Rand was solitary in his creative process, completing the vast majority of design work himself, even though sometimes he had a large staff. He wanted to produce books of theory to illuminate his philosophies. Moholy-Nagy asked Rand, when they first met, if he read art criticism. When Rand said no, Moholy-Nagy replied, "Pity."

Steven Heller noted that after that meeting with Moholy-Nagy, Rand sought out books by art critics and philosophers like Roger Fry, Alfred North Whitehead, and John Dewey, who had a lasting impression on Rand's work. In a 1995 interview (Kroeger 2008), Rand elaborated on the importance of Dewey's book *Art as Experience* (1934) by saying it dealt with everything and it was timeless. Every time you open the book you will find good things, he said. And when you read it again in another year, you will find something new.

Dewey was an important source for Rand. He uses Dewey's "functional aesthetic perfection" in his practice of designing work capable of retaining recognizable qualities even after being blurred or mutilated, which was one of Rand's routine "tests" for corporate identities.

Despite the prestige graphic designers place on his first book, *Thoughts on Design* (1946), Rand's later work earned him the reputation of being a reactionary and hostile to new design ideas. Steven Heller defended Rand by calling him "an enemy of mediocrity and a radical modernist," while Mark Favermann considered Rand's later work to be that of "a reactionary, angry old man" (Bierut et al. 1994, 2002). Differences like these are critical to scholarship and essential to contemporary philosophical dialogue.

Modernist Influences on Design

The ideology that drove Rand's career was the Modernist philosophy he so revered. He celebrated the works of artists like Paul Cézanne and constantly attempted to make connections between creative output and significant application in graphic design. In his book *A Designer's Art* (1985), Rand clearly demonstrates his appreciation for underlying connections from

Impressionism to Pop Art. The commonplace and the comic strip become ingredients for the artist's toolbox, he thought. Rand marveled at what Cézanne did with apples, Picasso with guitars, Léger with machines, Schwitters with trash, and Duchamp with urinals, making it clear that art ideas do not depend upon grandiose objects or concepts. The artist's job, thought Rand, was to make the ordinary unordinary, the familiar unfamiliar. This idea of de-familiarizing the ordinary was an important part of Rand's design choices.

Postmodern Design Issues and Practices

Making the familiar unfamiliar, or de-familiarizing the ordinary, as Rand put it, is part of the Postmodern art and design dialogue as well. Michael Cross, the product designer who used the museum as an experimental studio for considering space by eliminating the familiar and starting all over again, is one example and May Tveit is another. Tveit focuses on global issues and cultural identity, utilizing industrial manufacturing materials inspired by contemporary social issues and the power of words and language. She analyzes the physical, spatial, and architectural parameters of space and the historical, social, and cultural behavior intrinsic to a place.

Designing/Interpreting Cultural Space

May Tveit seeks to draw viewers' attention to the relevance of insignificant or previously unconsidered aspects of a place and its meaning. She uses huge cartoon-like thought/talk bubbles with bilingual text in Chinese, Spanish, and English to engage viewers in thinking about economics, immigration, histories, cultures, and peoples. The "conversations" Tveit creates are about what people think and do and buy and the controversies that surround those issues. Tveit earned her BFA at the Rhode Island School of Design and her master's in industrial design at the Domus Academy in Milan, Italy. She is a professor in the Department of Design at the University of Kansas and her work has been widely reviewed and exhibited.

Tveit's work expands and challenges traditional notions of fine art and industrial design and contributes to contemporary art and social discourse. Issues of corporate globalization, capitalism, and consumption find their

Figure 12.1 May Tveit, American (b. 1966). *a lot more*, 2007. Ultralight trupan, industrial acrylic, 47 × 41 × ⅝ inches.

Figure 12.2 May Tveit, *what do you want?* 2007. Ultralight trupan, industrial acrylic, 46 × 79 × ⅝ inches.

way into her work. She creates artworks that are all-encompassing experiential environments that provoke both thought and delight in viewers. Visually layered social commentary and critique and multi-sensory environments create thought-provoking, experientially powerful, and critically relevant cultural experiences.

Participants' Comments from a Gallery Talk by May Tveit on Her Work (2008)

Concept development can be a series of questions and the artworks do not necessarily have to answer those questions.

It was interesting to learn that Tveit came up with the thought bubbles while looking through a packaging catalog. Inspiration can come from anywhere.

Tveit proved that successful contemporary artists continue to explore all of the *oeuvres* of art.

The amount of research and experience required for Tveit's work is amazing. After listening to the justification she had for her choices, the show took on a much more significant meaning. I suddenly had more insight into her work and the ideas they were conveying. This made me think of Danto's philosophy – the meanings of consumerism, production, economy, and globalization – much larger than the physical bubbles and phrases that represented them.

Knowing the artist's intentions changes your views on the works of art. This relates to some of the philosophers we studied, particularly Arthur Danto, who said art needs interpretation in order to understand its meaning.

I always wonder about the meaning, value and thought behind artworks. It was more interesting to hear Tveit's explanation of the conversation bubbles in the gallery than to just read about them. Some of the work was so politically charged that it got me thinking about how important it is to view art in its social, political and cultural context and to consider the time period. I started thinking about art that endures over time, culture and place. Is that possible? That got me thinking about characteristics of art that "endures" and how I, as a teacher, can encourage this.

It was comforting to know that working professionals have insecurities and self-doubt just like I do. I no longer feel such a distance between the professional world and my current art world (still under construction). There *is* the possibility of being professional and still open enough to admit to imperfection.

May Tveit advised putting myself out there – no matter what! It was a relief to hear her say that if I want to go somewhere to be a designer – just go! Just show up where I want to spend the rest of my life and start getting my foot into *all* of the doors. She really inspired me not to get down on myself when I get rejected, but to roll with the punches and develop designs I will be proud of.

The outside world and our experiences interacting with different cultures can significantly influence what we create. Society plays a major role in creating aesthetic experiences.

Designing for Humanity

Emily Pilloton and her colleagues have created a new model for twenty-first-century design activism, claimed *Metropolis Magazine* (Steen 2009). Pilloton applied the terms "rant," "manifesto," and "call to arms" to her recently released book *Design Revolution: 100 Products That Empower People*, a collection of 115 design projects for social good. The young product designer's crankiness about the design world's failings is combined with her remarkable ability to take action. She runs Project H Design, a volunteer design firm that promotes humanitarian projects. In 20 months, it had more than 300 active members in nine chapters around the world and 22 projects completed or under way.

Pilloton is spirited and energetic and her Project H colleagues, also in their twenties, have a fresh attitude toward ownership, collaboration, technology, and design as a social mission. Many became designers to do good in the world, but they ran up against the demoralizing realities of the profession. Pilloton earned her bachelor's degree in architecture at the University of California, Berkeley, and her master's degree in product design at the School of the Art Institute of Chicago. Her thesis focused on the failure of the sustainable-design movement to incorporate humanitarian issues.

Carrying her philosophy into the work world was challenging. When she found herself ordering dressing room doorknobs for Gap, she decided she couldn't take it anymore. She became managing editor of the green design blog *Inhabitat* (*www.inhabitat.com*). "We need to challenge the design world to take the 'product' out of product design for a second and deliver results and impact rather than form and function." She realized she couldn't just complain; she had to help fix what was wrong, so she started Project H with a strong mission statement, "WE BELIEVE DESIGN CAN CHANGE THE WORLD."

The website further describes Project H Design as a charitable organization that supports, creates, and delivers life-improving humanitarian product design solutions.

> We champion industrial design as a tool to address social issues, a vehicle for global life improvement and a catalyst for individual and community empowerment. Using a scalable local-to global model for all projects, design fellows and volunteers in 6 US and 3 international chapters work to create systems and solutions for the developing world, homelessness, education, foster care, health care, and more. We are a global coalition of hundreds of designers worldwide. We work with, not for, organizations, enterprises, communities and individuals. We provide enabling, sustainable, meaningful, and efficient design solutions.

The secret to Project H's rapid success is that there are many designers who are strongly committed to these same ideas – designers who are eager to volunteer but who were frustrated by the typical experiences. "We're not afraid to volunteer our time, but we want to do something that has meaning and utilizes our skills," said one designer.

Chapters of Project H in New York, Los Angeles, Chicago, Austin, Seattle, London, Johannesburg, and Mexico City develop their own projects creating a model of modern efficiency. Pilloton set up the armature and the mission statement, and chapters interpret them as they want. Pilloton's willingness to share authority is one of her most striking leadership traits. Chapter heads say she doesn't give them much beyond the legitimacy of the name, a small annual budget, and unwavering moral support. "To have that name on my business card is priceless. If I call an investor or a nonprofit and say, 'I'm part of Project H Design, here's our web site, here's what we've done,' they are going to call me back," said one chapter member.

Project H redefined success to include modest moves like improving on existing designs. Pilloton manages to make this sound as exciting as being the lead designer on the latest Apple gadget: "How do you take the power of

something that's clearly awesome and make it much more efficient as a business model and production cycle?" This refers to the Hippo Roller, a device for transporting water. It's been a proven success in South Africa for 15 years, but at $100 each, it was too expensive for what is essentially a plastic barrel. Project H re-engineered the barrels as two-piece capsules that could be nested and stacked, making them far cheaper. Another project, The Learning Landscape, is a piece of playground equipment made from tires that teaches math concepts. Pilloton and volunteers conducted research and developed construction schemes so one Learning Landscape could be built in Uganda, four in North Carolina, and one in the Dominican Republic.

Currently Pilloton is unpaid and supports herself through freelance work. She and her partner recently moved out of an apartment in San Francisco and into their Airstream trailer in order to keep their overheads low. The trailer doubled as an exhibition space in early 2010, when they took "Design Revolution" on the road to 23 schools across the U.S. They exhibited objects from the book, gave lectures, and conducted workshops for professors to help them meet the growing demand for classes on humanitarian design.

Pilloton and her cohorts have a not-so-secret weapon for running their twenty-first-century start-up business: the Internet and its related technologies. As a blogger for *Inhabitat*, Pilloton built an audience and a huge mailing list. The Project H website, where a PayPal account brings in the majority of the group's funds, has an average donation size of $53. The ease of technology has empowered followers to get involved at whatever level they can, no matter the size of the contribution.

Pilloton attributes some of her generation's activism to growing up with pagers, cell phones, and e-mail, "feeling like you have a voice and the channels to publicize that voice," she says. She finds it helpful to practice condensing her messages to their essence. That's one thing I've learned from the Web, she says. "How to tell compelling stories simply and retaining the humanity." (See a video of Pillton's 20010 TED talk at *www.ted.com/talks/ emily_pilloton_teaching_design_for_change.html*; see also *www.ted.com/ speakers/emily_pilloton.html.*)

Designing for Social Justice

Luba Lukova, is an internationally recognized contemporary artist/designer who uses metaphors, and a juxtaposition of symbols, lines, and text, to capture the essence of humanity in posters that promote social justice. Her

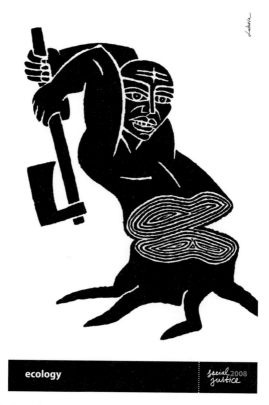

Figure 12.3 Luba Lukova, American. *ecology* from *Social Justice*, 2008. Silk screen, 27 ½ × 39 ⅜ inches.

exhibition *Umbrellas, Social Justice & More*, on view at La MaMa La Galleria in New York City in 2009, featured a wide range of work, including her critically acclaimed *Social Justice* poster portfolio. The Health Coverage poster, part of the collection, was in an exhibit at the Inauguration of President Obama in Washington, D.C. Saatchi Online TV & Magazine wrote that the exhibition was "intense and unrelenting, pointing out the injustices and foibles of society in a cheerful advertising aesthetic that surprises the viewer with its poignancy."

Social Justice 2008 is a book of posters packaged in a slip-cover featuring Lukova's sketches and thumbnails from the art in the posters. Lukova's statements require only two or three colors to say a thousand undeniable words about social conditions. This collection showcases Lukova's use of

metaphors and symbols to express themes that include peace, war, ecology, immigration, and privacy. Her distinctive style and visual imagination distill significant issues into deceptively simple, yet formidably unforgettable images that not only transfix, but also have the power to become indelible. Each poster addresses viewers in an accessible way.

No matter the scale of the work, she said, it's first and always the idea, the emotion, and the meaning. It doesn't matter if the work is called fine art or graphic design. "If you put enough seriousness into what you do, people always respond to it. I don't mind how my work is labeled" (*www. lukova.net*).

Building Design Careers

Echoing comments made by May Tveit in her gallery talk and Pilloton's work with Project H, Luba Lukova advises readers about careers in design or illustration. Lukova thinks it is more difficult to sustain growth than to attract initial attention when starting out in design and illustration, so first of all "you have to be excellent. You have to be professional in every aspect of what you do."

Sometimes designers become complacent after their first successes and they disappear in a year or two. "You have to keep striving for more, for personal growth." It is not about success and recognition, Lukova says, it's about "the satisfaction you feel by yourself, by growing, by learning something new and keeping the passion and interest in what you do." It's not easy to stay interested, she adds. Sometimes the work might look repetitive or it seems as if you're getting off-track and it's difficult to find new challenges. It's up to the creative person to expand their horizons and remain interested and challenged. That's what sustains a good designer and the quality of their work: "You have to be really good at what you do. You have to learn and keep learning and look for excellence in your work. That's the only way you can succeed. I don't believe it's possible any other way."

13

Art and Aesthetic Education

Experiencing Michelangelo's *David*

An art student majoring in sculpture at a university in California worked very hard to save enough money to travel to Italy to see Michelangelo's *David*. He saw *David* in the Palazzo degli Uffizi *outside* the Galleria dell'Accademia, where *David* is housed, *inside*. Outdoors the reproduction looks old and weathered (from lots of pigeon droppings). The art student was in awe of what he thought was the original *David*. He thought it was worth all the work it took for him to see it.

Then he went inside the Galleria dell'Accademia and saw the original *David* along with the video analysis kiosk next to the sculpture with a materials analysis that explained the features of deterioration with three-dimensional views.

After studying the original *David* and learning all he could from the educational kiosk, and comparing it to the *David* outside on the Plaza, the student preferred the *David* outside on the Plaza because it looked older and more weathered.

This young artist had at least three different kinds of learning experiences in different disciplines with different ways of knowing. Can you name them? This story causes us to wonder what and how we learn from art.

Ideas About Art, First Edition. Kathleen K. Desmond.
© 2011 Kathleen K. Desmond. Published 2011 by Blackwell Publishing Ltd.

> *The relation between what we see and what we know is never settled.*
>
> John Berger, *Ways of Seeing*

Some people agree with Plato that nothing can be learned from art, even after acknowledging that art is so powerful that it may require censorship because it can be a moral danger to society. Aristotle thought characteristics about being human could be learned from making and viewing art, like expression and imagination. Greek philosophy education included reading and writing, gymnastics, music, and drawing. Reading, writing, and drawing were considered useful on a variety of levels. Aristotle thought drawing could help boys judge the beauty of human forms. (Early Greeks educated boys only, not girls.)

Philosophers from the seventeenth to the twentieth centuries, John Locke, Frederick Froebel, and Horace Mann among them, wrote about education not as their primary philosophical work, but as it supported their theories. Thomas Hobbes and David Hume believed perceptual data are primary units of knowledge that are assembled during the act of thinking. John Dewey called knowledge through seeing the "spectator conception of knowledge" and warned against seeing without contemplation.

Art education, an area of study developed in the late nineteenth and early twentieth century centuries, investigates, interprets, and develops pedagogical practices steeped in a variety of theories from disciplines like art, philosophy, psychology, sociology, and education. Art educators think seeing and knowing are simultaneous processes, that knowing through seeing is a mode of cognition and a valid way of learning, and that seeing is an active process that transforms sensory data into useful knowledge. Prominent art educators have created significant learning practices and provided considerable insight into art and cultural learning. Art educators see art and education as a powerful tool for establishing social, cultural, political, and spiritual attitudes and behaviors. This chapter focuses on aesthetic education more than on studio art, art history, or art criticism, and advances ideas about how art and aesthetic education contributes to public education and connects Vincent Lanier's ideology with philosophers and educators like John Dewey and Paulo Freire.

Preeminent art educator Vincent Lanier (1991: 16–17) believed "aesthetics itself is the critical insight, the primary art discipline" because it is the one knowledge that applies to every aspect of our lives. Lanier thought aesthetics to be the "broadest common denominator of a proper art education." He advocated teaching aesthetics by including art history and art criticism as well as the sociology of art as supporting material. Lanier failed to see how teaching art making would teach an understanding of art or teach what "we need to know about our own aesthetic responses."

A Pragmatic Approach to Art Education

John Dewey provided a significant foundation for art education, and many art educators, including Vincent Lanier, consider him to be an influential theorist for the field. (So does graphic designer Paul Rand. See Chapter 12.) Dewey shares expressionist ideas with Aristotle and common ideologies with Arthur Danto, George Dickie, Nelson Goodman, and Ludwig Wittgenstein.

Danto argues that some artists make art based on the context of their era and culture, with which Dewey would agree. Both Danto and Dickie suppose all cultures have something like an artworld in which they theorize about art, also a concept with which Dewey would agree. Dewey, Goodman, and Wittgenstein all used language to help define the word "art" – from the philosophy of language to its correlations in Postmodernism and aesthetics. Goodman and Dewey both made significant contributions to education.

John Dewey was a seminal American philosopher whose ideas inspired several movements that shaped twentieth-century thought, including empiricism, humanism, and contextualism. Dewey ranks with the greatest thinkers of any age on the subjects of pedagogy, epistemology, aesthetics, logic, ethics, and social and political theory. He was the voice for progressive democracy that shaped America and the world. His pragmatic approaches to ethics, aesthetics, and education remain influential.

Dewey thought we learned the language of art by entering into the spirit, or the experience, of a relevant community. This is a broad and open concept promoted by Morris Weitz that goes beyond Wittgenstein's "family resemblances." Dewey's ideas echo Richard Anderson's anthropological descriptions of art as possessing culturally significant meaning encoded in a sensuous medium and Ellen Dissanayake's ethological descriptions of human needs to "make" objects and experiences "special."

Aesthetic Experience and Art Experience

Dewey's treatment of aesthetic theory in his book *Art as Experience* (1934) is based on lectures he delivered at Harvard University in 1931 and provides a continuity of his views on art. It includes themes from his previous philosophical work, offering important and useful extensions. He stressed the importance of recognizing the significance of all aspects of human experience and took into account that qualitative immediacy in his book *Experience and Nature* (1929), incorporating it into his view of the developmental nature of experience. It is in the enjoyment of the consummatory phase of experience that the adaptation of the individual with the environment is realized, thought Dewey. These central themes are enriched and deepened in *Art as Experience*, making it one of Dewey's most significant works and certainly the most influential to the field of art and aesthetic education.

The roots of aesthetic experience lie in commonplace experiences that are ubiquitous in the course of human life, argued Dewey. Aesthetic enjoyment is not only for the privileged few. Whenever there is a coalescence of an immediately enjoyed qualitative unity of meanings and values drawn from past experiences and present circumstances, life takes on an aesthetic quality. This is what Dewey called having "an experience." The process of intelligent use of materials and creative development of solutions to problems that results in a reconstruction of experience affording immediate satisfaction – the process found in the creative work of artists – is found in all intelligent and creative human activity. Artistic creation is the emphasis on the aims of immediate enjoyment of unified qualitative complexity and the ability of the artist to achieve these aims by refining the resources of human life, meanings, and values.

Ever concerned with the interrelationships between various domains of human activity and concern, Dewey concludes *Art as Experience* with a chapter devoted to the social implications of the arts. Art is a product of culture, and it is through art that cultures express the significance of their lives, as well as their hopes and ideals. Because art has its roots in values experienced in the course of life, those values have an affinity to commonplace values and assign to art a critical role in prevailing social conditions.

Educational Theories

Dewey gave a great deal of thought to both scientific and artistic processes of human creative behavior. He developed a five-step process for problem solving that remains useful to researchers in several disciplines

today. The process begins with observing a situation, then defining and refining the problem, considering and comparing alternative hypothetical solutions to the problem, and finally testing the hypotheses both in thought and in action. Dewey called this process "inquiry" in 1910. It's hard to believe that the word "inquiry," defined in this way, is over 100 years old in this day and age when inquiry-based and problem-based education are widely advocated.

Dewey's educational theories are connected to themes of democracy and communication and are effectively summed up in the first chapter of his 1916 book *Democracy and Education: An Introduction to the Philosophy of Education*, "Education as a Necessity of Life." "What nutrition and reproduction are to physiological life, education is to social life," he wrote. Education is transmitted through communication. "Communication is a process of sharing experience till it becomes a common possession" (Dewey 1916: 13).

Dewey was a relentless campaigner for educational reform, pointing out that the authoritarian, pre-ordained approaches of traditional education were too concerned with delivering facts and not concerned enough with learning and understanding students' actual experiences. Dewey was the most famous proponent of experiential education and advocated placing students in active roles of inquiry. One of his principles was that school was an "embryonic community." Cooperative conduct in a classroom setting represented a model and practical demonstration of democratic problem solving. Each student had a voice, learned collaboratively and cooperatively, and mirrored society beyond the classroom.

Nelson Goodman, Richard Anderson, Ellen Dissanayake, and perhaps even Postmodernist thinkers like Jean Baudrillard and Michel Foucault are among Dewey's heirs. Can you list ideas these philosophers developed that emanated from Dewey?

An Aesthetic Theory

Philosopher Nelson Goodman thought that symbols were pervasive and important for developing concepts. He thought we discovered and even created the worlds we live in through our interaction with symbols and that our interest in those symbols is cognitive. In his book *Languages of Art* (1976), Goodman attempts to explain symbols, both linguistic and non-linguistic, in science as well as in regular life and the arts. His version of aesthetic theory is grounded in the philosophy of language. His primary

contribution was to define works of art as symbols within symbolic systems and treat the problematic issues of artistic representation and expression as semantically based questions of reference and denotation.

Because Goodman thought that general, communicable knowledge about arts education was zero, he founded Project Zero at the Harvard School of Education, where he was professor of philosophy, in 1967. Project Zero is an interdisciplinary program studying education in and through the arts. Goodman thought arts learning should be studied as a serious cognitive activity. Project Zero's mission is to understand and enhance learning, critical thinking, and creativity in the arts, as well as humanistic and scientific disciplines. The learner is placed at the center of the educational process, respecting the different ways individuals learn at various stages of life, as well as differences among individuals in the ways they perceive the world and express ideas, a precursor to current constructivist educational theory.

Goodman thought that understanding a certain style of art or work by a particular artist, or comprehending a symphony in an unfamiliar form – to see or hear in new ways – was as cognitive an achievement as learning to read or to write or to add.

It would be difficult to overemphasize the influence of Goodman's philosophies on twentieth-century aesthetics. His systematic differentiations among media, symbolic forms, modes of expressivity, and reference/context, and his contribution to constructivist theory, greatly influence and are integral to much of contemporary art and aesthetic education thinking and teaching.

Project Zero's research continues to contribute to understandings of human cognitive development and processes of learning in the arts through the work of Howard Gardner, professor of cognition and education at the Harvard Graduate School of Education, adjunct professor of psychology at Harvard University, and currently senior director of Harvard Project Zero. Gardner is best known in educational circles for his theory of multiple intelligences. During the past 25 years he and Project Zero colleagues have been working on the design of performance-based assessments, education for understanding, and the use of multiple intelligences to achieve a more personalized curriculum, instruction, and assessment. It is worth noting that Project Zero was founded by a philosopher and is now headed by a professor of cognition, education, and psychology, making good on the earlier claim that art educators investigate and interpret theories in various disciplines like art, philosophy, psychology, sociology, and education in order to develop significant pedagogical practices.

Art Education Inquiry

Twentieth-century art education histories are described and explained in Frederick Logan's *Growth of Art in American schools* (1955) and Arthur Efland's *History of Art Education: Intellectual and Social Currents in Teaching the Visual Arts* (1990). While both books explain education at the school level, they don't explain much about adult or aesthetic education. The National Art Education Association published two useful volumes in 1996 that explain contemporary histories in art and aesthetic education a little more broadly: *Postmodern Art Education: An Approach to Curriculum*, co-authored by Arthur Efland (Efland et al. 1996), and *Art Education: Issues in Postmodernist Pedagogy*, by Roger Clark (Clark 1996).

Creative and Mental Development

Viktor Lowenfeld is a major figure in the field of art education with widespread influences. *Creative and Mental Growth*, published in 1947, became the single most influential textbook in art education. It described characteristics of aesthetic, social, physical, intellectual, and emotional growth reflected in the art of children. Lowenfeld studied children's artistic behaviors directly. Subsequent editions of *Creative and Mental Growth* contained contemporary observations and studies that kept the work current and useful.

Lowenfeld's developmental stages describe the scribbling stage, 2–4 years, the preschemtic stage, 4–7 years, the schematic stage, 7–9 years, the dawning of realism, or the gang (group) age, 9–12 years, and the pseudo-naturalistic stage, or the age of reasoning, 12–14 years old. Lowenfeld's stages are sometimes used in concert with Jean Piaget's stages of cognitive development, providing a rich psychological foundation for understanding and teaching children. Lowenfeld's stages of artistic development describe emotional, intellectual, physical, perceptual, social, aesthetic, and artistic growth and remain a standard in the field.

Lowenfeld also developed the Visual–Haptic Theory, using psychological methodologies that helped learners understand their psychological preference for learning visually or tactilely. Originally developed for training pilots in the military, the Visual–Haptic Theory is still useful today in adult education.

Lowenfeld's approach to art education was about creativity. It was student centered (psychological) rather than art (content) centered or group (socially/culturally) centered, like Dewey's. Lowenfeld thought good teaching was a dialogue. He developed motivations and evaluations with a strong expressionist bias. Even though Lowenfeld and his followers have died or retired, his concepts are carried on in third- and fourth-generation reincarnations. Lowenfeld's ideas about art as a catalyst for creativity have prompted many research dissertations in art education.

Social/Cultural Learning and Behavior

June King McFee made significant contributions to the world of art education with her "Perception Delineation Theory" based on sociology, anthropology, psychology, and the needs of urban children. According to her theory, learning is a behavioral adjustment. The education of a society takes shape through changes in behavior.

McFee developed a cross-cultural definition of art rooted in sociology and cultural studies. She believed that art was created as a result of behavior and that the foundation of behavior was the intentional motivation to "interpret and enhance the quality or essence of experience." McFee wrote *Preparation for Art* in 1961 and, with Rogena Degge, *Art, Culture and Environment* in 1991. *Preparation for Art* portrays a range of individual differences to visual phenomena and visual arts. Like Lowenfeld, McFee believed in teaching to the child's needs. She is best known for advancing cultural understanding through the arts.

Dewey's influence on Lowenfeld, Lanier, and McFee is evident. In addition, Ellen Dissanayake's research in the field of ethology, the scientific study of behavior, and current research in non-Western aesthetics contributes to the efficacy of these art educational theories and practices.

Human Thought and Art Learning

Edmund Burke Feldman, art historian and past president of the National Art Education Association, defines art education as an enterprise that encompasses teaching and learning for the purpose of making and understanding art, as well as finding out more about the world and ourselves

through visual art. Visual art includes everything from traditional painting, sculpture, and architecture to design, photography, film, television, and computer art. According to Feldman, art education studies the form and function of every kind of object and every way we have devised to make and transmit images of all kinds of people and environments. Finally, he says, art education embraces various modes of discourse employed in making art, studying the history and anthropology of art, discerning meanings of art, and assessing the value of individual works of art. Feldman borrows from the discipline of art history in his applications to art education and is content centered rather than individual centered (Lowenfeld) or culturally centered (McFee). Feldman offered five dimensions of human thought and action relative to art teaching and learning: social, economic, political, psychological, and cognitive. These dimensions are another way of talking about art education.

From Aesthetic Education to Discipline Based Art Education

Several trends in art education evolved in the twentieth century. Manuel Barkan was a visionary art educator at The Ohio State University who designed a model of art education in 1962 that included artistic inquiry based on the kinds of questions artists deal with in their work. The artist did not stand alone, according to Barkan, but was accompanied by the art historian and the art critic, with each profession following its own "model of inquiry." Aesthetic education guidelines developed by Barkan and his colleagues were used by CEMREL, a private nonprofit corporation that operated between 1968 and 1980, supported in part as an educational laboratory by funds from the National Institute of Education, Department of Health, Education, and Welfare, located in St. Louis, MO. (CEMREL stands for Central Midwestern Regional Educational Laboratory.) Several yearbooks of collected articles from CEMREL conference proceedings edited by Stan Madeja were produced, including *Arts and Aesthetics: An Agenda for the Future* (1977) and *The Teaching Process and Arts and Aesthetics* (1979). Contributors included Arthur Efland, Gil Clark, Laura Chapman, Brett Wilson, D. Jack Davis, Harlan Hoffa, Morris Weitz, David Ecker, Harry Broudy, Howard Gardner, Ralph Smith, and Elliot Eisner, reading like a who's who of art education during that time.

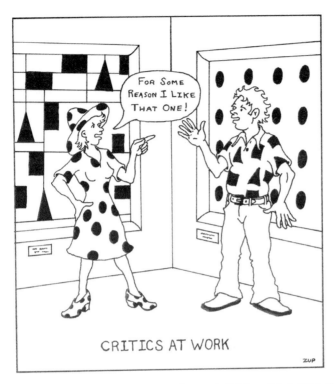

Figure 13.1 Matthew Zupnick, American (b. 1961). *Critics at Work*, 2010. Graphite, ink, marker. 6 × 8 inches.

In 1971 Ralph Smith, professor of aesthetic education at the University of Illinois and editor of the *Journal of Aesthetic Education*, edited a volume called *Aesthetics and Problems of Education* in the "Readings in the Philosophy of Education" series, which elaborated on the field of philosophical aesthetics to clarify basic problems of aesthetic education. The Preface noted the differences among three types of aesthetics: scientific, analytic, and speculative. Scientific inquiry, including sociological and psychological studies, was not included in these readings. (Feminist critics would have a thing or so to say about this exclusion in the coming Postmodern decades.) Smith deemed only analytic and speculative aesthetic inquiry to have a philosophical character that was useful in this volume. Smith dedicated this volume to Harry S. Broudy, who was the "Readings in the Philosophy of Education" series general editor, and "with whom systematic,

persuasive philosophy of aesthetic education begins in the modern era." Broudy was also influential in developing the aesthetics component of discipline-based art education (DBAE).

By the late 1970s the J. Paul Getty Trust funded thinkers Arthur Efland, Gil Clark, Michael Day, and Dwaine Greer to develop theories to support the best practices in art education. Clark, Day, and Greer elaborated on DBAE in a special edition of *The Journal of Aesthetic Education* in 1987. Widely publicized and used in California schools after a state proposition eliminated art teachers in elementary schools, DBAE made a major impact on the way we think about and practice art teaching. In the past, art education was studio based, almost to the exclusion of art history, art criticism, and aesthetics. DBAE promoted teaching all four disciplines to foster critical and creative thinking and doing. It did not advocate spending equal time on each of these four disciplines; instead it recommended they be incorporated into traditional studio-based art programs. The Getty Trust funded Regional Centers throughout the country for teams of elementary school art teachers, classroom teachers, principals, and librarians to develop methods for implementing DBAE in their schools under the tutelage of university professors.

The goal of DBAE was to develop abilities for understanding and appreciating art. This involved knowledge of theories and contexts of art and the abilities to respond to as well as to create art. Another goal was that art would be taught as an essential component of general education.

The content of DBAE was derived from the disciplines of aesthetics, art criticism, art history, and art production. These disciplines deal with concepts about the nature and value of art, foundations for valuing and judging art, knowledge of the contexts in which art has been created, and processes and techniques for producing art. Studies are derived from a broad range of the visual arts, including design and the fine arts from Western and non-Western cultures and from ancient to contemporary times. The implementation of DBAE is marked by systematic, regular art instruction with art education expertise, administrative support, and adequate resources and assessed by appropriate evaluation criteria and procedures.

While DBAE is not practiced exactly as it was proposed in 1987 in the *Journal of Aesthetic Education*, it is implemented in diverse ways that suit the cultural environment of schools across the country. Adaptations take into account audience, school system, resources, and knowledge of teachers

and students. The practice of DBAE includes art education theories that make sense to the practitioner.

Art educators continue to think about and publish research and practical articles about current issues in art, society, culture, and education in journals such as *Art Education, School Arts, The Journal of Multicultural and Cross-Cultural Research in Art Education,* and *Studies and Art Education. The Journal of Aesthetic Education* and *The Journal of Aesthetics and Art Criticism* focus on aesthetics and the philosophies of aesthetic education.

Movements and Contemporary Issues in Art Education

Movements in twentieth-century art education are similar to those in art and philosophy. From the seventeenth to the nineteenth centuries the mimetic view of art as an imitation of nature was the norm. In the early twentieth century a formalist view was prevalent until mid-century, when creative self-expression took over as a movement in art education. From 1930 until the 1960s "Art for Daily Living" was explored, with art as an instrument for enhancing aesthetic qualities of an individual's environment. Between 1960 and 1990 art as a concept was the subject of artistic and scholarly inquiry. In the 1990s a Postmodern attitude prevailed in art education. Art was considered a form of cultural production that constructed symbols of shared reality and promoted deeper understandings of the social and cultural landscape. It is with this Postmodern attitude that mini-narratives of various unrepresented groups, those not represented by the "canon of master artists," were featured.

Theories from a variety of disciplines like philosophy, psychology, sociology, and cultural studies have engaged art educators for more than a century, and contemporary times are no different. Postmodernism, Feminism, multiculturalism, cultural and psychoanalytical studies, and visual culture are studied by art educators and incorporated into their thinking and practice. Aspects of individual and cultural identity, popular media, and new artistic practices present themselves in relationship to pedagogical theory with applications for specific strategies, assessment, and evaluation. There are too many art educators tackling contemporary issues in art education to mention here, but not as many committed to aesthetic education and issues of public education.

Aesthetics: Issues and Inquiry for Art Educators

Louis Lankford, Des Lee Foundation Endowed Professor in Art Education at the University of Missouri Saint Louis, is an articulate, accessible (and entertaining) scholar and practitioner of art and aesthetic education. Lankford studied with the prominent theoretician E. F. Kaelin, professor of philosophy and art criticism at Florida State University, who claimed, in *An Aesthetics for Art Educators* (1989), that aesthetics serves as a foundation for theory and practice in art education.

Lankford's *Aesthetics: Issues and Inquiry*, published in 1992 by the National Art Education Association, remains one of the most widely read and used texts in the field. It is short, clear, accessible, and useful to art educators who may have hesitated to teach aesthetics because books and articles in aesthetics are so dense and laden with specialized words and references. Those outside the field of aesthetics are unlikely to try negotiating this unfamiliar territory. Art educators teach what they are familiar with and what they understand. If aesthetics is not accessible, it is unlikely to be taught.

Lankford's text and his presentations to art education groups have moved teaching aesthetics beyond questions like "Is this art?" and "How does this artwork make you feel?" to issues relevant to teachers and students. *Aesthetics: Issues and Inquiry* focuses on the practical concerns of teaching, with sections devoted to teacher preparation, curriculum development, methods of instruction, and student assessment. Practical examples demonstrate the application of ideas presented. (Lankford also studied with Lowenfeldian storyteller Jack Taylor at Arizona State University.) Lankford's stories or case study puzzles like his "Preparation and Risk in Teaching Aesthetics" in *The Journal of Art Education* (1990) are useful and enjoyable ways to apply aesthetics.

Lankford was a proponent of discipline-based art education when it was in its glory days and he still promotes utilizing ideas and concepts from history, criticism, aesthetics, and the studio. He resists the idea of thinking that any of those disciplines are the only way of approaching, solving, or posing problems. Disciplinary boundaries are dissolving today, he says, and that's very healthy. Lankford urges us to use what we know about art and the visual sensory world to mediate and navigate through life and maximize our abilities to take new ideas and weave them into everyday practice.

Rationales for art education usually include references to the importance of art and culture, addressing the nature, value, and function of art in society and topics in aesthetics. Lankford makes clear that ideas drawn from aesthetics, applied to philosophical foundations for art education, help determine concepts central to teaching and learning art and establishing art education's role in general education. Public education is literally about changing lives, says Lankford, and if you're going to do this, you want to be very thoughtful about it so that you are making changes that are going to be meaningful.

Acts of Culture and Freedom

Paulo Freire was a Brazilian educator and one of the most influential educational thinkers of the late twentieth century who advocated a system of education that emphasized learning as an act of culture and freedom. Born in Recife, Brazil, he was a lawyer for a time, taught Portuguese in secondary schools, and became active in adult education and workers' training. He was the first Director of the Department of Cultural Extension of the University of Recife (1961–4.) He gained international recognition for his work in literacy training in Northeastern Brazil, but following the military coup d'état of 1964, he was jailed by the new government and forced into political exile.

Throughout Freire's best-known work, *Pedagogy of the Oppressed* (1970), and subsequent books, he argued for a system of education that emphasized learning as an act of culture and freedom. He is known for concepts such as "banking" education. This is when passive learners have pre-selected knowledge deposited in their minds. Freire called this "conscientization" and described it as a process by which learners advance towards critical consciousness. This "culture of silence" is one in which dominated individuals lose the ability to critically respond to a culture that is forced on them by a dominant culture. First-time Freire readers can benefit by starting with *Pedagogy of the Oppressed*.

Freire has much to offer art educators armed with theories from Dewey and Nelson, from Lowenfeld, McFee, and the host of thinkers who developed aesthetic education and discipline-based art education, and from Lankford, who echoes Freire when he says, "If we are to have a healthy and useful art education paradigm for today and tomorrow it would have to be one that stresses openness to ambiguity" (Childress 2007: 5).

What Can Be Learned in Art Class?

A polytechnic university facing economic problems, not unlike many institutions of higher education these days, is trying to decide where cuts to the budget can be made. Should budget cuts be made horizontally or vertically? Horizontal cuts would come from every area in the institution with a percentage cut from each department. Vertical cuts would eliminate entire departments or programs. If vertical cuts are agreed upon, it is one dean's recommendation that the entire art program be cut. After all, he argues, this institution's mission cannot be met in art classes because nothing can be learned from art. Besides, he adds, the art program is expensive. Only a small number of students can engage in studio art classes and even large numbers in art history classes do not make up for the small numbers in studio classes.

How do faculty of an art program that includes studio art, art education, interior design, and graphic design explain the goals of art education to the administrators of the institution? Name philosophies, philosophers, and art educators whose ideas could support a rationale for keeping the art program in the polytechnic university. What do students learn by studying art?

Some questions to consider include: Are certain kinds of art skills like drawing, painting, or printmaking, important? Which ones? Why? Is making art important or is learning its history important? Why? Is the experience of art making important? How? Does it matter if the objects made are art or not? Is it an important learning objective to develop creativity? Do technicians have to think creatively? Is the goal of art class to make "art" or have experiences developing creative abilities and to "see" and to know? Is creative development as important as cognitive learning?

Does cognitive learning take place in art classes? Which ones? Studio art classes? Design classes? Art history classes? Both? Neither? Is creative or critical thinking applicable to other professions? What about social and cultural learning? Is it important for students to learn to work cooperatively? Is cooperative learning applicable to the workforce? Is it important for students to understand their creative process? What useful knowledge can be gleaned from art histories?

What in the world can be learned in art class?

14

Artists, Art Critics, Art Historians, Curators, Museums, and Viewers
Making Art Ideas Your Own

Tom Wolfe wrote *The Painted Word* in 1975, commenting on modern art and the 1960s and 1970s art scene in America. With scathing social criticism, he wrote about what artists do, what critics do, what collectors and art museums and art galleries do, and about how all of these characters negotiate the artworld. His observations are to satire as bullets are to a gun, claimed the *Boston Sunday Globe*. Wolfe began his observations with the realization, after reading a review in the *New York Times* written by Hilton Kramer, that "these days, without theory to go with it, I can't see a painting" (Wolfe 1975: 2). "Modern art has become completely literary: the paintings and other works exist only to illustrate the text" (Wolfe 1975: 4). Wolfe, ever the engaging, entertaining, and brilliant writer, told a satirical and blasphemous (so thought some of us in the artworld) story about the New York art scene that had, as all social criticism does, lots of truth to it. Chapter 2 is titled, "The Public Is Not Invited (and Never Has Been)."

The roles of artists, collectors, philosophers, social, cultural, and art critics, art historians, art galleries, art museums, and general public art viewers have changed since 1975, as has culture itself. Wolfe was writing over three decades ago, after the artworld had settled in New York City and Modernism was in full swing. Today we live in a global, Postmodern world that is all-encompassing and where Wolfe's observations are only part of the picture.

Other social critics, like Susan Sontag and Jean Baudrillard, have written about art and culture, too. Sontag's *On Photography* is featured in Chapter 11 and Baudrillard's concepts of simulacra and simulation are explained in Chapter 10. Many philosophers have tried to explain their observations of

art and culture in philosophical terms, both analytical and continental, as described in previous chapters.

What Artists Think and Do

Art has been made in every society we know about for as far back in history as we can trace and for a variety of reasons, some of which have been explained by ethologist Ellen Dissanayake and anthropologist Richard Anderson in Chapter 2. Mark Getlein, author of *Living with Art* (2009), has identified roles artists have filled at different times and in different cultures: for instance, artists create places for human purposes; they create extraordinary versions of ordinary objects. Artists record, commemorate, and give tangible form to the unknown and to feelings and ideas. Artists refresh our vision and help us see the world in new ways. Some artists have written about their philosophies and their work, most notably Wassily Kandinsky in *Concerning the Spiritual in Art*, and Mark Rothko in *The Artist's Reality: Philosophies of Art*.

Concerning the Spiritual in Art

Wassily Kandinsky, a nonobjective painter in the late nineteenth and early twentieth centuries, explained his theory of painting, and clarified ideas and influenced other modern artists in his book *Concerning the Spiritual in Art* (1910). Kandinsky's book had an impact on the development of modern art. It was presented in two parts. The first part, "About General Aesthetic," called for a spiritual revolution in painting that would allow artists to express their own inner lives in abstract terms. Just as musicians don't draw on the material world for their music, he said, artists should not depend on the material world for their art. In the second part of the book, "About Painting," Kandinsky wrote about the psychology of colors, language of form and color, and the responsibilities of the artist.

The Artist's Reality: Philosophies of Art

Mark Rothko wrote *The Artist's Reality* sometime around 1940 but it wasn't published until 2004. The manuscript was stored in a warehouse after his death in 1970. In the Introduction, Rothko's son, Christopher, describes the

complicated and fascinating process by which, after its discovery, he completed this manuscript, whose existence had previously only been a rumor, and brought it to publication. Rothko's ideas in the book on the modern artworld, art history, beauty, and the challenges of being an artist in society offer insight into both his work and his philosophies. Short, engaging sections include his thoughts about "Art as a Natural Biological Function," "Art as a Form of Action," "Art, Reality and Sensuality," "Particularization and Generalization," "Plasticity, Space, Beauty," and "Indigenous Art." Rothko was one of the most influential painters of the mid-twentieth century. We have his son to thank for this rare and important opportunity to engage with his thinking after all these years.

Make Space in Art History and Theory

Contemporary African-American artist Kerry James Marshall, in a 2008 artist talk at the Nelson-Atkins Museum of Art, made it clear why artists need to know art history, theory, and philosophy of art. He said, "Young artists have to produce something that fits into the critical and commercial/collecting market" (Marshall 2008). He advocated that young artists strategically develop their careers rather than leaving it to chance. He referenced artists, art historians, critics, writers, collectors, and himself to prove his point. His own goals for making art are fourfold. He seeks to make art that (1) is challenging enough to gain critical attention, (2) is meaningful enough in terms of conventional art theory and aesthetics, and (3) has a broad enough appeal to (4) occupy a secure place in the history of art, theory, and aesthetics.

Marshall is widely acclaimed and his work is extensively collected. He was keynote speaker for the College Art Association's 2001 Annual Conference (Marshall 2001) and his letter is published in *Letters to a Young Artist* (Nesbit and Andress 2006) – a book of 23 letters written by contemporary artists to a young artist worried about developing his or her art career. (Everyone interested in careers in art should read this little book.) Marshall thinks knowing about artists' and philosophers' ideas is very important. In fact, he had a few things to say about some of the philosophies and theories in this text (Marshall, 2008): for instance, he thinks self-expression is a myth. Artists are not about self-expression. It is more important for artists to find meaningful "space" (in the artworld) and fill it, he advised.

What Artists Do

Artists create objects or experiences of extraordinary significance to express their thoughts, feelings, beliefs, or ideas. They are involved in their own personal philosophies as well as those in their respective artworlds, societies, and cultures. Sometimes artists make work that emanates from their personal experiences. Sometimes their work is about their spiritual or political beliefs. Artists can't always explain their work at the time they make it, and it's possible, as Monroe Beardsley speculated, that they can never do so, although Arthur Danto disagreed with this. Nevertheless, mainstream contemporary artists are pretty much required to be able to explain their work. Artists can talk about their process, their ideas, and the context. It is the demand and the expectation in this conceptual rather than perceptual artworld.

Toward these goals, artists seek value judgments about their work. They want to know how it is viewed by teachers, colleagues, and sometimes curators and gallery owners. They also want to know how they can improve it, and here the structured critiques of art schools provide useful assistance. Kendall Buster and Paula Crawford, in their *Critique Handbook* (2007), suggest framing critiques to focus on several concepts: formal concerns, subject matter, content, the narrative, and how the work fits into the artworld. Art professors deconstruct the artwork, evaluate its parts, and offer solutions to perceived deficiencies. Even though it is psychologically difficult, artists learn how to distance themselves from their work so they can actively participate in critiques and learn from them. The idea that critique is useful in the larger context of an artist's career allows both the teacher and the artist to think of it as a useful device rather than a judicial drama. Critique favors process over product and encourages the fluidity of several creative elements, including the artists, the creative act, and the work itself.

Artists seek opportunities to learn how to improve the visual qualities and the content of their artwork through critiques. They seek judgments from people whose knowledge they value. Contemporary artists study art history, art theory, and philosophy. They are engaged with the world around them, their culture, and their times. Artists know how their work addresses current art issues and ideas and how it fits into art and cultural contexts.

What Art Critics Think and Do

Art critics seek to educate their readers about art for their increased under-standing and appreciation. Making value judgments is not the main goal of art critics these days. Art critics use their knowledge about art and culture, art elements and principles, media and techniques to interpret what they know and develop a meaningful context for the purpose of educating art viewers. Edmund Burke Feldman's *Practical Art Criticism* (1994) describes schools of art critical thinking. Most critical approaches come from literary criticism, but some originate from philosophy, anthropology, sociology, and cultural studies. Some are relevant to literature only, some ignore mat-ters of technique, some are extensions of the critic's political or psychologi-cal predilections, some respond to new kinds of art, and some are general theories of art rather than art criticism.

Feldman discussed critical approaches: contextualism, Marxism, psycho-analysis, phenomenology, semiotics, Feminism, Structuralism, Deconstruc-tion, and Postmodernism. Some of these critical approaches will be familiar after engaging with this text, and you can probably name the originators of these ways of thinking. Feldman developed a useful framework for art criti-cism that includes description, analysis, interpretation, and judgment. His art critical methodology has been modified over the years by art critics, philosophers, and teachers, most notably by philosopher Morris Weitz, who added theory as the final step in Feldman's framework. Engaging in the theoretical constructs of the artwork provides the critic with important contextual knowledge.

What art critics do differs dramatically from what artists do when they seek value judgments about their work in art critiques. In fact, it is not appropriate to use an art criticism methodology for studio art critiques because the purposes are different. The purpose of an artist's critique is to help the artist improve their work. The purpose of art criticism is to help viewers understand and appreciate art.

Milton Esterow, editor and publisher of *ARTnews*, one of the most widely distributed art magazines, echoed critic Bill Jay (Chapter 11) when he said art criticism today spouted "existential gas" (Carpenter 2006). Esterow thought "there's a lot of nonsense written about art," as did Jay, who, referring specifically to writing about photography, said that critics wrote "nonsensical reviews loaded with complex language that ultimately

said little or nothing about art or artists." In so doing, they were reneging on their educational role, something that was at odds with the general ideals of the profession. As evidence here, Esterow cited a study by the National Arts Journalism Program at Columbia University that found nearly 75 percent of art critics surveyed thought "rendering a personal judgment is considered the least important factor in reviewing art," and 91 percent felt it was the role of the art critic to "educate the public about visual art and why it matters." Not everyone agreed that this non-judgmental approach was a good thing, however. Raphael Rubenstein, in his essay "A Quiet Crisis" (2003), proclaimed that "this has been a period of interpretation rather than judgment" (cited by Danto 2006). Rubenstein cited Arthur Danto, one of the most widely read critics, for being somewhat responsible for this "crisis."

Danto and 91 percent of the art critics who participated in the Columbia University survey find support in Nelson Goodman's *Languages of Art* (1976), a framework for interpreting symbols in a symbol system, or educating, rather than providing a judgment for, the art viewer. Both Danto and Goodman promote understanding over judgment.

Interpreting Symbols in Symbol Systems

Nelson Goodman, a professor of philosophy at Harvard University, made significant contributions to aesthetics (the nature of art) and epistemology (knowledge). His contributions to twentieth-century aesthetics are still influential in the twenty-first century, as noted in Chapter 13. Goodman was, for a time, a gallery director in Boston and was a life-long art collector with an in-depth knowledge of Western and non-Western art. The visual and performing arts, especially in multi-disciplinary contexts, were an important part of his life and work. Although his major work was in philosophy, Goodman also wrote about the arts, sciences, psychology, and education. "Goodman was an authority in fields from cognitive science to artificial intelligence to art criticism to analytic philosophy and had a massive yet unobtrusive influence on contemporary thinking in a wide variety of disciplines," noted W. J. T. Mitchell in *Artforum* (cited in Desmond 2007).

Goodman made no distinction between scientific understanding and aesthetics; he thought they were two complementary means for making and understanding our worlds. Goodman believed the cognitive nature of

art could partner with the sciences in pursuit of knowledge and understanding. Knowledge, he thought, depended on interpretation both in the sciences and in art. Interpretation is knowledge of what an object or experience refers to, how it refers to it, and within which system of rules it makes that reference.

Art and Interpretation

Both Kerry James Marshall (2001) and Arthur Danto (2006) have addressed the College Art Association as keynote speakers, and their published remarks are available in issues of *CAA News* found on the CAA's website (*www. collegart.org*), a good resource for contemporary art thinking. College Art Association publications and annual conference presentations reveal current trends in visual art that include theory, aesthetics, visual studies and cultural theory.

Arthur Danto's keynote address was titled "Art and Interpretation" (2006). In his remarks he referenced Nelson Goodman's ideas about cognition, knowledge, interpretation, and contextual art criticism as they support Danto's own thinking and practice of art criticism. Danto explained that in the past artists were lauded for the creation of beauty or an extension of knowledge, but now the experience of art no longer represents an aesthetic experience. He noted another change in our current pluralistic society and way of thinking in that we do not always understand the content of the artwork immediately. We have to have it explained to us, preferably by the artist. When Danto is invited to an art school as a visiting art critic, he spends time with individual artists listening to them talk about what they are doing. He admits he would have a hard time figuring it out by himself. He thinks this cognitive approach to art is what art criticism is all about today. "Criticism in the present post-aesthetic period is just what the cognitivist character of contemporary art calls for," he said.

Danto arrived at his definition of art – that works of art are embodied meanings – after years of reflection on the nature of works of art. He thought that art had to be about something, that it had to have meaning. When Pop Art turned out to be about a lack of meaning, he faced the fact that not all vehicles of meaning are works of art. He developed his idea that works of art embody their meanings and require interpretation to map the meaning onto the artwork. This is now a central move in art criticism. Danto provided the example of an art exhibition he curated called *The Art*

of 9/11 (Apex Art, Tribeca, N.Y.C., 2005), in which even the most seemingly ordinary material had embodied meaning that the viewer could not know without an explanation by the artist or the art critic.

A Transatlantic Case Study

Radical changes in visual art ideas, artists, artworks, and the role of art museums, art historians, curators, collectors, and viewers can be explained through examples of transatlantic influences on contemporary art collections in museums such as the Museum of Modern Art Brussels, the Ludwig Forum in Aachen, Germany, the Stedelijk Museum in Amsterdam, and Dundee Contemporary Arts in Scotland.

Artists, art critics, art museums, art historians, and curators moved through radical changes in art and art history in the mid-twentieth century that impacted the international art scene. Four art trends emanated from the Fluxus art movement at the beginning of the twentieth century that have continued into the twenty-first century. These are embodied in the work of German artist Joseph Beuys, the work of Belgian French-speaking artist Marcel Broodthaers, and a transatlantic connection between Italian Arte Povera and American Minimalism (all discussed below). The seminal contemporary art collection at the Bonnefantenmuseum in Maastricht, the Netherlands, contains works from each of these artists and movements and provides opportunities for thinking about new roles in the Western art world.

Contemporary art has had an impact on the museum as a cultural institution, the role of the museum curator as preservationist, and the role of the contemporary art viewer. The radical shifts in the artworld during the mid-1960s required curators to think about the preservation, presentation, and development of their collections in new ways, and viewers had to develop new ways of thinking about and viewing visual art.

Can you identify contemporary themes, or threads, that started with these four new art ideas/trends? What does new art look like today? How have the changes described affected today's global cultural art scene?

Art Ideas

Visual art ideas influential on art of the later part of the twentieth century and the twenty-first century were born in the international Fluxus art movement, which began in the late 1950s, lived on in the legacy of Joseph Beuys, and continue today. Willem de Ridder's claim that "Fluxus's goal was the journey but alas it became art" (Jenkins 1993: 14) was among the many captions in the *In the Spirit of Fluxus* catalog that accompanied the traveling exhibition from the Walker Art Center in Minneapolis, Minnesota, where it was organized in 1993. Additional explanations of Fluxus in the introductory pages of the exhibition catalog include:

> ... artists and composers and other people who wanted to do beautiful things began to look at the world around them in a new way (for them). They said: Hey! – coffee cups can be more beautiful than fancy sculptures. A kiss in the morning can be more dramatic than a drama by Mr. Fancypants. The sloshing of my foot in my wet boot sounds more beautiful than fancy organ music.

Artists began to wonder why the beauty of cups and kisses and sloshing feet had to be made into something fancier and bigger. Why couldn't they just bring into play these elements of beauty for their own sake?

In the early 1960s Fluxus was a ground-breaking and idiosyncratically imaginative avant-garde movement with a history in experimental music and concrete poetry of the 1950s; in turn, it made way for Minimalism, Conceptual Art, Pop Art, and Performance Art of the 1960s, 1970s, and 1980s. Although Fluxus began with a series of concerts organized in New York City, it grew into an improvisational clearing-house for artistic events and activities in Western Europe: Paris, Copenhagen, Düsseldorf. The German–American connection was crucial to early Fluxus. Fluxus was a vital tradition with significant influences in aesthetic practices of many subsequent visual art movements and individual artists. It was never a "school" or an art movement in the traditional sense.

With the shift in the artworld from Paris to New York in the mid-twentieth century and the domination of American art in Europe, the artworld developed several transatlantic contextual connections. American artists strived for independence from the past, particularly from European traditions, and argued for a more theoretical and impersonal attitude. Artists operated on an international level within various groups and collaborative contexts and

responded to past Abstract Expressionist and figurative tendencies by seek-ing new meaning for their work. Contemporary artistic attitudes opposed the idea that art should provide access to a world of beauty, peace, and har-mony or that it provided direct insight into the artist's subconscious.

Artists adopted an attitude that was in direct opposition to the personal and emotional art of past Expressionist and Representational movements. These new artistic attitudes changed aesthetics and were happening at the same time as new ideas in social and intellectual arenas. These new inter-pretations were carried out in radical ways and reached audiences quickly by means of simple and inexpensive dissemination through publications and performances.

Another change that took place at this time was the abandonment of traditional easel painting and pedestal sculpture in favor of more freedom in presenting artwork. No longer hindered by previous norms with regard to material, construction, size, and function, artists experimented on a large scale. New and advanced materials such as fast-drying acrylic paint, polyes-ter, and neon lighting were employed. It was considered an advantage that these materials were not burdened with art historical connotations.

Personal Myth, Language and Literature, Arte Povera, and Minimalism

Joseph Beuys brought new positions into art historical prominence. He laid a foundation for artwork in the prestigious Whitney Biennial in 2000 in terms of medium, materials, and meaning. Beuys was an art teacher who became a political activist, founded political parties, and used a wide vari-ety of materials and processes to create mysterious and compelling objects and performances. He functioned as a poetic social critic and teacher of humanity and appealed to artistic imagination and aesthetic sensibilities.

Beuys expressed the suffering found in medieval religious paintings, the transcendent expressions in Dürer's engravings, and the recreated myths, spiritual beliefs, and tormented angst of German Expressionism. His art extended beyond historic sources and created a compelling and disturbing social and aesthetic dynamic. In Beuys, the artworld found a leader whose activities and ideas were admired and imitated. Beuys's ideas continue to influence the work of artists around the world today.

Belgian artist Marcel Broodthaers raised issues about cultural institu-tions. In Broodthaers's work, viewers discover countless ambiguities behind

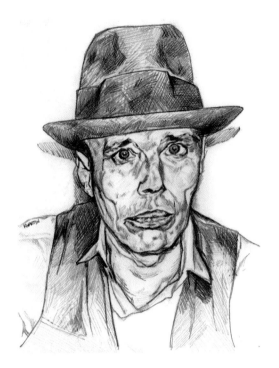

Figure 14.1 Kyle Martin, American (b. 1964). *Illustration of Joseph Beuys,* 2010. Graphite on illustration board, 5 × 8 inches.

which he seemed to take refuge as a poet, a collector, and even as a museum curator. While the works of Beuys presented a world of personal history and passion with mystical and magical rituals, Broodthaers exposed mystery. With roots in Surrealism, Broodthaers focused on relationships between text as image, such as the pictorial value given to text when it is rendered in individual handwriting. Literary in his orientation, Broodthaers used the relationships that existed between language and image as his instruments for artistic innovation and social change.

The work of Beuys and Broodthaers represents the continuation of two important visual cultures: the Northern and Central European culture, in which personal myth is a binding element, and the French-speaking culture, which was influenced by language and literature. Artists do not produce their work in a vacuum. As with anyone living in any society, artists are subject to political and economic power structures and linguistic codes.

Arte Povera brought a third visual culture to contemporary art in Europe. The Southern European and Byzantine cultures were entirely individual and radical, poetic and classical. A fourth visual culture, American Minimalism, was in direct opposition to the poetic writings of the Arte Povera movement with its impersonal attitude and promotion of the recurrent principle: maximal content through minimal form.

Arte Povera ("Poor Art") was a term first used in exhibitions in Italy in the late 1960s and referred to the materials used in the artwork, not to the content. Coal, steel plates, rubber, pieces of burlap, and other non-aesthetic and easily obtained raw materials were used to make works of art. These materials, free of art historical reference, functioned as a medium for metaphors. Through the consistent use of a variety of materials in one work, a contrast between nature and culture was expressed in many Arte Povera works.

Italian Luciano Fabro's sculpture *Prometeo* (1986) is an example of Arte Povera with a classical reference to a contemporary social issue. The title of the work provides interpretive clues. For instance, Prometeo, or Prometheus, the Greek Titan, created the first human being out of clay and stole fire from the gods. The sculpture was made in 1986, the same year as the disaster at the Chernobyl nuclear power plant. Nuclear energy, a natural force comparable to the stolen fire of Prometheus, is an uncontrollable force. By way of this sculpture, Fabro suggests that in comparison to nature, the presence of humanity is chaotic, despite attempts at order, and humans have forces at their disposal that can destroy nature.

Prometeo has a rigid base of eight upright marble pillars from which upside-down surveying markers protrude vertically. Several measuring sticks rest on top of the grayish white marble. The pillars are arranged in an organized fashion, not immediately recognizable as triangular and pentagonal. Despite the materials from which the sculpture was made, sturdy marble pillars and scientific measuring devices, its general appearance was one of instability and disorder; the measuring sticks seem to be lying pointlessly on top of the pillars. Even when the basic geometric forms that made up the piece are recognized, the construction remains an enigma. The style and materials were symbolic references that provided an iconographic interpretation.

Although American Minimal art developed at the same time as European neo-constructivism, its influence was far greater and more sustained. The theoretical basis of Minimal art, translated by artists trained in art history, was an independence from European traditions, an impersonal attitude very different from the Arte Povera writings of the same time.

Minimal artists sought to produce non-emotional and non-expressive works of art; art they thought was pure and consistent. Minimalists had a preference for geometric structures and modular principles. Each component within the work of art was equal in terms of form and value. Industrial techniques and materials, and consequently industrial execution, were favored.

Minimalist works were made specifically for galleries and museums, such as wall paintings or light sculptures. Sometimes the work existed only for the length of the exhibition; a precursor of Conceptual Art. The concepts and design sketches needed for the execution of Minimalist works became significant because of the transient nature of the actual work. Works of art were as concrete and as objective as possible. Sculptors Richard Serra and Sol LeWitt and painters Robert Mangold and Robert Ryman were major figures in Minimal art.

A Case Study in "Erweiterter Kunstbegriff"

Maastricht's Bonnefantenmuseum (see above) had an impact on contemporary art policies adopted by museums in neighboring Germany and Belgium. In keeping with the new roles of a contemporary art museum, the Bonnefantenmuseum invited Joseph Beuys to explain his ideas and his position as an artist and teacher, as well as his views on the purpose of an artwork within what he called the "Erweiterter Kunstbegriff" (extended idea of art). They invited him to do this, in 1975, by means of an exhibition, a lecture, and a discussion. After the installation of the exhibition Beuys donated all of the displayed documents to the museum. Beuys's objects and activities became the foundation of the Bonnefantenmuseum's contemporary art collection.

The value of this collection lies not only in its completeness – almost all of Beuys's documents from the period 1960 to 1975 are represented – but also in the rareness of many of the publications. By signing the documents, Beuys gave them a place in his *oeuvre*; their significance all the greater owing to the disintegration of many of his works of art. The disappearance of these works is a consequence of Beuys's disregard for the preservation of materials. "Aktionen" (Performances) and Installations have, owing to their nature and material, a limited life span. The consciousness that the works represented, not the archival nature of the materials he used, was of prime importance to Beuys. In the museum's collection of

documentary works, posters, books, and prints by Beuys, it is clear how drastically contemporary art had changed.

The Bonnefantenmuseum also owns a group of approximately 400 black and white photographs by Marcel Broodthaers and a large number of manuscripts about South Limburg (Maastricht is in the Province of Limburg) dating from 1960–70. While these photographs are important for the study of Broodthaers's *oeuvre*, the majority of them were produced when he was working as a journalist and poet and not yet as a visual artist. At that time Broodthaers had not yet found the right form for his largely language-oriented intellectual play on images and words. Broodthaers published curious articles about the landscape and history of Limburg in magazines and newspapers. Like the documentation of Joseph Beuys, these are not intended to be works of art, but rather they are a chronicle of an artist's developing attitude toward the artworld. These attitudes of the artists speak to what these artists do and the impact these attitudes have on museums, curators, and the art public.

Contemporary Art Museums, Art Historians, Curators, and Viewers

Traditionally, art historians adopted the ideologies of dominant cultural centers that supported the authority of the canon of "great" art. This has changed in the past 25 years. Discourse about gender and race was important in displacing a canon, reappraising art's social origins, and revising the condition of "peripheral traditions" within Europe itself. The task of contemporary art historians and curators in museums now includes a responsibility to viewers who are skilled in looking, living with, and criticizing art and its contexts. Curators attempt to create a dialogue with museum viewers so they can contribute to, rather than passively accept, the voices of art critics and art historians.

Museums with contemporary art collections are not like historical art museums that are institutions of cultural elitism or sanctums of an aesthetic that is removed from daily, lived experiences. Contemporary art museums attempt to collect and preserve objects, organize experiences, clarify looking, make visual ideas understood, sharpen vision, and, through the demands that contemporary work makes, induce viewers to "see." This goal of educating viewers is shared with contemporary art critics, as noted above.

Since the late nineteenth century, art has oscillated between reliance on the museum and the need to establish its social meaningfulness beyond the museum's walls. At the beginning of the twentieth century, formalism had faded and the plurality of cultures was asserted, even within the "old cultures" of Europe. The bonds between artistic practice, historical traditions, and existing conditions of production became more obvious.

Originally, the purpose of museums was to make available to the public, through exhibitions, collections of artifacts and curiosities belonging to royalty, the aristocracy, or the societies of cultured citizens. These two most important duties of a museum, preservation of a legacy for future generations and displaying artifacts to the general public, validate each other, yet they are also in direct conflict with each other. From the preservation point of view, any collection would best be stored out of the public's reach. In practice, museum objects are exposed to dangers that threaten their survival. Museums are continually faced with the task of making compromises between their two main functions: preservation and public accessibility.

Curators of contemporary art are confronted with the task of enabling the public to share in the experiences of artworks that have not yet been bestowed with historical interpretation while also ensuring that future generations will be able to partake of these works. To complicate curators' jobs even further, contemporary art is often temporal in nature, like the documentation of Beuys's Performance pieces or Broodthaers's Text and Image pieces, or work made with impermanent materials or specific installation requirements like Fabro's Arte Povera pieces, Ryman's Minimalist paintings or Sol Le Witt's sculptures.

Contemporary art collections redefine the role of the museum as a cultural institution, the work of art historians and curators as preservationists, and the viewer as a passive participant in the art viewing experience.

Museums Mediate Relationships between Artists, Art Critics, and Viewers

Contemporary art museums no longer use traditional classifications of painting or sculpture because contemporary artists actually make a point of liberating their work from such restrictive labels, thus creating a lack of interpretive framework. The problem is of increasing significance because of new art movements, theories, and philosophies. Sometimes viewers are

left with a feeling of dissatisfaction, if not downright resentment, by a work of art whose theoretical background they may sense but with which they are unfamiliar. Here is where Arthur Danto might step in and try to determine the embodied meaning of the work and map out an interpretation for the education of the viewer.

The contemporary art museum has become a prime locus of special experiences and practical criticism, forging a public discourse around representation, object-hood, and interpretation. The extent to which the reconnection of the museum to social experiences had occurred depended on the acknowledgement that the museum is not culturally neutral or universal in its authority.

One of the most radical changes in the contemporary artworld is the responsibility of the museum in mediating a relationship between artists and viewers that requires the viewer to take on a more active relationship with the work of art. This mediation by museums in the art experience is motivated by a desire to involve the viewer more intensively with the artwork and evidenced by artists' creating art forms such as installations and environments in which viewers are completely surrounded by the physical presentation. The art and ideas of contemporary visual artists have led to new works of art, new theories of art, and new roles for art critics, art museums, museum curators, and viewers.

What Aestheticians Do

Why do artists, art critics, viewers, and collectors want to know philosophies of art? So they can clarify their ideas and their points of view and make good arguments. Knowing the philosophies and theories of art that you have learned in this text may have you behaving like an aesthetician! You know what artists and art critics do and what art historians and museum curators do and even what viewers are required to do, but what do aestheticians do, and whom do they affect? Aestheticians think and write about the nature and value of art. They study artists and the culture in which the art was made, and, in conjunction with art critics, they help educate the general public about art for their extended appreciation. Aestheticians affect artists/ designers, art directors, art critics, art journalists and writers, art teachers and professors of art and philosophy, museum directors, museum education directors, museum curators, art gallery owners, art collectors, and art viewers.

Try This…

After you have thought about these varied philosophies and art theories, reflected on what artists, art critics, curators, and art critics have had to say, and the way they say it, the way they complement and contradict one another, and after you have developed your own ideas about the nature of art and beauty and expression, ethics, politics, Feminism, and Postmodernity as they are manifested in design, photography, new media, and aesthetic education, develop your own philosophy(ies) and use them to defend your position on the multitude of multifaceted issues in today's artworld. Try this for practice.

Slippery Slopes

Current economic situations have presented some interesting new developments and changes from, perhaps even conflicts with, previously accepted artworld practices and consequently require informed discussion and debate. A recent issue surfaced when the New Museum in New York City decided to exhibit the art collection of one of its trustees. The show was guest-curated by artist Jeff Koons, whose artworks were avidly collected by the trustee, Dakis Joannou.

Two art critics disagreed about the conflict of interest and curatorial control issues of this case (Thorson 2009). Jerry Saltz, of *New York* magazine, thought the arrangement was acceptable, citing the quality of the show and the tight budgets in today's economy as justifications. Tyler Green of *Modern Art Notes*, however, was troubled by the museum's decision to give curatorial control to Koons because of his relationship with the trustee. Saltz was troubled by the conflict of interest between the museum and the trustee by increasing the economic value of Dakis Joannou's collection by showing it at the museum. Green believed that in difficult economic times museums would be better off making use of their collections rather than entering into possibly compromising arrangements with commercial galleries. Green thought curatorial inquiry was limited when working with a single commercial gallery. "There's everything wrong with an art museum effectively extending the reach of a commercial gallery into its own galleries."

One of the most famous examples of similar issues was the *Sensation* show exhibited at London's Royal Academy of Art in 1997 and at the Brooklyn Museum of Art in 1999. All of the work in the Sensation exhibition, owned by one collector, British advertising executive Charles Saatchi, gave Saatchi even more advantages than the New Museum trustee Dakis Joannou. Saatchi not only had curatorial control, but the economic value of his collection increased with an exhibition at such a prestigious venue. Additionally, the Royal Academy, suffering financially, earned a tidy sum in the admissions of visitors to this popular and "sensational" exhibition so completely different from shows typically exhibited at this conservative institution.

Other world-class museums are fielding such conflict of interest issues, as well. In 2010 the Nelson-Atkins Museum of Art exhibited contemporary Venetian glass art from a major exhibit organized by Barry Friedman Ltd., a commercial gallery in New York City. The exhibition was a retrospective of approximately 200 pieces by three leading artists in the field of contemporary Venetian glass. In defense of their decision, the curator at the Nelson-Atkins, Catherine Futter, said she curated the exhibition from the original Friedman exhibition to fit the space available in the Museum. She focused on a different point of view than the original exhibition. One art critic noted that any museum's curatorial independence should be paramount because that's what makes the museum's educational mission different from the commercial mission of the Friedman gallery. Futter checked the guidelines of the American Association of Museums before deciding to go ahead with the show. A spokesperson for the AAM, Dewey Blanton, said "transparency, intellectual integrity and keeping with the museum's mission are the essential elements," and these standards had been met (Thornton 2009).

Another museum curator said commercial galleries have access to wonderful objects and sometimes their exhibitions are quite scholarly. Nevertheless, although she could "understand the temptation," she thought "it can be a slippery slope" (Thorson 2009). Profit and non-profit venues have different agendas. A museum exhibit will increase the economic value of the works in the show, creating different issues for the work of artists and art collections that are already established

from those that are still growing. A slightly different practice, with different ethical conflicts, is museum and exhibition venues showing works from corporate collections. Corporate collections are accrued for economic rather than scholarly reasons, and without the stamp of the museum's curators, these exhibitions could present ethical dilemmas: corporate collections are curated by employee curators with the goal of building financially solid collections rather than for scholarly, historical, or conceptual curatorial purposes.

Make It Your Own

Philosophical ideas overlap, connect, and interconnect and can be used to develop your own philosophy(ies) and your own arguments to defend your positions on art issues. Philosophies and art theories can come to the aid of art critics, art historians, curators, philosophers, art viewers, and artists who want to defend their positions or develop the content of their artwork.

Bibliography

No author (1962) *Image*, Vol. II, No. 6, reproduced from Société Française de Photographie Bulletin, April 1930.

No author (1991) *Women Artists*. Twenty-four women artists, each with a representative color portfolio, artist's statement, biographical sketch, and description of her work. San Raphael, CA: Cedco Publishing Co.

Adams, B., Jardine, L., Maloney, M., Rosenthal, N. and Shone, R. (1997) *SENSATION*. Exhibition Catalog. London: Thames and Hudson in association with the Royal Academy of Arts.

Adams, L. S. (1996) *The Methodologies of Art*. New York: Icon Editions, HarperCollins Publishers.

Agee, J. and Evans, W. (1941) *Let Us Now Praise Famous Men*. New York: Houghton Mifflin Company, Ballantine Books, Inc.

Alexander, C. (1979) *The Timeless Way of Building*. New York: Oxford University Press.

Alexander, C., Ishikawa, S. and Silverstein, M. (1977) *A Pattern Language: Towns, Buildings, Construction*. New York: Oxford University Press.

Allison, R. (2002) "9/11 wicked but a work of art, says Damien Hirst." *The Guardian*, September 11. Available online: *http://www.guardian.co.uk/uk/2002/sep/11/arts.september11*

Anderson, R. L. (1988) "The non-Western artist: Mythic or mythical hero?" Paper read at the Annual Meeting of the Mid-America College Art Association, Kansas City, MO.

Anderson, R. L. (1990) *Calliope's Sisters: A Comparative Study of Philosophies of Art*. Englewood-Cliffs, N.J.: Prentice-Hall.

Anderson, R. L. (1992) "Do other societies have art?" *American Anthropologist*, 90(2), 926–9.

Anderson, R. L. (2000) *American Muse: Anthropological Excursions into Art and Aesthetics*. Englewood Cliffs, N.J.: Prentice-Hall.

Appignanesi, R. and Garratt, C. (1999) *Introducing Postmodernism*. Cambridge: Icon Books.

Arnheim, R. (1954) *Art and Visual Perception*. Berkeley: University of California Press.

Aronowitz, S. (1994) *Dead Artists, Live Theories and Other Cultural Problems*. London: Routledge.

Ashton, D. (1985) *Twentieth Century Artists on Art*. New York: Pantheon.

Aspinwall, J. (2008) Curator's talk, Nelson-Atkins Museum of Art, January 19.

Associated Press (2009) "Mexico graffiti arrests prompt rights complaint." *Kansas City Star*, January 16.

Bailey, B. (1994) *The Remarkable Lives of 100 Women Artists*. Holbrook, MA: Bob Adams Publisher.

Barnard, M. (1998) *Art, Design and Visual Culture*. New York: St. Martin's Press.

Barthes, R. (1981) *Camera Lucida: Reflections on Photography*. Translated by R. Howard. Originally published in French. Toronto: Farrar, Straus, and Giroux, Inc. Publishers and McGraw-Hill Ryerson Ltd.

Barthes, R. (1990) *S/Z*. Translated by R. Miller. Originally published in French. Oxford: Blackwell.

Basa, L. (2008) *The Artist's Guide to Public Art: How to Find and Win Commissions*. New York: Allworth Press.

Battin, M. P., Fisher, J., Moore, R., and Silvers, A. (1989) *Puzzles About Art: An Aesthetics Casebook*. Boston/New York: Bedford/St. Martin's Press.

Baudrillard, J. (1991) "Simulacra and simulations," in H. Smagula (ed.), *Re-Visions: New Perspectives on Art Criticism*. Upper Saddle River, N.J.: Prentice Hall.

Becker, W. (1991) Director Ludwig Forum für *Internationale Kunst Catalog*. Aachen: Ludwig Forum, Aachen und die Autoren.

Beckley, B. with Shapiro, D. (eds.) (1998). *Uncontrollable Beauty*. New York: Allworth Press.

Bell, C. (1914) *Art*. Fourteenth impression. New York: Capricorn Books, G. P. Putnam's Sons, 1958.

Benhamou-Huet, J. (2001) *The Worth of Art: Pricing the Priceless*. New York: Assouline Publishing.

Benjamin, W. (1936) "The work of art in the age of mechanical reproduction." Available online: *http://www.marxists.org/reference/subject/philosophy/works/ge/benjamin.htm*; also available as *The Work of Art in the Age of Its Technological Reproducibility, and Other Writings on Media by Walter Benjamin*. Edited by M. W. Jennings, B. Doherty, and T. Y. Levin. Translated by E. Jephcott, R. Livingston, H. Eiland, and others. Originally published in German. Cambridge, MA and London: The Belknap Press of Harvard University Press.

Berger, J. (1972) *Ways of Seeing*. London: British Broadcasting Corporation and Penguin Books.

Berleant, A. (1992) *The Aesthetics of Environment.* Philadelphia: Temple University Press.

Best, S. and Kellner, D. (1991) *Postmodern Theory: Critical Interrogations.* New York: The Guilford Press.

Bevan, R. (2008) "Damien Hirst is rewriting the rules of the art market." *The Art Newspaper,* August 1. Available online: *http://www.theartnewspaper.com/ articles/Damien-Hirst-is-rewriting-the-rules-of-the-market-1%29/8665*

Bierut, M., Drenttel, W., Heller, S., and Holland, D. K. (eds.) (1994) *Looking Closer: Critical Writings on Graphic Design.* New York: Allworth Press.

Bierut, M., Drenttel, W., and Heller, S. (eds.) (2002) *Looking Closer 4: Critical Writings on Graphic Design.* New York: Allworth Press.

Bloemink, B. and Cunningham, J. (2004) *Design ≠ Art: Functional Objects from Donald Judd to Rachel Whiteread.* Foreword by Paul Warwick Thompson. Exhibition Catalog. Smithsonian Cooper-Hewitt, National Design Museum: Merrell Publishing.

Blumenthal, L. (2007) "Smithsonian will return skeletal remains to tribe." *Kansas City Star,* June 4

Bonwell, C. C. and Eison, J. A. (1991) *Active Learning: Creating Excitement in the Classroom.* ASHE: ERIC Higher Education Report No. 1. Washington, D.C.: The George Washington University, School of Education and Human Development.

Borger, H. (ed.) (1996) *Museums in Cologne.* Munich: Prestel-Verlag.

Boyer, E. (1990) *Scholarship Reconsidered: Priorities of the Professoriate.* Carnegie Foundation for the Advancement of Teaching. Princeton, N.J.: Princeton University Press.

Brand, P. Z. (2005) "Mining aesthetics for deep gender." American Society for Aesthetics online: *http://aesthetics-online.org/articles/index.php?articles_id=29*

Brand, P. Z. and Korsmeyer, C. (eds.) (1995) *Feminism and Tradition in Aesthetics.* University Park, PA : The Pennsylvania State University Press.

Brand, P. Z. and Devereaux, M. (eds.) (2003) *Hypatia: A Journal of Feminist Philosophy. Special Issue: Women, Art and Aesthetics,* 18(4), Fall/Winter

Broude, N. and Garrard, M. D. (eds.) (1994) *The Power of Feminist Art: The American Movement of the 1970s, History and Impact.* New York: Harry N. Abrams, Inc. Publishers.

Bunscombe, A. (2002) "Cover-up at US Justice Department." *The Independent,* January 29. Available online: *http://www.commondreams.org/headlines 02/0129–04.htm*

Burgin, V. (2006) *The End of Art Theory: Criticism and Postmodernity.* Basingstoke: Macmillan.

Buszek, M. E. (2006) *Pin-Up Grrrls.* Durham, N.C. and London: Duke University Press.

Buster, K. and Crawford, P. (2007) *The Critique Handbook.* Upper Saddle River, N.J.: Pearson/Prentice Hall.

Butler, C. (2002) *Postmodernism: A Very Short Introduction*. Oxford and New York: Oxford University Press.

Capital Improvements Management Office of Kansas City, Missouri/Kansas City Municipal Art Commission (2009) *Art City: Public Art in Kansas City 1986–2009*. Catalog.

Carpenter, K. (2006) "The art of art criticism: *ARTnews* publisher Milton Esterow at the Joslyn Art Museum." *REVIEW*, 9(2), December, 33–5.

Carter, C. L. (n.d.) "Nelson Goodman remembered." American Society for Aesthetics on-line: *http://www.aesthetics-online.org/memorials/index.php?memorials_id=6*

Carter, C. L. (2006) "Hockey seen: Nelson Goodman," in *Hockey Seen: A Nightmare in Three Periods and Sudden Death. A Tribute to Nelson Goodman*. Milwaukee, WI: Haggerty Museum of Art, Marquette University.

Cash, S. (2000) "Sleeker, thinner, sexier" in Design, *Art in America*, July.

Ceramics Today (n.d.) Featured Artist: Jun Kaneko. Online: *http://www.ceramicstoday.com/potw/kaneko.htm*

Chadwick, W. (1990) *Women, Art, and Society*. Second edition. London: Thames and Hudson.

Chicago, J. and Lucie-Smith, E. (1999) *Women and Art: Contested Territory*. New York: Watson-Guptil Publications.

Childress, J. (2007) "Conversations … with Dr. E. Louis Lankford," *NYSATA News*, Spring.

Chisholm, R. M. (1966) *Theory of Knowledge*. Englewood Cliffs, N.J.: Prentice-Hall, Inc.

Christensen, C. R., Hansen, A. J., and Moore J. F. (1987) *Teaching and the Case Method Instructor's Guide*. Cambridge, MA: Harvard Business School.

Chung, S. K. (2003) "The challenge of presenting cultural artifacts in a museum setting." *Art Education*, January, 13–18.

Clark, G., Day, M. D., and Greer, D. W. (eds.) (1987) "Special Issue: Discipline-Based Art Education." *The Journal of Aesthetic Education*, 21(2), Summer.

Clark, R. (1996) *Art Education: Issues in Postmodernist Pedagogy*. Reston, VA: National Art Education Association.

Coke, V. D. (1964) *The Painter and the Photograph: From Delacroix to Warhol*. Albuquerque: University of New Mexico Press.

Coleman, F. J. (1968) *Contemporary Studies in Aesthetics*. New York: McGraw-Hill, Inc.

Collingwood, R. G. (1964) *Essays in the Philosophy of Art*. Edited by Alan Donagan. Bloomington: Indiana University Press.

Danto, A. C. (1990) *Encounters and Reflections: Art in the Historical Present*. Berkeley, Los Angeles, and London: University of California Press.

Danto, A. C. (1991) *The Transfiguration of the Commonplace*. Cambridge, MA: Harvard University Press.

Danto, A. C. (1992) *Beyond the Brillo Box: The Visual Arts in Post-Historical Perspective*. New York: The Noonday Press, Farrar, Straus & Giroux, Inc.

Danto, A. C. (1996) *Playing with the Edge: The Photographic Achievements of Robert Mapplethorpe.* Berkeley, Los Angeles, and London: University of California Press.

Danto, A. C. (1997) *After the End of Art.* Princeton, N.J.: Princeton University Press.

Danto, A. C. (2003) *The Abuse of Beauty: Aesthetics and the Concept of Art.* The Paul Carus Lecture Series 21. Chicago and La Salle, IL: Open Court Publishing/ Carus Publishing.

Danto, A. C. (2005) *Unnatural Wonders: Essays from the Gap between Art and Life.* New York: Farrar, Straus and Giroux, Inc.

Danto, A. C. (2006) "Art and interpretation." Keynote Address. College Art Association Annual Meeting, February, New York. Available online: *http://www.collegeart.org/news/archives/*

Davies, S. (1991) *Definitions of Art.* Ithaca, N.Y., and London: Cornell University of Press.

De Domizio Durini, L. (1997) *The Felt Hat, Joseph Beuys, A Life Told.* Translated by H. Rodger MacLean. Edited by Anthony Shugaar. Originally published in Italian. Milan: Edizioni Charta.

Desmond, K. (1976) *Photography as a Function of Visual Aesthetic Judgment.* Unpublished Master's Thesis. Arizona State University

Desmond, K. (1981) *A Model for Teaching Photographic Art Criticism.* Doctoral Dissertation. Arizona State University. Dissertation Abstracts International & University Microfilms international #SAB81–24489.

Desmond, K. (2000) "Transatlantic influences on contemporary visual arts," in W. Kaufman and H. S. Macpherson (eds.), *Transatlantic Studies.* Lanham, MD, and Oxford: University Press of America, Inc.

Desmond, K. (Chair) (2001) "What do first year college students know about art, anyway?" College Art Association, Education Committee. Chicago, February.

Desmond, K. (2004a) *Joyce Jablonski: Process as Ritual.* Exhibition Catalog. Sedalia, MO: Daum Museum of Contemporary Art.

Desmond, K. (2004b) "'More real than real': Manipulated realties: From Pop Art to New Realism." *REVIEW,* 7(2), November, 54–5.

Desmond, K. (2004, 2007) "Teaching contemporary art," in *Living with Art Instructor's Manual.* Seventh and eighth editions. New York: McGraw-Hill Publishers.

Desmond, K. (2005a) "Joyce Jablonski: An artist's way of being." *Ceramics Monthly,* 53(8), October, 43–6.

Desmond, K. (2005b) "Art history survey: A roundtable discussion." Edited by P. Phelan. *Art Journal* 64(2), Summer, 32–51. New York: College Art Association.

Desmond, K. (2005c) "CENSORED: Suzanne Klotz art in the age of Homeland Security." *REVIEW,* 7(7), June, 54–7.

Desmond, K. (2005d) "Paradoxical postmodern landscapes: Armin Mühsam at Arts Incubator." *REVIEW,* 6(8), December–January, 54–5.

Desmond, K. (2006) "Visions of Mexicanidad: Photographs by Manuel Alvarez Bravo." *REVIEW*, 8(4), May, 46–9.

Desmond, K. (2007a) "Collaborating with the philosophies of Nelson Goodman." *REVIEW*, 9(6), April, 28–9.

Desmond, K. (2007b) "Developing greatness: The origins of American photography 1839–1885." *REVIEW*, 9(12), September, 38–41.

Desmond, K. (2008a) "Actively teaching (artists) aesthetics." American Society for Aesthetics online: *http://www.aesthetics-online.org/articles/index.php? articles_id=39*

Desmond, K. (2008b) "Rethinking gender and identity." Charles Smith II, Untitled Exhibition @ Skinless Productions. *REVIEW*, 10(10), August, 42.

Desmond, K. (2008c) "Defend yourself – Why artists should know the philosophy of art." *REVIEW*, 10(10), August, 26–9.

Desmond, K. (2010) "Defend yourself: Ideas about art." Part of "WTF? Talking Theory with Art and Art History Undergrads," College Art Association. Chicago, February.

Dewey, J. (1916) *Democracy and Education: An Introduction to the Philosophy of Education*. Noderstedt: GRIN Verlag, 2009.

Dewey, J. (1929) *Experience and Nature*. New York: Dover, 1958.

Dewey, J. (1934) *Art as Experience*. Eighteenth impression. New York: Capricorn Books, G. P. Putnam's Sons, 1958.

Dewey, J. (1960) *The Quest for Certainty*. New York: Capricorn Books.

Dickie, G. (1997) *The Art Circle: A Theory of Art*. Chicago Spectrum Press.

Dickie, G. (1988) *Evaluating Art*. Philadelphia: Temple University Press.

Dickie, G. (2001) *Art and Value*. Oxford and Cambridge, MA: Blackwell.

Diepeveen, L. and Van Laar, T. (2001) *Art with a Difference: Looking at Difficult and Unfamiliar Art*. Mountain View, CA: Mayfield Publishing Company.

Dissanayake, E. (1988) *What Is Art For?* Seattle/London: University of Washington Press.

Dissanayake, E. (1992) *Homo Aestheticus: Where Art Comes From and Why*. Seattle/London: University of Washington Press.

Dissanayake, E. (2000) *Art and Intimacy: How the Arts Began*. Seattle/London: University of Washington Press.

Douglas, D. (1974) "Is photography really art?" *Newsweek*, October 21.

Dutton, D. (2009) *The Art Instinct: Beauty, Pleasure and Human Evolution*. New York, Berlin, and London: Bloomsbury Press.

Dutton, D. (2010) "A Darwinian theory of beauty." TED talk. Available online: *http://www.ted.com/talks/denis_dutton_a_darwinian_theory_of_beauty.html*

Eaton, M. M. (1988) *Basic Issues in Aesthetics*. Prospect Heights, IL: Waveland Press, Inc.

Eco, U. (ed.) (2005) *History of Beauty*. Translated by A. McEwen. Originally published in Italian. New York: Rizzoli International Publications, Inc.

Efland, A. (1990) *History of Art Education: Intellectual and Social Currents in Teaching the Visual Arts*. New York: Teachers College Press.

Efland, A., Freedman, K., and Stuhr, P. (1996) *Postmodern Art Education: An Approach to Curriculum*. Reston, VA: National Art Education Association.

Fabozzi, P. F. (2001) *Artists, Critics, Context: Readings in and Around American Art since 1945*. Upper Saddle River, N.J.: Prentice-Hall, Pearson Education, Inc.

Feagin, S. and Maynard, P. (eds.) (1997) *Aesthetics*. Oxford and New York: Oxford University Press.

Feldman, E. B. (1994) *Practical Art Criticism*. Englewood Cliffs, N.J.: Prentice-Hall.

Feldman, E. B. (1996) *Philosophy of Art Education*. Upper Saddle River, N.J.: Prentice-Hall, Inc.

Ferguson, R., Gever, M., Minh-ha, T.T., and West, C. (eds.) (1990a) *Out There: Marginalization and Contemporary Cultures*. Cambridge, MA, and The New Museum of Contemporary Art, New York: MIT Press.

Ferguson, R., Tucker, M., and Baldessari, J. (eds.) (1990b) *Discourses: Conversations in Postmodern Art and Culture*. Paperback edition. Cambridge, MA, and The New Museum of Contemporary Art, New York: MIT Press.

Filliou, R. (1970) *Teaching and Learning as Performance Arts*. Cologne and New York: Konig Verlag.

Fisher, J. A. (1993) *Reflecting on Art*. Mountain View, CA: Mayfield Publishing Company.

Freeland, C. (2001) *But Is It Art?* Oxford and New York: Oxford University Press.

Freire, P. (1970) *Pedagogy of the Oppressed*. Translated by M. Bergman Ramos. Originally published in Portuguese. New York: The Continuum Publishing Company.

Frueh, J. E. (1991) "Towards a feminist theory of art criticism," in H. Smagula (ed.), *Re-Visions: New Perspectives on Art Criticism*. Upper Saddle River, N.J.: Prentice Hall.

Gaudelius, Y. and Speirs, P. (2002) *Contemporary Issues in Art Education*. Upper Saddle River, N.J.: Prentice-Hall, Pearson Education, Inc.

Gaut, B. and Lopes, D. M. (eds.) (2001) *The Routledge Companion to Aesthetics*. New York: Routledge (Taylor & Francis Group).

Gaze, D. (ed.) (1998) *Dictionary of Women Artists*. 2 volumes. Chicago: Fitzroy Dearborn Publishers.

Getlein, M. (2009) *Living with Art*. Ninth edition. New York: McGraw-Hill Companies, Inc.

Goldwater, R. and Treves, M. (eds.) (1945) *Artists on Art*. New York: Pantheon Books.

Gopnik, B. (2007) "Feminism and art." Special Feature, *Washington Post*, April 22.

Goodman, N. (1976) *Languages of Art*. Indianapolis, IN: Hackett Publishing Co.

Gordon, G. (1997) *Philosophy of the Arts: An Introduction to Aesthetics*. London and New York: Routledge.

Gott, S. (2003) "Golden emblems of maternal benevolence: Transformations of form and meaning in Akan regalia." *african arts* (UCLA), XXXVI(1), Spring, 66–81.

Gott, S. (2004) "Asante funerals: The art of West African performance." Artspace Public Program. Kansas City Art Institute. October 15

Gouma-Peterson, T. and P. Matthews (2001) "Second-generation art criticism and methodology," in H. Smagula (ed.), *Re-Visions: New Perspectives on Art Criticism*. Upper Saddle River, N.J.: Prentice Hall.

Gracyk, T. (2008) "Reflective equilibrium in the aesthetics classroom." American Society for Aesthetics online: *http://aesthetics-online.org/articles/index.php? articles_id=38*

Grampp, W.D. (1989) *Pricing the Priceless: Art, Artists, and Economics*. New York: Basic Books, Inc.

Greer, G. (1979) *The Obstacle Race: The Fortunes of Women Painters and Their Work*. New York: Farrar, Straus and Giroux.

Guerrilla Girls (n.d.) *The Guerrilla Girls Greatest Hits*. Postcard Book. Available from: *http://www.guerrillagirls.com/for_sale/index.shtml*

Guerrilla Girls (1998) *The Guerrilla Girls' Bedside Companion to the History of Western Art*. Harmondsworth, Middlesex: Penguin Books.

Harrison, C. and Wood, P. (eds.) (1996) *Art in Theory 1900–1990: An Anthology of Changing Ideas*. Oxford and Cambridge, MA: Blackwell.

Hawthorne, N. (1851) *The House of the Seven Gables*. New York: Bantam Books, 1981.

Heartney, E. (2001) *Postmodernism*. London: Tate Publishing.

Heartney, E., Posner, H., Princenthal, N., and Scott, S. (2007) *After the Revolution: Women Who Transformed Contemporary Art*. Foreword by L. Nochlin. New York: Prestel Publishing Ltd.

Helfand, J. (2001) *Screen: Essays on Graphic Design, New Media, and Visual Culture*. New York: Princeton Architectural Press.

Hein, H. (2006) *Public Art: Thinking Museums Differently*. New York, Toronto, and Oxford: AltaMira Press, Rowman & Littlefield Publishers.

Heller, N. G. (1987) *Women Artists: An Illustrated History*. Third edition. New York: Abbeville Press.

Heller, S. and Pettit, E. (2000) *Graphic Design Time Line: A Century of Design Milestones*. New York: Allworth Press.

Hess, T. B. and Baker, E. C. (eds.) (1971) *Art and Sexual Politics*. Art News Series. New York: Macmillan Publishing Co.

Higgins, H. (2002) *Fluxus Experience*. Berkeley: University of California Press.

Hillerman, T. (1989) *Talking God*. New York: HarperCollins.

Huether, G. (2006) *Gordon Huether Projects*. Napa, CA: Gordon Huether.

Hughes, A. (2008) "Resisting the silence." *Centerings*, XXXV(1), Fall, 5.

Huyssen, A. (1993) "Back to the future: Fluxus in context," in J. Jenkins (ed.), *In the Spirit of Fluxus*. Walker Art Center, New York: Distributed Art Publishers

Isaak, J. A. (1996) *Feminism and Contemporary Art* (Re:Visions: Critical Studies in the History and Theory of Art). New York: Routledge.

Jackson, P. W. (1998) *John Dewey and the Lessons of Art.* New Haven and London: Yale University Press.

Jacobs, A. (2007) "XX-rated art." *Elle*, March, 429–33.

Jay, B. (1968–2007) *http://www.billjayonphotography.com/*

Jeffries, S. (2002) "Gunther von Hagens' Body Worlds show." *The Guardian*, March 19. Available online: *http://www.guardian.co.uk/education/2002/mar/19/arts. highereducation*

Jenkins, J. (ed.) (1993) *In the Spirit of Fluxus.* Walker Art Center, New York: Distributed Art Publishers.

Jones, A., Dowling, K., and Pidd, H. (2008) "Recession reaches Hirst's studios." *The Guardian*, November 22.

Kaelin, E. F. (1989) *An Aesthetics for Art Educators.* Columbia University, New York: Teachers College Press, Columbia University.

Kandinsky, W. (1910) *Concerning the Spiritual in Art.* Translated by M. T. H. Sadler. Originally published in German. New York: Dover Publications, Inc., 1977.

Kansas City Star (2006) "On ethics." *Kansas City Star* column, April 7.

Karash, J. A. (1995) "Hotel decorators use Picasso painting." *Kansas City Star*, November 12.

Katter, E. and Erickson, M. (1992) *Philosophy and Art.* CRIZMAC Art and Cultural Education Materials. Tucson, AZ.

Kemper Museum of Contemporary Art (1998) *Hung Liu.* Catalog. Kemper Museum of Contemporary Art, Kansas City, MO.

Kepes, G. (1944) *Language of Vision.* Chicago: Paul Theobald.

Kepes, G. (1956) *The New Landscape in Art and Science.* Chicago: Paul Theobald.

Korsmeyer, C. (2004) *Gender and Aesthetics: Understanding Feminist Philosophy.* New York and London: Routledge.

Kramer, H. (1970) "The photograph assumes a new 'artiness,'" *New York Times*, Art View, December 21.

Kroeger, M. (ed.) (2008) *Paul Rand: Conversations with Students.* New York: Princeton Architectural Press.

Lacy, S. (1994) "Affinities: Thoughts on an incomplete history," in N. Broude and M. D. Garrard (eds.), *The Power of Feminist Art: The American Movement of the 1970s, History and Impact.* New York: Harry N. Abrams, Inc.

Lambe, J. (1994) "'Tag' art is illegal graffiti." *Kansas City Star*, July 14.

Landi, A. (1998) "Is the price right?" *ARTnews*, October.

Landi, A. (2003) "Who are the great women artists?" *ARTnews*, March.

Langer, S. K. (1957) "Expressiveness," in G. Pappas (ed.), *Concepts in Art and Education.* London: Macmillan.

Langer, S. K. (1979) *Philosophy in a New Key: A Study in the Symbolism of Reason, Rite, and Art.* Third edition. London and Cambridge, MA: Harvard University Press.

Langer, S. K. (1982) *Mind: An Essay on Human Feeling*, Vol. III. Baltimore and London: The Johns Hopkins University Press.

Lanier, V. (1991) *The World of Art Education According to Lanier*. Reston, VA: National Art Education Association.

Lankford, E. L. (1986) "Making sense of aesthetics." *Studies in Art Education* 28(1), 49–52. Reston, VA: National Art Education Association.

Lankford, E. L. (1990) "Preparation and risk in teaching aesthetics." *Art Education*, September. Reston, VA: National Art Education Association.

Lankford, E. L. (1992) *Aesthetics: Issues and Inquiry*. Reston, VA: National Art Education Association and The Ohio State University Foundation.

Leen, F. (1996) "Contemporary tendencies," in J. De Geest and J.-M. Duvosquel (eds.), *The Museum of Modern Art Brussels: Musea Nostra*. Ludion-Ghent: Credit Communal

Levinson, J. (ed.) (2003) *The Oxford Handbook of Aesthetics*. New York: Oxford University Press.

Linker, K. (1991) "From imitation to the copy to just effect: On reading Jean Baudrillard," in H. Smagula (ed.), *Re-Visions: New Perspectives on Art Criticism*. Upper Saddle River, N.J.: Prentice Hall.

Lippard, L. R. (1971) *Changing Essays in Art Criticism*. New York: E. P. Dutton.

Lippard, L. R. (1990) *Mixed blessings: New Art in a Multicultural America*. New York: Pantheon Books.

Lippard, L. R. (1995) *The Pink Glass Swan: Selected Feminist Essays on Art*. New York: The New Press.

Liu, H. (1989) Artist talk. Kemper Museum of Contemporary Art, Kansas City, MO, in conjunction with exhibition *Hung Liu: A Ten Year Survey*, November 15.

Loeb, J. (ed.) (1979) *Feminist Collage: Educating Women in the Visual Arts*. Columbia University, N.Y.: Teachers College Press.

Logan, F. (1955) *The Growth of Art in American Schools*. New York: Harper and Bros. Co., Inc.

Lowenfeld, V. (1947) *Creative and Mental Growth*. New York: Macmillan Publishing Co. (subsequent editions with W. L. Brittain).

Lyons, N. (2002) "Photography and its authority over imagination," *Current Works*, Exhibition Catalog. Kansas City, MO: Society for Contemporary Photography.

McArthur, E. (1999) "Seeing ourselves as other (with apologies to Robert Burns): Some thoughts about looking at art (here and now)." *Dundee Contemporary Arts*. Dundee, Scotland: Dundee Contemporary Arts.

McCoy, K. (2002) "A cold eye: When designers create culture…" *PRINT.*

McFee, J. K. (1961) *Preparation for Art*. Belmont, CA: Wadsworth Publishing Company.

McFee, J. K. and Degge, R. (1991) *Culture and Environment*. Dubuque, IA: Kendall/Hunt Publishing Co.

Madeja, S. S. (ed.) (1977) *Arts and Aesthetics: An Agenda for the Future*. St. Louis, MO: CEMREL, Inc.

Madeja, S. S. (1979) *The Teaching Process & Arts and Aesthetics*. St. Louis, MO: CEMREL, Inc.

Magnan, R. (ed.) (1990) *147 Practical Tips for Teaching Professors*. Madison, WI: Magna Publications.

Maine, S. (2008) "Report from Kansas City: Live–work options." *Art in America*, October, 58–63.

Margolis, J. (ed.) (1978) *Philosophy Looks at the Arts: Contemporary Readings in Aesthetics*. Philadelphia: Temple University Press.

Marshall, K. J. (2001) "Knowing better: Access, the academy, and expectations." Keynote Address. College Art Association Annual Meeting, February 28, Chicago. *CAA News*, 26(3), May.

Marshall, K. J. (2008) Artist Lecture: "An evening with Kerry James Marshall." Nelson-Atkins Museum of Art, Kansas City, MO, May 29.

Meyers, C. and Jones, T. B. (1993) *Promoting Active Learning: Strategies for the College Classroom*. San Francisco: Jossey Bass Publishers.

Moholy-Nagy, L. (1947) *Vision in Motion*. Chicago: Paul Theobald.

Moller, J. (2002) Artist statement for Fellowship Award, "Our culture is our resistance: Photographs of exhumations of clandestine cemeteries in Guatemala," in *Current Works*. Exhibition Catalog. Kansas City, MO: Society for Contemporary Photography.

Moller, J. (2004) *Our Culture is Our Resistance*. New York: Powerhouse Books.

Morris, F. (1997) *Luciano Fabro*. London: Tate Gallery Publishing.

Mountford, R. and Richardson, B. (eds.) (1998) *A sourcebook for large enrollment course instructors: Contributions from the literature and The Ohio State University Faculty*. Center for Teaching Excellence, Columbus, OH.

Murray, C. (ed.) (2003) *Key Writers on Art: The Twentieth Century*. London and New York: Routledge, Taylor & Francis Group.

Neill, A. and Ridley, A. (eds.) (1995) *The Philosophy of Art: Readings Ancient and Modern*. New York: McGraw-Hill.

Neill, A. and Ridley, A. (eds.) (2002) *Arguing About Art: Contemporary Philosophical Debates*. Second edition. London and New York: Routledge.

Nesbit, P. and Andress, S. (eds.) (2006) *Letters to a Young Artist*. New York: Darte Publishing.

Nochlin, L. (1971) "Why have there been no great women artists?" *ARTnews*, January; see also "Why have there been no great women artists?" in Nochlin, *Women, Art, and Power and Other Essays*. Boulder, CO: Westview Press.

Nochlin, L. (2007) "Foreword," in E. Heartney, H. Posner, N. Princenthal, and S. Scott, *After the Revolution: Women Who Transformed Contemporary Art*. New York: Prestel Publishing Ltd.

O'Keeffe, G. (1977) *Georgia O'Keeffe*. New York: Penguin Books.

Painter, C. (2002) *Contemporary Art and the Home*. Oxford and New York: Berg.

Pappas, G. (1970) *Concepts in Art and Education*. London: The Macmillan Company, Collier-Macmillan Limited.

Parker, R. and Pollock, G. (1981) *Old Mistresses: Women, Art and Ideology*. New York: Pantheon Books.

Peers, A. (1999) "Blurring the line between art and commerce." Art & Collecting. *New York Times*.

People for the American Way (1995) *Artistic Freedom under Attack*, Vol. 3. Washington, D.C.: People for the American Way.

Perloff, M. (1996) *Wittgenstein's Ladder*. Chicago and London: University of Chicago Press.

Perry, W. G. (1970) *Forms of Intellectual and Ethical Development in the College Years*. New York: Holt, Rinehart and Winston.

Petersen, K. and Wilson, J. J. (1976) *Women Artists: Recognition and Reappraisal from the Early Middle Ages to the Twentieth Century*. New York: Harper Colophon Books, Harper & Row Publishers.

Pieters, D. (1997) *A Survey of the Collection*. Stedelijk Museum Amsterdam. Amsterdam: Beeldrecht Amstelveen.

Plagens, P. (2007) "Contemporary art, uncovered." *Art in America*, February.

Pollock, G. (ed.) (1996) *Generations and Geographies in the Visual Arts: Feminist Readings*. London and New York: Routledge.

Pollock, G. (1999) *Differencing the Canon: Feminist Desire and the Writing of Art's Histories*. London and New York: Routledge.

Potts, B. (1997) "Strategies for teaching critical thinking." NAEA Advisory, Summer. ED385606 ERIC/AE Digest, ERIC Clearinghouse on Assessment and Evaluation, Washington, D.C.

Povoledo, E. (2008) "Art historians outraged over Berlusconi decision over painting." *International Herald Tribune*, August 5.

Poynor, R. (2003) *No More Rules: Graphic Design and Postmodernism*. New Haven, CT: Yale University Press.

Rader, M. (1979) *A Modern Book of Esthetics*. New York: Holt, Rinehart and Winston.

Rand, P. (1946) *Thoughts on Design*. New York: Wittenborn Schultz.

Rand, P. (1985) *A Designer's Art*. New Haven: Yale University Press, 2010.

Raven, A. (1988) "The last essay on feminist criticism," in A. Raven, C. Langer, and J. Frueh (eds.), *Feminist Art Criticism: An Anthology*. New York: Icon Editions, HarperCollins Publishers.

Raven, A., Langer, C., and Frueh, J. (eds.) (1988) *Feminist Art Criticism: An Anthology*. New York: Icon Editions, HarperCollins Publishers.

Roberts, L. (2006) *Good: An Introduction to Ethics in Graphic Design*. Worthing: AVA Publishing (UK) Ltd.

Robertson, J. and McDaniel, C. (2005) *Themes of Contemporary Art: Visual Art after 1980*. New York and Oxford: Oxford University Press.

Robinson, H. (ed.) (2001) *Feminism–Art–Theory: An Anthology 1968–2000*. Malden, MA: Blackwell Publishers, Inc.

Robinson, H. P. (1869) *Pictorial Effect in Photography*. London: Piper & Carter. Reprinted 1971: Pawlet, VT: Helios. Second Impression 1972: Rochester, N.Y.: International Museum of Photography at George Eastman House.

Rosenblum, L. (2005) "For sale: Our permanent collection." *New York Times*, Opinion, November 2.

Rothko, M. (2004) *The Artist's Reality: Philosophies of Art*. Edited by C. Rothko. New Haven and London: Yale University Press.

Rubenstein, R. (2003) "A quiet crisis." *Art in America*, March.

Ruskin, J. (1906) *Modern Painters*, Vol. 1. Third edition. New York: Thomas Crowell.

Santayana, G. (1896) *The Sense of Beauty*. Cambridge, MA: MIT Press, 1988.

Schall, J. (2004) "The influence of the photograph on Pop Art and Photorealism." Opening presentation for the exhibition *Manipulated Realities: From Pop Art to New Realism*, Belger Arts Center, Kansas City, MO.

Shiner, L. (2001) *The Invention of Art*. Chicago and London: The University of Chicago Press.

Shipps. S. (2008) *(Re)thinking art: A Guide for Beginners*. Oxford, Malden, MA, and Victoria: Blackwell Publishing Ltd.

Simmons, C. (1977) "Sontag talking." *The New York Times Book Review*, December 18.

Slatkin, W. (1993) *The Voices of Women Artists*. Englewood Cliffs, N.J.: Prentice-Hall.

Slatkin, W. (1997) *Women Artists in History: From Antiquity to the Present*. Third edition. Englewood Cliffs, N.J.: Prentice-Hall.

Smagula, H. (ed.) (1991) *Re-Visions: New Perspectives of Art Criticism*. Upper Saddle River, N.J.: Prentice-Hall, Inc.

Smagula, H. (ed.) (1989) *Currents: Contemporary Directions in the Visual Arts*. Second edition. Englewood Cliffs, N.J. : Prentice Hall.

Smith, R. A. (ed.) (2001) *Aesthetics and Criticism in Art Education: Problems in Defining, Explaining, and Evaluating Art*. Second printing. Reston, VA: National Art Education Association.

Smith, J. Quick-to-See (2003a) Gallery walk/talk. Belger Arts Center for Creative Studies. Kansas City, MO, April 5.

Smith, J. Quick-to-See (2003b) *Made in America*. Curated by Charles Muir Lovell, Director, Harwood Museum of Art, The University of New Mexico. Belger Arts Center for Creative Studies. Kansas City, MO.

Smith, R. A. (ed.) (1971) *Aesthetics and Problems of Education* (Readings in the Philosophy of Education Series). Champaign Urbana: University of Illinois Press.

Solomon, G. and Perkins, D. N. (1989) "Rocky roads to transfer: Rethinking mechanism of a neglected phenomenon." *Educational Psychologist*, 24(2), 113–42.

Sontag, S. (1973) *On Photography.* New York: Dell Publishing.

Steen, K. (2009) "Fast forward: Project H." *Metropolis Magazine.* Available online: *http://www.metropolismag.com/story/20090916/fast-forward-project-h*

Sterling, C. (1951) "A fine 'David' reattributed." *Metropolitan Museum of Art Bulletin,* 9(5), 121–32.

Thistlewood, D. (ed.) (1995) *Joseph Beuys: Diverging Critiques. Critical Forum Series,* Vol. 2. Liverpool: Liverpool University Press and Tate Gallery Liverpool.

Thompson, D. (2008) *The $12 Million Stuffed Shark: The Curious Economics of Contemporary Art.* London: Aurum Press Ltd.

Thornton, S. (2008) *Seven Days in the Art World.* New York and London: W. W. Norton & Company.

Thorson, A. (2000) "Wit and Whitney." *Kansas City Star,* Arts section, April 9.

Thorson, A. (2008) "Public art program is honored again." *Kansas City Star,* August 24.

Thorson, A. (2009) "More public displays for artworks." *Kansas City Star,* The Arts: Visual Art, January 18.

Tribe, M. and Jana, R. (2006) *New Media Art.* Cologne: Taschen.

Tuchman, P. (1984) "Minimalism and critical response," in A. Baker Sandback (ed.), *Looking Critically: 21 Years of Artforum Magazine.* Ann Arbor, MI: UMI Research Press.

Vogel, C. (2008) "Damien Hirst's next sensation: Thinking outside the dealer." *New York Times,* September 14.

Warburton, N. (2003) *The Art Question.* New York and London: Routledge.

Weintraub, L. with Danto, A. and Mcevilley, T. (1996) *Art on the Edge and Over.* Litchfield, CT: Art Insights, Inc.

Werhane, P. H. (1984) *Philosophical Issues in Art.* Englewood Cliffs, N.J.: Prentice-Hall.

Wittgenstein, L. (1980) *Culture and Value.* Translated by P. Winch. Originally published in German. Chicago: University of Chicago Press.

White, W. (1943) "When is photography," reproduced in J. Alinder (ed.), *Exposure* (The Journal of the Society for Photographic Education), 14(3), 1976, 7–8.

Wittgenstein, L. (1922) *Tractatus Logico-Philosophicus.* Translated by C. K. Ogden. Originally published in German. London: Routledge & Kegan Paul, 1981.

Wolfe, T. (1975) *The Painted Word.* New York: Bantam Books.

Some useful websites:

Berleant, Arnold: *http://www.autograff.com/berleant/pages/recentart10.html* and *http://www.autograff.com/berleant/pages/recentart3.html*

Dickie, George: *http://www.blackwellreference.com/public/tocnode?id=g9781405106795_chunk_g978140510679510_ss1–135*

Dutton, Denis: *http://www.ted.com/index.php/speakers/denis_dutton.html*
Essentialism and Feminism: *http://science.jrank.org/pages/9219/Essentialism-Feminist-Disputes.html*
Feminist Art Project: *http://feministartproject.rutgers.edu*
Kansas City One Percent for the Arts Program: *http://www.kcmo.org/cimo*
Levine, Sherry: *http://aftersherrielevine.com/aftersl.html*
n.paradoxa international feminist art journal. Art Data, London: *http://web.ukonline. co.uk/n.paradoxa/index.htm*
Postmodern art: *http://www.postmodern-art.com/*
Wittgenstein, Ludwig: *http://plato.stanford.edu/entries/wittgenstein/#Lan* and *http:// www.project-aristotle.com/web/philosophy/wittgensteinart-01.html*

From Icon Books (Cambridge, UK) and Totem Books (USA) a series of books about philosophers and philosophical ideas. They all start with *Introducing* and then the name of the person or the idea.

Introducing Aristotle (R. Woodfin and J. Groves), 2010
Introducing Barthes (P. Thody and A. Course), 2006
Introducing Baudrillard (C. Horrocks and Z. Jevtic), 2011
Introducing Critical Theory (S. Sim and B. Van Loon), 2004
Introducing Derrida (J. Collins and B. Mayblin), 2005
Introducing Ethics (D. Robinson and C. Garratt), 2004
Introducing Foucault (Z. Jevtic and C. Horrocks), 2004
Introducing Kant (C. Kul-Want and A. Klimowski), 2005
Introducing Modernism (C. Garratt and C. Rodrigues), 2004
Introducing Philosophy (J. Groves), 2004
Introducing Plato (D. Robinson and J. Groves), 2005
Introducing Postmodernism (R. Appignanesi and C. Garratt), 1999
Introducing Wittgenstein (J. Groves and J. M. Heaton), 2005

Two films:

Dirty Pictures (2000), directed by Frank Pierson (aired on Showtime Network)
Exit Through the Gift Shop (2010), directed by Banksy

Illustration Credits

Figure 1.1: Reproduced by permission of GEAR.

Figure 1.2: Reproduced by permission of Jun Kaneko. Photo credit: Takashi Hatakeyama.

Figure 1.3: Reproduced by permission of the Nelson-Atkins Museum of Art, Kansas City, Missouri. Purchase: acquired through the generosity of the Sosland Family, F94-1/2. Photo credit: Edward C. Robinson III.

Figure 2.1: Reproduced by permission of the Nelson-Atkins Museum of Art, Kansas City, Missouri. Purchase: acquired through the generosity of the Sosland Family, F94-1/2. Photo credit: Edward C. Robinson III.

Figure 2.2: Reproduced by permission of the Kemper Museum of Contemporary Art and Hung Liu. Museum Purchase, 1997.22a–b.

Figure 2.3: Reproduced by permission of the Nelson-Atkins Museum of Art, Kansas City, Missouri. Acquired through the Print Collectors' Fund for the Friends of Art, F73-5/1. Photo credit: Louis Melusa and Jamison Miller. © 2010 The Andy Warhol Foundation for the Visual Arts, Inc. / Artists Rights Society (ARS), New York.

Figure 3.1: Reproduced by permission of the Nelson-Atkins Museum of Art, Kansas City, Missouri. Purchase: acquired through the generosity of Mr. and Mrs. Louis Sosland, F73-53. Photo credit: Robert Newcombe. © 2010 Artists Rights Society (ARS), New York/ADAGP, Paris/ Succession Marcel Duchamp.

Figure 4.1: Reproduced by permission of the Nelson-Atkins Museum of Art, Kansas City, Missouri. Bequest of Katherin Harvery, 63–44. Photo credit: Jamison Miller.

Figure 4.2: Reproduced by permission of the Nelson-Atkins Museum of Art, Kansas City, Missouri. Gift of Hallmark Cards, Inc., 2005.27.240. Photo credit: Thomas Palmer.

Ideas About Art, First Edition. Kathleen K. Desmond.
© 2011 Kathleen K. Desmond. Published 2011 by Blackwell Publishing Ltd.

Figure 7.1:	Reproduced by permission of Matthew Zupnick.
Figures 7.2 and 7.3:	Reproduced by permission of Luba Lukova.
Figure 7.4:	Farhat Art Museum collection, Beirut, Lebanon. Reproduced by permission of Suzanne Klotz.
Figures 9.1 and 9.2:	Reproduced by permission of Joyce Jablonski.
Figure 10.1:	Reproduced by permission of Kyle Martin.
Figure 11.1:	Reproduced by permission of the Nelson Atkins Museum of Art, Kansas City, Missouri. Gift of Hallmark Cards, Inc., 2005.27.3999. Photo credit: John Lamberton.
Figure 11.2:	Reproduced by permission of the Nelson-Atkins Museum of Art, Kansas City, Missouri. Gift of Hallmark Cards, Inc., 2005.27.315. Copyright 1998 Robert and Shana Parke-Harrison. Photo credit: Jamison Miller.
Figures 12.1:	Hallmark Art Collection, Kansas City, Missouri. Reproduced by permission of May Tveit.
Figure 12.2:	Reproduced by permission of May Tveit.
Figure 12.3:	Reproduced by permission of Luba Lukova.
Figure 13.1:	Reproduced by permission of Matthew Zupnick.
Figure 14.1:	Reproduced by permission of Kyle Martin.

Index

Ideas About Art, First Edition. Kathleen K. Desmond.
© 2011 Kathleen K. Desmond. Published 2011 by Blackwell Publishing Ltd.

Navajo 15
Nelson-Atkins Museum of Art 156, 172, 207, 222
 Hallmark collection 168
Neo-Classicism 75
Neo-Dada 153
Neo-Expressionism 149
Neshat, Shirin 134, 154
New Bauhaus 176, 177
New Media 166–70
new vision 176
New York Correspondence School 153
New York Public Library 90, 91
NeXT Computer 180
Niépce, Joseph Nicéphore de 158
Nietzsche, Friedrich 69
Nisqually 15, 83
Nochlin, Linda 125, 129, 133, 134
Nolde, Emil 75
non-Western ideas of art 15–32
normative ethics 81, 82
Novitz, David 25

O'Keeffe, Georgia 46
O'Sullivan, Timothy 61, 159, 160
 Ancient Ruins in the Cañon de Chelle, New Mexico Territory 62
Obama, Barack 6, 187
obesity 87
Oldenburg, Claes and Bruggen, Coosjie van 11, 12
 Batcolumn 10
 Clothespin 3, 10
 Shuttlecocks 10, 11
 Trowel I 10
 Trowel II 10
Omni Hotel, Kansas City 93, 94
ontology (metaphysics) 80, 81
"Open Door" policy 27
Oppenheim, Meret: *Object* 152
organic form 71
organic unity 71

Osborne, Harold 71
Otto-Peters, Louise 134

Paolucci, Anton 95
ParkeHarrison, Robert and Shana: *Pollination* 169, 170
Parker, Cornelia 154
Parker, Roszika 131
Parthenon, Athens 3
Pater, Walter 59
Patriot Act 110
pattern language 174–5
Paul VI, Pope 66
People for the American Way 93, 110
"Perception Delineation Theory" 197
Performance Art 149, 213
personal myth 214–17
personal revolution 26–9
Pfaff, Judy 134
phenomenology 209
philosophies of art 206–7
philosophy 80–1
photo secessionists 160
photograms 176
photography 156–70
 aesthetic debates about 160–1
 art and culture 161–4
Photorealism 114, 156, 157
Piaget, Jean 196
Picasso, Pablo 45, 90, 94, 152, 182
 Guernica 93–4
 Guitar, Sheet Music and Glass 152
Pilloton, Emily 185–7, 189
plagiarism 149, 151
plastination 85, 86
Plato 35, 37–8, 41, 43–4, 46, 51, 83, 96, 100, 135, 162, 167, 170, 191
 Pure Forms 55
Platonic essentialism 37
Plotinus 56
 hierarchy of Forms 55
pluralism 149